Fresh Ideas
in Promotion 2

BETSY NEWBERRY

NORTH LIGHT BOOKS
CINCINNATI, OHIO

This hardcover edition of *Fresh Ideas in Promotion 2* features a "self-jacket" that eliminates the need for a separate dust jacket. It provides sturdy protection for your book while it saves paper, trees and energy.

Other fine North Light Books are available from your local bookstore, art supply store or direct from the publisher.

00 99 98 97 96 5 4 3 2 1

Library of Congress Cataloging-in-Publication Data

Newberry, Betsy
 Fresh ideas in promotion 2 / Betsy Newberry.
 p. cm.
 Includes indexes.
 ISBN 0-89134-727-5 (paper-over-board: alk. paper)
 1. Commercial art—United States—Themes, motives. I. Fresh
 ideas in promotion. II. Title.
 NC998.5.A1N49 1996
 741.6'0973—dc20 96-12186
 CIP

Edited by Lynn Haller, Joyce Dolan and Terri Boemker
Interior designed by Brian Roeth
Cover designed by Angela Lennert Wilcox

The permissions on page 140 constitute an extension of this copyright page.

North Light Books are available for sales promotions, premiums and fund-raising use. Special editions or book excerpts can also be created to specification. For details, contact the Special Sales Manager, F&W Publications, 1507 Dana Avenue, Cincinnati, Ohio 45207.

METRIC CONVERSION CHART		
TO CONVERT	**TO**	**MULTIPLY BY**
Inches	Centimeters	2.54
Centimeters	Inches	0.4
Feet	Centimeters	30.5
Centimeters	Feet	0.03
Yards	Meters	0.9
Meters	Yards	1.1
Sq. Inches	Sq. Centimeters	6.45
Sq. Centimeters	Sq. Inches	0.16
Sq. Feet	Sq. Meters	0.09
Sq. Meters	Sq. Feet	10.8
Sq. Yards	Sq. Meters	0.8
Sq. Meters	Sq. Yards	1.2
Pounds	Kilograms	0.45
Kilograms	Pounds	2.2
Ounces	Grams	28.4
Grams	Ounces	0.04

about the author

Betsy Newberry is a Cincinnati-based writer specializing in business and graphic design topics. She has been writing about the design industry for more than twelve years and is a frequent contributor to *HOW* magazine. She also writes regularly about business management, finance and operations for numerous regional and nationally distributed publications.

acknowledgments

I would like to thank the primary editors of this book, Lynn Haller, Joyce Dolan and Terri Boemker, for the exceptional guidance, responsiveness and organization they brought to this project; Brian Roeth, who came up with a great, flexible design for the book's interior; Angela Lennert Wilcox, who did the book's cover design; our in-house team of judges—Lynn Haller, Sandy Kent, Kathleen Reinmann and Angela Wilcox, who looked at lots of great design and made some tough choices; Marilyn Daiker, who coordinated numerous details to get the book produced—and made sure it looked great at every step of the way; CopperLeaf Design, who laid out great-looking pages; Anne Slater, who made one last editing pass through the text; Pam Monfort Braun who shot all the pieces for which we didn't have slides; Jenny Long, for calling for extra pieces of art when we needed them; and finally, all the office managers and other support personnel within the studios included here, who entered the work for our consideration, and who got us the art and information we needed.

With such a great team behind me, there was no such thing as writer's block as I worked on this book. The creativity, ingenuity and originality behind the promotions featured were truly inspirational. Finally, I would like to thank all the designers who shared their work with us here; this book really belongs to them.

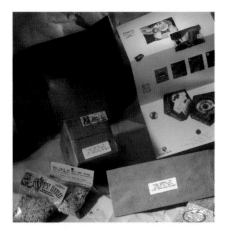

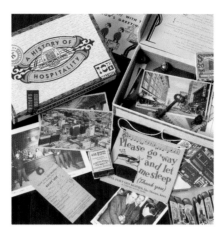

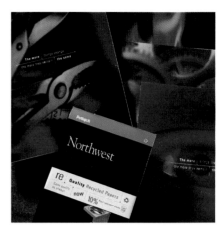

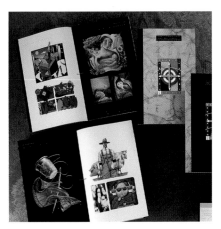

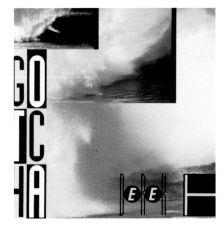

What makes a great promotion? Is it a memorable image? A catchy phrase? Neat colors and shapes? Or is it simply something—maybe a combination of the three—that makes you react, a message that pushes you to actually think about or question what you've just seen or heard. As Austrian writer and philosopher Karl Kraus once wrote, "Only he is an artist who can make a riddle out of a solution." If you can challenge someone to think about what you're promoting and to apply any level of analysis to it, you've made contact—you've triggered interest and achieved the ultimate communication feat.

That's what we think the promotions featured in this book have done. Their designers have taken solutions—that is, the product, service, company or idea being promoted—and presented them in a way that encourages us to question, decipher, study and eagerly learn more about them. Their techniques range from the simple to the complex.

For example, there's the commemorative poster created for the San Francisco Film Society's International Film Festival in which designers assembled a collage of images representing the city—and its film heritage—and then sprayed it with an industrial lubricant to give it a vintage look. Then there's the wedding invitation consisting of a specially designed box containing two trays. One tray supports eight individually designed inserts, while the second tray is cut to hold a bottle of Italian champagne. And then there's the photo ensemble of tropical islands that motivated us to turn the pages to see more, while at the same time subtly making us aware of the printing services being promoted in the brochure.

The inspiration for such innovative promotion ideas can come from any of a limitless number of sources—anything that piques the designer's imagination and curiosity. Again, to quote Karl Kraus: "A philistine is habitually bored and looks for things that won't bore him. An artist finds things boring, but is never bored." What most would consider the mundane and insignificant—like a clock, a ball cap, even a cliché—the designer thinks of as a possible element in the next riddle and a device with which to communicate the message.

Consider the studio that found inspiration in the everyday scene of cows grazing in a pasture. This studio, located in a rural, dairy region, mailed clients a mooing toy wrapped in a "Happy Noo Year" holiday greeting. Another studio based a paper promotion on the work of an architect renowned for his passion for changing existing forms and

materials into explosively unique and novel designs. Still another studio was inspired by a gaudy deck of cards from a Las Vegas resort with old movie posters reprinted on them.

Of course, one of the greatest challenges in creating a promotion is being inspired, inspiring others and doing it all within a specified time frame and budget. As you'll see in this book, the challenge is being met over and over again. Many of these promotions were created on a shoestring budget and produced within a matter of days.

One studio, for instance, spent only $30 on an invitation to its clients to help celebrate its ten-year anniversary at a lakeside party. The invitation consisted of a laser-printed and hand-glued announcement card tied to an inner tube. Another designer created a self-promotion piece for only $250. This piece was laser-printed and assembled in-house, the copyediting was donated in exchange for dinner at a nice restaurant, and many of the pieces were delivered in person to cut mailing costs. So far, the designer attributes more than $26,000 in new revenue to the promotion.

You'll also find in this book a thorough description of the materials and production techniques used to create each promotion. From simple illustrations to complex computer-generated images, there are lots of ways to get a message across. You'll see that a great promotion does not necessarily require the most elaborate or high-tech production techniques. A one-color laser-printed brochure can be just what's needed. In other cases, a special die cut or an eye-catching electronic interface is warranted.

You'll also notice that despite the hype over multimedia, on-line and the Worldwide Web, *most* promotions in this book are for products and services that are simple, everyday solutions for the consumer or business, like outdoor summer concerts sponsored by county parks, or clothing or even electricity. The tools with which to promote are changing and advancing, but the art of promotion is not. No matter who the client is or what type of format is used, the promotion must incite its target audience to contemplate, to ponder, to think—even for just a second—about the communication it just received. It must present a riddle for which the audience is driven to find a solution.

Part One

Self-Promotional Pieces for Designers

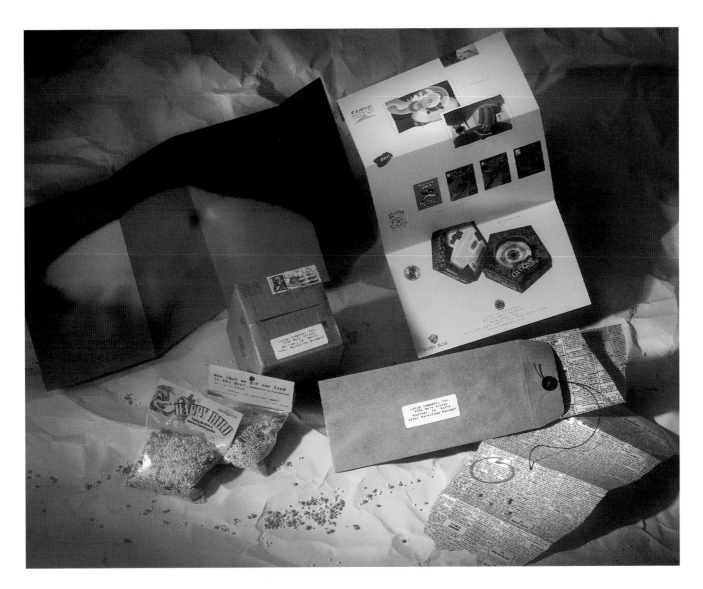

Piece is Promotion for opening of studio

Art Directors/Studio Carrie English and Ken Roberts/Canary Studios

Designers/Studio Carrie English and Ken Roberts/Canary Studios

Illustrator Carrie English

Photographer Robert Sondgroth

Client/Service Canary Studios, Oakland, CA/Graphic design

Paper Warren Lustro Gloss, Fox River Confetti Yellow

Colors Four, process

Type OCRA, Garamond

Printing Offset

Software QuarkXPress, Adobe Photoshop, Adobe Illustrator, Fractal Design Painter

Initial Print Run 100 of three-part mailing; 1,000 four-color brochures

Cost $3,200

Concept To publicize the opening of its office, Canary Studios placed a classified ad for a "multitalented" canary with "two heads" and "personality +" in the "Pets/Birds" section of a metropolitan newspaper. What appeared to be a hastily torn section of the newspaper was then sent to prospective clients with the mysterious canary ad circled in red. Two weeks later, clients were mailed a box containing a bag of bird seed that was followed by a four-color brochure featuring samples of the studio's work. This eccentric promotion helped create name recognition and showed potential clients that—unlike many of its counterparts that had chosen trendy dog names for their studios—Canary dared to be different and was looking for clients who had an appreciation of the unconventional.

Special Visual Effects
The bag of bird seed was sealed with a "Happy Bird" label that identified it as a product of Canary Studios. An abstract photo of a canary was printed on the outer side of the four-color brochure.

Distribution of Piece Each of the three parts was mailed at two-week intervals to one hundred Fortune 500 companies; approximately 1,000 bro-chures were sent to other companies.

Response to Promotion Canary received many calls from people who were simply intrigued by the newspaper ad. From the three-part mailing, the studio received a number of calls from potential clients who they identified as being "ideal," or those who, like the studio, were interested in going beyond the norm. In addition, $16,000 of billings has been attributed to the promotion.

Grafik Communications Ltd.

Piece is Self-promotional portfolio for design firm

Designers/Studio David Collins, Judy Kirpich, Richard Hamilton/ Grafik Communications, Ltd.

Photographer David Sharpe

Client/Service Grafik Communications, Ltd., Alexandria, VA/ Promotion

Paper Ikonofix Dull and Curtis Brightwater Artisian Riblade bright white (inside), Confetti Red (outer cover), handmade paper (inner black cover)

Colors Three, match; four, process; plus two spot varnishes

Type Futura

Printing Offset

Software QuarkXPress, Adobe Photoshop, Adobe Illustrator

Initial Print Run 2,500

Concept To expand its corporate client base and increase visibility among existing clients, Grafik created this professional-looking portfolio showcasing their work. The studio used a simple format—photos of completed projects accompanied by quotes from satisfied corporate clients. Both photos and quotes were set against a dull black background (with spot use of black-on-black for emphasis). The works were then spiralbound in notebook form—to emphasize the studio's clean, effective and creative style. Projects featured run the gamut in terms of the type of service provided by the studio and the design itself, thus conveying their diversity and their fresh, creative approach to every job.

Special Visual Effects With the black cover and spiral binding, the piece closely resembles a small briefcase or day planner that many corporate professionals carry.

Distribution of Piece The promotion was sent by mail as requested to existing and potential clients.

Response to Promotion The studio has received an overwhelming thumbs-up from its target audience.

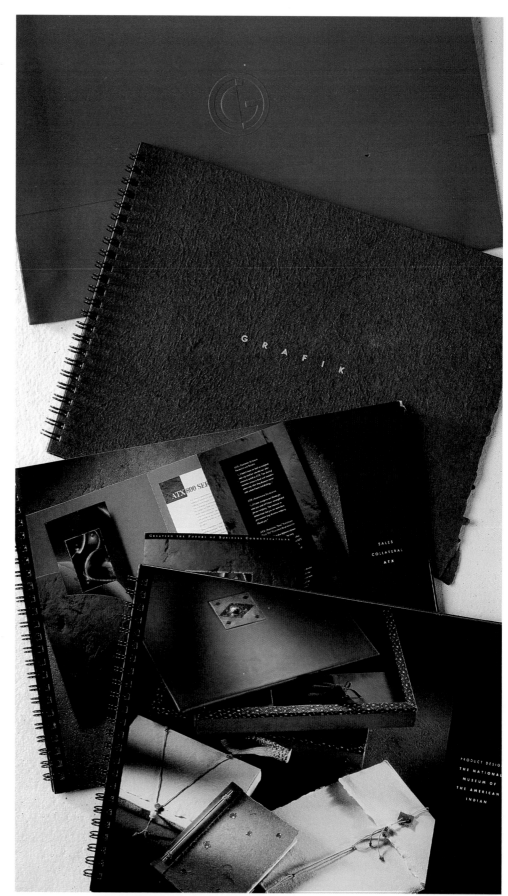

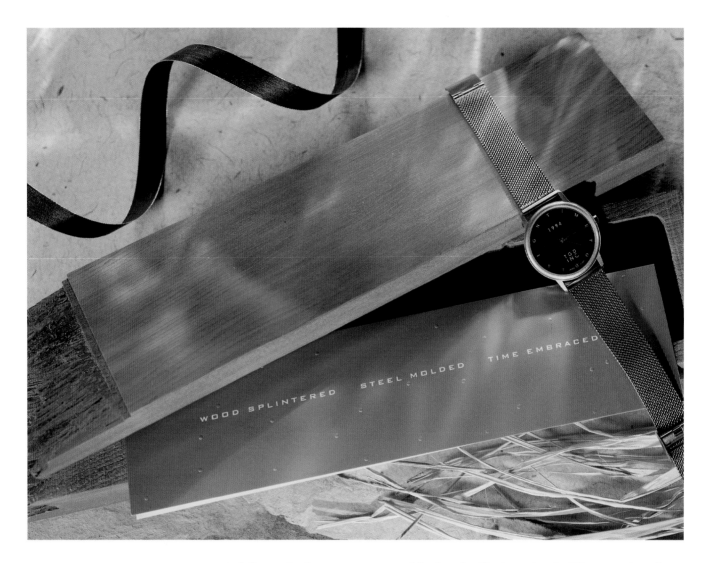

Piece is Self-promotional holiday gift

Art Director/Studio Tim Girvin/Tim Girvin Design Inc.

Designer/Studio Tim Girvin/Tim Girvin Design Inc.

Illustrator Tim Girvin

Client/Service Tim Girvin Design Inc., Seattle, WA/Graphic design

Paper Kromekote 2000 C1S 10 pt.

Colors One

Type Bank Gothic Medium, Bauer Bodoni

Printing Laser printed

Software MacroMedia FreeHand

Initial Quantity 250

Cost Watches, $17 each; boxes, $4 each; printing, $125 (approx.)

Photography of piece Kristy Lindgren

Concept "There's no time like the present to call Tim Girvin Design." That's the message clients got when they opened this sleek, specially designed wristwatch. The hand-crafted watch, which was designed by Girvin, displays on its face the tag line, "Time to Design." The watch was packaged in a velvet case that was enclosed in a wooden box. The box, also designed by Girvin and reproduced by a box-making firm, was sharply splintered at one end. The different textures—the metals in the watch, the fabric of the velvet case, and the jagged-edged wood box—show how the different energies and natural characteristics of both organic and hand-crafted materials can be extracted to form an entirely new object. Employing such different materials is a fitting way to unveil the studio's unique and energetic style in communicating new messages.

Distribution of Piece The watches were mailed to existing and potential clients as a holiday gift.

Response to Promotion The studio received inquiries from intrigued potential clients and numerous "thank yous" from existing clients.

Vaughn Wedeen Creative

Piece is Self-promotional holiday gift

Art Director/Studio Rick Vaughn/Vaughn Wedeen Creative

Designer/Studio Rick Vaughn/Vaughn Wedeen Creative

Photographer Dave Nufer

Client/Service Vaughn Wedeen Creative, Albuquerque, NM/Design studio

Paper Simpson Starwhite Vicksburg

Colors Four, process

Printing Offset

Software QuarkXPress, MacroMedia FreeHand, Adobe Photoshop

Initial Print Run 200

Photography of Piece Dave Nufer

Concept Christmas is for kids, and the clients and friends who received this promotion probably felt like kids again as they got the chance to construct their very own toy. Each canister contained a hodgepodge of brightly colored "stuff," including beads, coils, nails, a spool and a piece of pipe, which could be used to create any number of gizmos. An accompanying "Book of Vaughn Wedeen Gizmos" features some of the toys that can be created with the gadgets. The bright colors and geometric design on the exterior of the canister and the book connote fun and games. Even the most staid of adults couldn't resist fiddling around with this promotion.

Cost-Saving Technique Photography for the "Book of Gizmos" was donated.

Distribution of Piece The canisters were hand-delivered and express mailed to existing and potential clients, vendors and friends.

Response to Promotion The studio has received so many favorable comments on the promotion that it's thinking about marketing the toy.

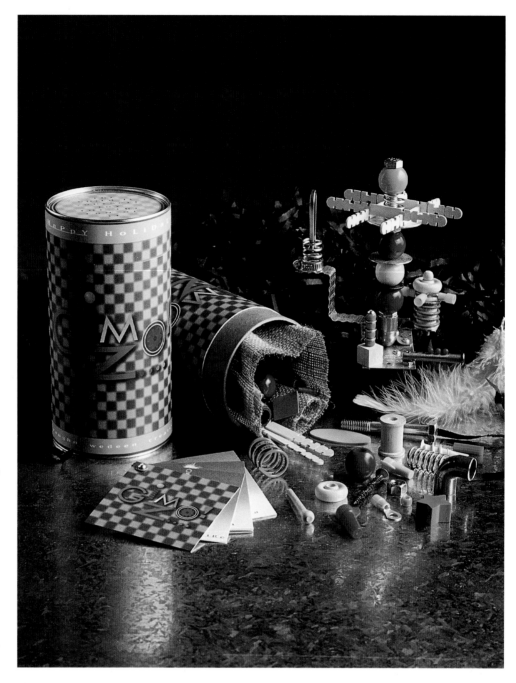

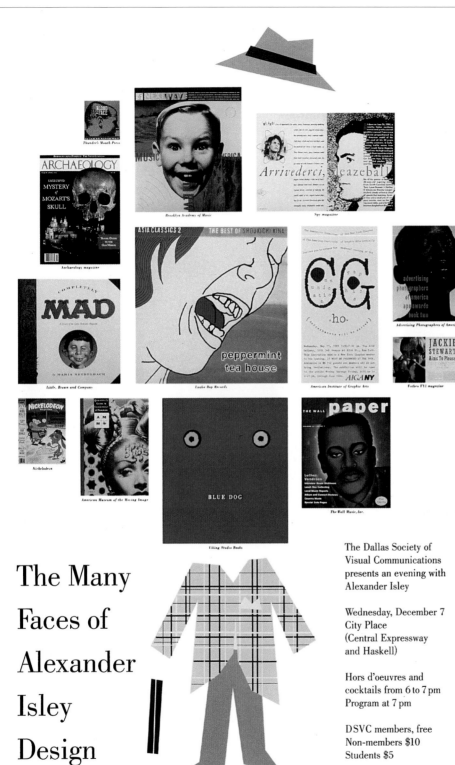

The Dallas Society of
Visual Communications
presents an evening with
Alexander Isley

Wednesday, December 7
City Place
(Central Expressway
and Haskell)

Hors d'oeuvres and
cocktails from 6 to 7 pm
Program at 7 pm

DSVC members, free
Non-members $10
Students $5

Piece is Poster promoting design-
er's lecture
Art Director/Studio Alexander
Isley/Alexander Isley Design
Designer/Studio Alexander
Isley/Alexander Isley Design
Client/Service Alexander Isley
Design, New York, NY/Graphic
design
Paper 100 lb. Preeminence Dull
Book
Colors Four, process and two,
match
Type Bodoni
Printing Offset
Software QuarkXPress
Initial Print Run 1,500
Cost Done in lieu of an honorari-
um from lecture sponsor

Concept This poster for a lecture
sponsored by the Dallas Society of
Visual Communications serves a
dual purpose—to draw attendees
to the designer's presentation and
to communicate the diversity and
emotion of the studio's style. Photos
of past projects that incorporated
faces in their design were assem-
bled to form the "face" of an illus-
trated salesman figure. (The
designer's fondness for gaudy plaid
jackets inspired the illustration.)
A secondary motivation was his
desire to weaken the pompous
stereotype often attached to de-
signers in general. The myriad
designs of faces done for a variety
of clients and campaigns show the
extent of the studio's capabilities
and relays the fact that it can't be
pigeonholed into a certain style
or look.
Cost-Saving Technique The
Dallas Society of Visual Communi-
cations paid for the costs to produce
the poster in lieu of an honorarium
to Isley. Extras were printed for
him to distribute to the studio's
clients.
Distribution of Piece The poster
was mailed to designers and clients.

Curry Design

Piece is Self-promotional portfolio

Art Director/Studio Steve Curry/Curry Design

Designer/Studio Jason Schiedeman/Curry Design

Photographers Mark Scott, Bill Vanscoy

Client/Service Curry Design, Venice, CA/Graphic design

Paper Simpson EverGreen (cover); Quintessence 65 lb. cover (body)

Colors Two, match; four, process; plus two foil stamps

Type ITC Garamond, Futura Bold

Printing Offset

Software QuarkXPress, Adobe Photoshop

Initial Print Run 2,000

Cost $30,000

Concept What appears to be a traditional miniportfolio of the studio's work is also a thoughtful commentary on its philosophy of design and commitment to the client. A simple but elegant cover opens to a first page of copy that has a three-dimensional look. A statement about the art of graphic design is reversed out of a light-colored block, serving as the "background" (both literally and figuratively) for the qualities and design services Curry has to offer. Words like "integrity," "motivation" and "curiosity" are layered above this philosophy of design and the studio's services are listed vertically, floating "above" both these supporting layers of text. Photographs of completed projects are placed dominantly on the following pages, complemented by subtly placed quotes of famous artists.

Distribution of Piece The portfolio was mailed and hand-delivered to existing and potential clients.

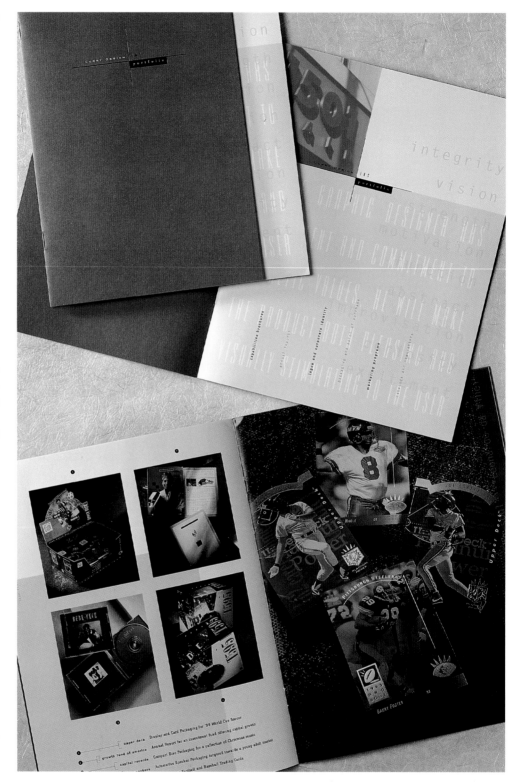

The Riordon Design Group

Piece is Self-promotional brochure sent to clients in the music industry

Art Director/Studio Ric Riordon/The Riordon Design Group

Designers/Studio Dan Wheaton, Ric Riordon/The Riordon Design Group

Illustrator Andrew Lewis

Photographers David Graham White, Stephen Grimes

Client/Service The Riordon Design Group, Oakville, Ontario, Canada/Design communications

Paper Cougar, Wyndstone Transcard Parchment Vellum, Royal Impression

Colors Two, match; four, process

Type Latino Longated, Futura, Palatino

Printing Offset

Software QuarkXPress, Adobe Photoshop, Adobe Illustrator

Initial Print Run 1,000

Cost $30,000

Concept To showcase its work in the entertainment industry (primarily music packaging), the designers chose a likely theme for this promotional piece—music! Entitled "Show Tunes," a collection of the studio's work for its clients in the music and recording industry is featured in a sleek spiral-bound booklet, which is inserted in a black folder and tied with a shimmering bronze ribbon. This whole package is placed in a fabric-covered box, somewhat reminiscent of a CD boxed set. The sophisticated materials provide an interesting contrast to the playful use of musical icons that symbolize the studio's creative and innovative design style. This piece is the first in a two-part promotional campaign. The second, entitled "Show & Tell," features the studio's corporate work, such as annual reports, identities and advertising.

Cost-Saving Technique The studio designed an ad campaign for its film house in exchange for the film work on both promotional pieces.

Distribution of Piece The booklets were delivered in person and express mailed.

Response to Promotion A number of new clients have approached the studio with projects. The firm estimates that it has generated between $25,000 and $30,000 in revenues after distributing only 20 percent of the brochures.

The Pushpin Group

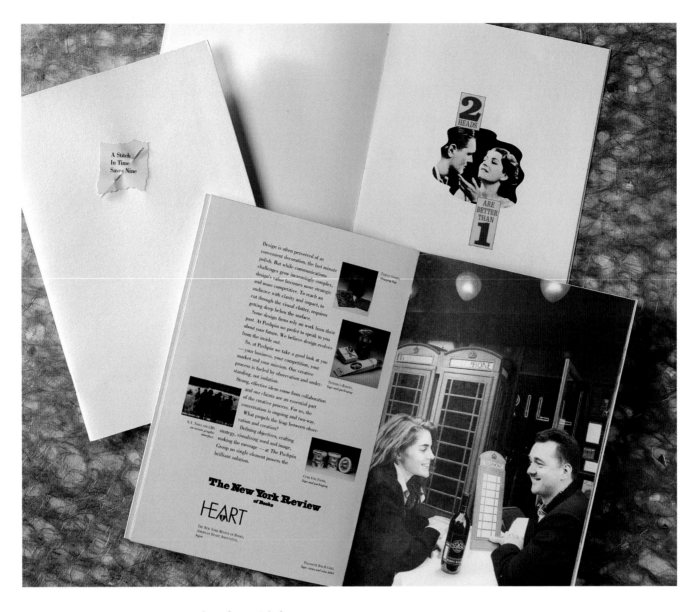

Piece is Capabilities brochure
Art Director/Studio Seymour Chwast/The Pushpin Group
Designer/Studio Roxanne Slimak/The Pushpin Group
Photographers Peter Bittner (black-and-white), Ed Spiro (color)
Client/Service The Pushpin Group, New York, NY/Graphic design
Paper Domtar Fusion 80 lb. Text (die-cut shape attached to cover); Domtar Plainfield Plus 65 lb. Cover Antique Finish (cover); Domtar Plainfield Plus 100 lb. Text Smooth Finish (interior)

Colors One, match; four, process
Type Bodoni Book
Printing Offset
Software QuarkXPress
Initial Print Run 5,000

Concept In this capabilities brochure, The Pushpin Group demonstrates how clever design can rejuvenate even the most worn-out clichés. The goal of the piece is to convey the firm's commitment to creating fresh, inspirational and mindful design without relying on overused quick-fix solutions. By interspersing clichés—such as "good things come in small

packages"—with photos and samples of its design that indirectly represent that truth, Pushpin skillfully and subtly informs existing and potential clients of its capability for creating unique and inspiring design solutions.

Special Visual Effects A piece of paper die-cut to look like a swatch of fabric was attached by hand with a sewing needle to the cover. The cliché, "A stitch in time saves nine," was printed in black on the swatch.

Distribution of Piece Direct mail and in press kits.

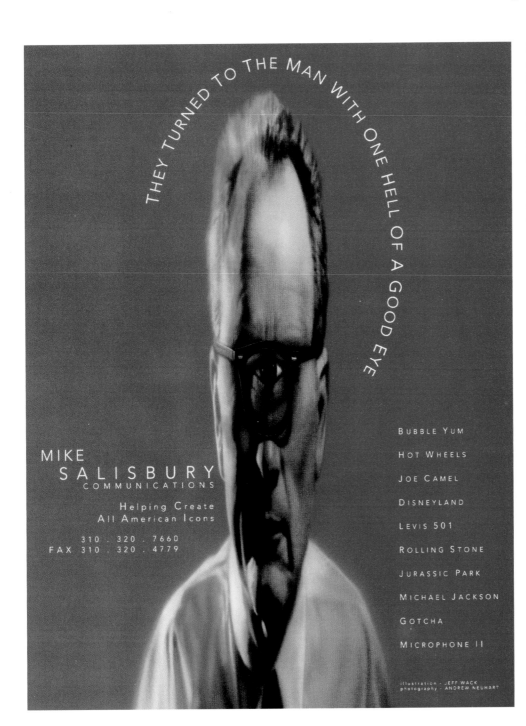

THEY TURNED TO THE MAN WITH ONE HELL OF A GOOD EYE

MIKE
SALISBURY
COMMUNICATIONS

Helping Create
All American Icons

310 . 320 . 7660
FAX 310 . 320 . 4779

BUBBLE YUM

HOT WHEELS

JOE CAMEL

DISNEYLAND

LEVIS 501

ROLLING STONE

JURASSIC PARK

MICHAEL JACKSON

GOTCHA

MICROPHONE II

illustration - JEFF WACK
photography - ANDREW NEUHART

Piece is Advertisement/mailer
Art Director/Studio Mike Salisbury/Salisbury Communications
Designer/Studio Mike Salisbury/Salisbury Communications
Illustrator Jeff Wack
Photographer Andrew Neuhardt
Client/Service Salisbury Communications, Torrance, CA/Graphic design
Colors Four, match
Type News Gothic
Printing Laser printed
Software Aldus PageMaker
Initial Print Run 2,500
Cost $1,500 (ad space)

Concept Here's a studio that thinks conceptually. Inspired by the look of an ad from the 1960s, a photograph of a man was reconstructed to give him only one eye in the center of his face. The accompanying text reads, "They turned to the man with one hell of a good eye." A partial list of well-known clients appears in the lower right corner, immediately calling to mind some of the designer's images associated with their products and services. While the piece conveys the studio's success and good reputation, it also signifies its sense of humor, creativity and unconventionality. Instead of simply creating a portfolio of work samples, the designer opted for something that informs and entertains.
Cost-Saving Technique The illustrator traded his services for those of the designer to produce his own promo piece.
Distribution of Piece The ad was placed in *CA: Workbook* and the mailer is distributed on an ongoing basis to existing and potential clients.

Sam Smidt, Inc.

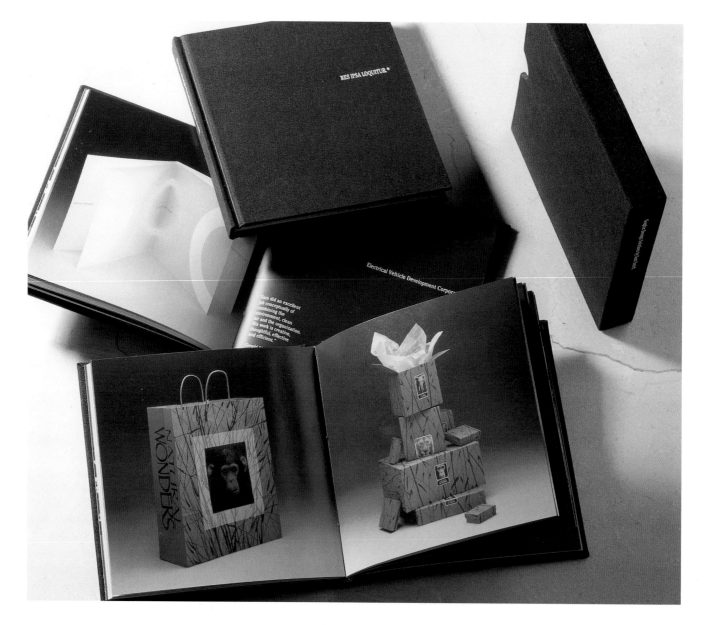

Piece is Self-promotional portfolio

Art Director/Studio Sam Smidt/Sam Smidt, Inc.

Designer/Studio Sam Smidt/Sam Smidt, Inc.

Photographers Michael Neimann, Paul Fairchild

Client/Service Sam Smidt, Inc., Palo Alto, CA/Graphic design

Paper Quintessence Text 80 lb., Durotone Text

Colors Four, process, plus dull and gloss varnishes

Type Garamond Light Condensed

Printing Offset

Software Adobe Illustrator

Initial Print Run 500

Cost $30,000

Concept Good design work speaks for itself. That's the message of this simple, understated portfolio of design solutions. The piece consists of a small (5 ¾" x 5 ¾") hardbound book covered in black fabric and inserted in a case covered in the same black fabric. "Graphic Design Solutions by Sam Smidt." is printed on the side of the case as well as on the spine of the book. On the book's cover is the phrase "Res ipsa loquitur," or "The thing speaks for itself," as noted on the opening page. Various pieces are showcased throughout the 96-page book and accentuated with comments from clients about the quality of Smidt's work. The starkness of the book cover and the black background of various pages throughout ensure that the clients' needs and the studio's capabilities in meeting them take center stage.

Distribution of Piece The books are delivered in person to prospective clients.

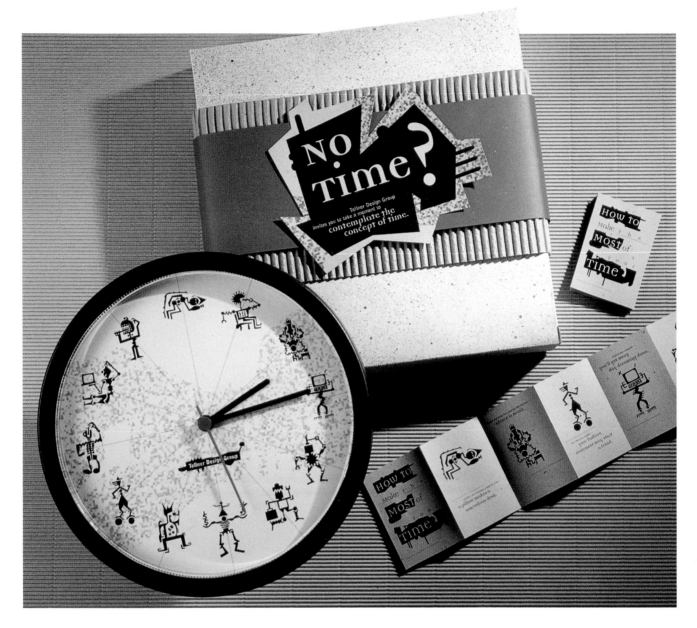

Piece is Self-promotion for design and marketing firm

Art Director/Studio Lisa Tollner/Tollner Design Group

Designers/Studio Christopher Canote, Tracy Spencer, Rochelle Orosa/Tollner Design Group

Illustrator Christopher Canote

Copywriter Holly Kaslewicz

Client/Service Tollner Design Group, San Jose, CA/Design and marketing communications

Paper Fox River Confetti (booklet); corrugated cardboard (packaging)

Colors Three, match

Type Democratica, Bell Gothic

Printing Laser printing (booklet); custom print (clock face)

Software Adobe Illustrator, Adobe Photoshop, QuarkXPress

Initial Print Run 100

Cost $2,154

Concept A light-hearted approach to effectively managing time was the focus of this self-promotion. Realizing that most of its clients are racing against the clock to meet deadlines, Tollner Design created a wallet-size booklet that offers some zany solutions to the

problem of not enough time, e.g., "Don't iron your clothes—your fashion statement may start a trend." The booklet was taped to a functional, battery-operated wall clock. The clock reinforces the fact that Tollner understands the time constraints and pressures under which its clients operate on a day-to-day basis. It also conveys the message that Tollner can provide communications solutions that will lessen the stress and strain of "not enough time."

Special Visual Effects Illustrations of robotic characters were used in

the booklet and repeated on the face of the clock.

Distribution of Piece Some were hand-delivered, others were sent by courier, and the remaining were mailed to key prospects and current clients.

Response to Promotion Almost all recipients have the clock hanging in their offices and have commented favorably on its design. Two clients want a clock designed for their own promotions.

Platinum Design

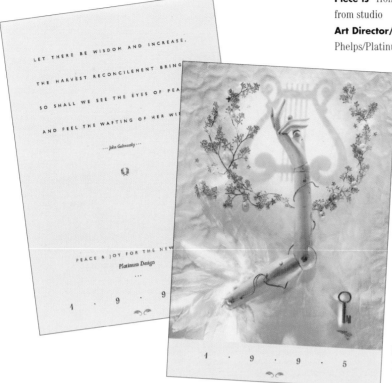

Piece is Holiday greeting card from studio

Art Director/Studio Kathleen Phelps/Platinum Design

Designer/Studio Kathleen Phelps/Platinum Design

Photographer Hans Neleman

Client/Service Platinum Design, New York, NY/Graphic design

Paper Starwhite Vicksburg

Colors One, match; four, process

Type Gill Sans, Perpetua

Printing Offset

Software QuarkXPress

Initial Print Run 1,000

Concept This nondenominational holiday greeting was designed to send a message of hope and peace to Platinum's existing and prospective clients. Inspired by the traditions and music associated with the holidays, photographer Hans Neleman used a mannequin arm with feathery wings at the shoulder to represent the arm of an angel pointing heavenward to the harp image in the background. The John Galsworthy poem on the inside was selected once the cover image was complete. It, too, evokes a feeling of peace and serenity.

Special Visual Effects Neleman's photos are much like paintings, often accentuated with enigmatic icons—like the key in the lower right corner—that mean different things to different people.

Distribution of Piece Cards were mailed.

White Design

Piece is Self-promotional holiday gift

Art Director/Studio John White/White Design

Designer/Studio Aram Youssefian/White Design

Illustrator Aram Youssefian

Client/Service White Design, Long Beach, CA/Graphic design

Paper Strathmore Wove Ultimate White (overlay); Strathmore Wove Crack 'N Peel Ultimate White (tin label)

Colors Three, match

Type Futura

Printing Offset

Software Adobe Illustrator, Adobe Photoshop, QuarkXPress

Initial Print Run 250

Cost $2,529

Concept This holiday gift tin of chocolates tastefully promotes the studio's services and capabilities.

The label design on the lid of the tin abstractly depicts the four seasons; thus, the canister can be used or displayed year-round. A holiday greeting from the studio is printed on the overlay. Playing off the Whitman candy "Sampler" idea, the studio offers up a "sampling" of its logo designs in the form of chocolates, each of which has a different logo imprinted on its top. The logos are also reproduced around the border of the overlay so that clients can indulge and still keep samples of the studio's design.

Distribution of Piece The tins were hand-delivered to clients and vendors.

Response to Promotion The studio reports that "Everyone thought it was very innovative and creative."

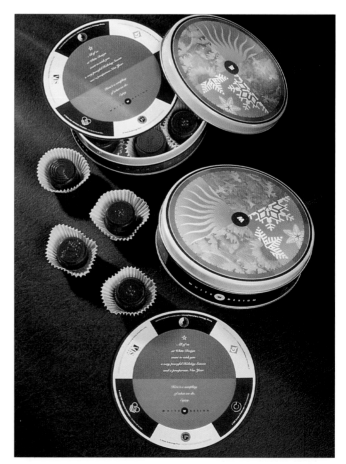

Evenson Design Group

Piece is Self-promotional holiday gift

Art Director/Studio Stan Evenson/Evenson Design Group

Designer/Studio Sherry Lambie/Evenson Design Group

Client/Service Evenson Design Group, Culver City, CA/Graphic design

Paper Premade Chinese food boxes; Strathmore Natural (labels)

Colors Three, match

Type Copper Plate, Shelly Script

Printing Offset, Anderson Printing

Software QuarkXPress

Initial Print Run 350

Cost Trade-off with Anderson Printing

Photography of Piece Anthony Nex

Concept The holiday season was the appropriate time to send a box of fortune cookies wishing clients a happy, prosperous year. Each cookie contained an inspirational message, most from Confucius and other famous people, but one "oddball" quote—as Stan Evenson calls it—from his father: "If you get it done now, you'll get it done early."

Cost-Saving Technique The green Chinese food boxes were purchased at a party supply store. The cost to print the labels and note cards was traded out with a local printer.

Distribution of Piece The boxes were delivered to clients by courier.

Response to Promotion Many clients responded with notes and calls of thanks.

Vrontikis Design Office

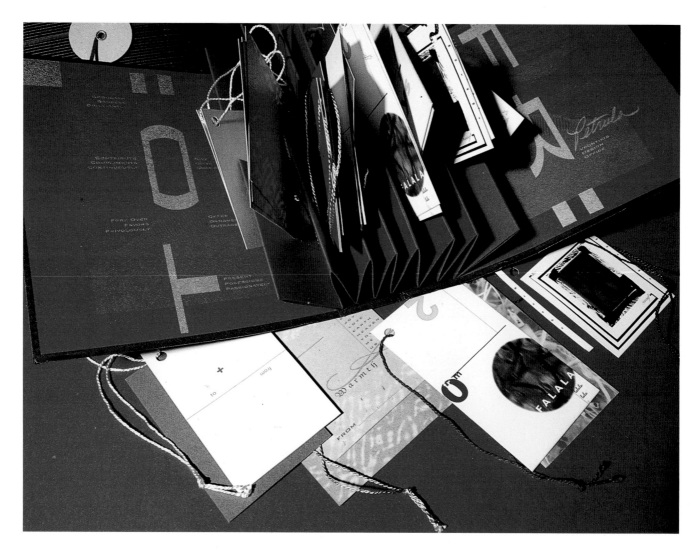

Piece is Self-promotional gift tag set

Art Director/Studio Petrula Vrontikis/Vrontikis Design Office

Designers/Studio Petrula Vrontikis, Kim Sage, Christina Hsiao/Vrontikis Design Office

Client/Service Vrontikis Design Office, Los Angeles, CA/Graphic design

Paper Black corrugated and red Fox River Confetti (tag holder); various (individual cards)

Colors One, silver metallic (tag holder); various (individual cards)

Type Bronzo (tag holder); various (individual cards)

Printing Offset

Software QuarkXPress, Adobe Photoshop, Adobe Illustrator

Initial Print Run 500

Cost $1,300

Concept This practical holiday gift to clients consists of eight individually designed gift tags packaged in a contemporary-looking black tag holder tied with a red ribbon. The holder opens to dramatically display pop-up pleats, each of which is cut to hold three copies of each of the cards. On the inside of the front and back panels of the holder are the words "To:" and "Fr:" (from) and alliterations about gift-giving printed in a festive metallic silver. The design of each of the tags was inspired by the designers' dislike of the typical gift tags sold in stores. The tags vary in size and feature inventive treatments of traditional holiday images. Each is hole-punched with a string attached.

Cost-Saving Technique The gift tags are gang printed with various projects completed during the year, utilizing paper that would otherwise be discarded.

Distribution of Piece The tag sets are mailed once a year to clients, vendors and friends.

Response to Promotion The studio attributes about $10,000 in new revenue to the tags and receives many notes of thanks from clients.

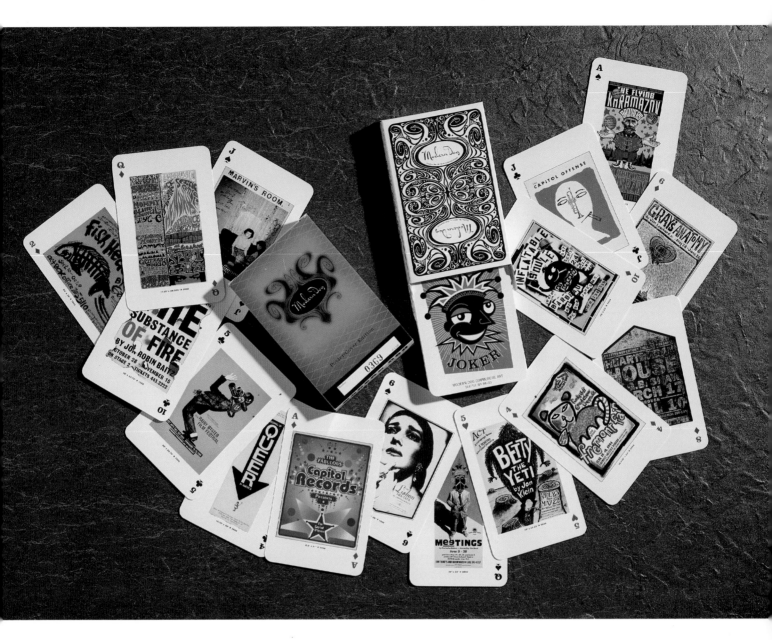

Piece is Deck of playing cards

Art Directors/Studio Robynne Raye, Michael Strassburger/Modern Dog

Designer/Studio Michael Strassburger (deck packaging)/Modern Dog

Illustrators Michael Strassburger, Robynne Raye, Vittorio Costarella, George Estrada

Client/Service Modern Dog, Seattle, WA/Graphic design

Paper 14 pt. Carolina Cover

Colors Four, process

Type Rosewood, Clarendon, Akzidenz Grotesk (card box); various (cards)

Printing Offset

Software QuarkXPress, Adobe Photoshop, Adobe Illustrator

Initial Print Run 2,500

Cost $14,000

Photography of Piece Greg Montijo

Concept Since people often request samples of their posters, the designers at Modern Dog decided to compile them in a limited edition deck of playing cards. The idea came to art director Robynne Raye during a plane ride. She was sitting next to a passenger playing with a deck of cards that had old MGM movie posters reproduced on them. Creating a similar deck for Modern Dog sounded like a "fun thing to do," and a practical way for the studio to promote itself. The back of each card is a different poster or cover design. The deck is packaged in a compact, easy-to-carry box with the Modern Dog logo on it.

Special Visual Effects Each case is individually numbered with a hand stamp. The inside of the box is printed with a complementary pattern.

Distribution of Piece Mailed and handed out to existing and potential clients. On sale for $13 each at the Seattle Art Museum and Cooper-Hewitt coffee shop in Seattle.

Response to Promotion Many favorable comments. Museum and coffee shop sales are ongoing.

Mires Design

Pieces are Self-promotional booklets, ads and mailer

Art Directors/Studio Jose Serrano, Scott Mires/Mires Design

Designer/Studio Jose Serrano, Scott Mires/Mires Design

Copywriters John Kuraoka (packaging booklet); Kelly Smothermon (mailer)

Client/Service Mires Design, San Diego, CA/Graphic design and marketing communications

Paper Kromekote (identities booklet and mailer); E-Flute cardboard (covers of packaging booklet)

Colors Three, match (identities booklet); three, match and four, process (packaging booklet); four, process (ad series and mailer)

Type Palatino and Futura Extra Bold (identities booklet); Franklin Gothic (packaging booklet); Franklin Gothic and Bodoni Book (ad series)

Printing Offset (all four pieces); packaging booklet has a silkscreened cover; identities booklet has thermography on cover

Software QuarkXPress

Initial Print Run 2,000 (each of the booklets); 2,500 (the mailer)

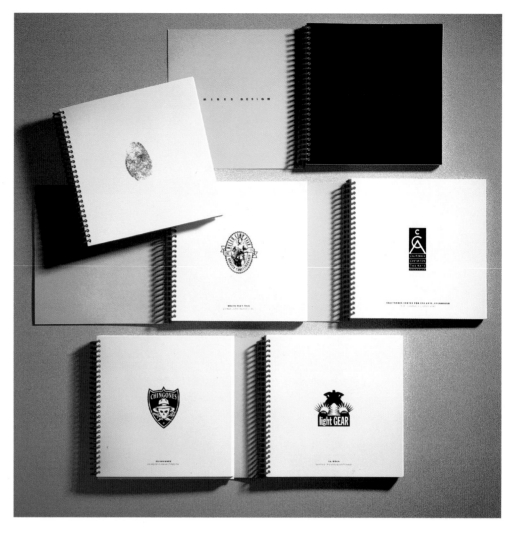

Concept This all-encompassing promotional campaign gives prospective clients a comprehensive look at the services and capabilities of Mires Design. The four pieces were distributed at different times to existing and prospective clients. The identities booklet is a spiralbound showcase of the many logos and corporate identities the firm has designed. A simple fingerprint on the cover—a universal symbol for a person's unique identity—conveys the studio's sense of the importance of one-of-a-kind identity. Inside are more than forty examples of logos and identities, each reproduced in black on its own page. The back side of each page is printed in a brightly contrasting gold.

The packaging booklet was developed after a positive response to the identities book. The packaging concept is conveyed through the use of corrugated cardboard used for the booklet's cover. Inside are full-color photos of various projects accompanied by a brief explanation of their concept and how they were produced. The booklets were sealed with kraft-colored shipping tape. A message on the back cover—"Packaging Projects Handled With Care"—adds a witty touch.

Many of the packaging and logo designs were repeated in a four-page ad series appearing in *The Workbook*. The clean, balanced design of the ads is reader-friendly and provides a suitable contrast to other ads that consist of just a logo and a headline.

Lastly, the mailer was created to show prospective clients how graphic design can be effective, even on a limited budget. The three-fold piece includes examples of one- and two-color projects completed by the studio. The brochure is small but it communicates well how you don't need a big budget or extravagant production techniques to create something with high impact.

Distribution of Pieces The identities booklets were wrapped in old posters designed by the studio for an added personal touch, and mailed to existing and prospective clients. The packaging booklets and mailers also were mailed to existing and prospective clients.

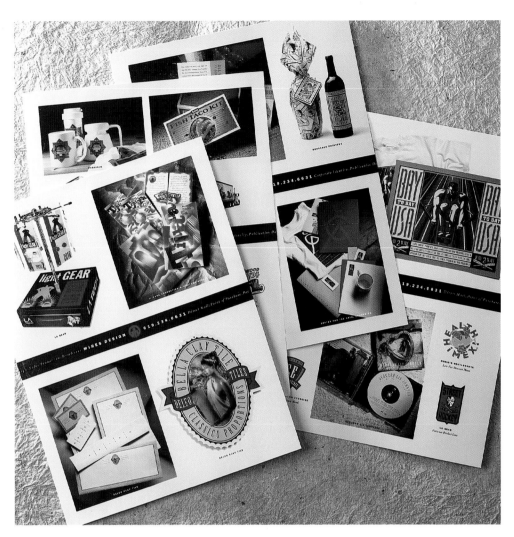

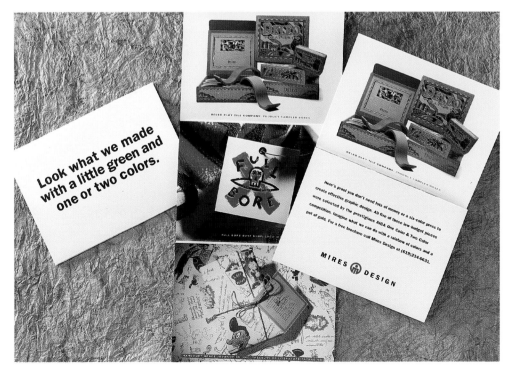

Invitations and Event Promotions

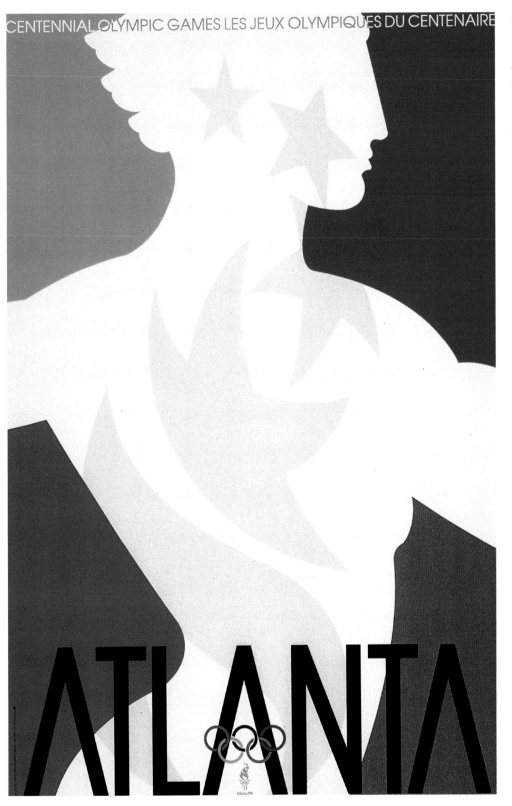

Piece is Poster promoting 1996 Summer Olympic Games in Atlanta

Art Director/Studio Primo Angeli/Primo Angeli Inc.

Designer/Studio Primo Angeli/Primo Angeli Inc.

Computer Illustrators Marcelo De Freilas, Mark Jones

Client/Event Atlanta Committee for the Olympic Games, Atlanta, GA/1996 Summer Olympic Games in Atlanta

Paper Enamel stock

Colors Five

Type Hand typography

Printing Litho

Software Adobe Illustrator

Initial Print Run 10,000

Cost $12,000

Photography of Piece June Fouche

Concept This commemorative poster for the one-hundredth anniversary of the modern-day Olympics combines symbols of the games from past and present. The androgynous athletic figure at the center of the poster takes on the look of a classic Greek sculpture through the shadow overlay of the Atlanta Olympics torch logo on its torso. Use of the five official Olympics colors—black, red, blue, green and yellow—provides high recognition of what the poster is promoting.

Hotel Fort Des Moines

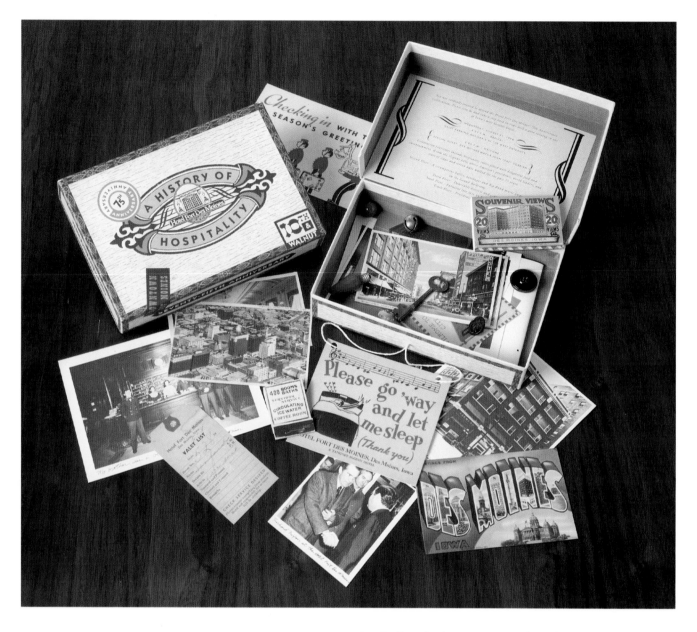

Piece is Campaign for seventy-fifth anniversary of Hotel Fort Des Moines

Art Director/Studio John Sayles/Sayles Graphic Design

Designer/Studio John Sayles/Sayles Graphic Design

Illustrator John Sayles

Client/Service Hotel Fort Des Moines, Des Moines, IA/hotel

Paper Curtis Eggshell 80 lb. linen (poster); Curtis Antique Parchment 70 lb. text (box wrap); Curtis Eggshell 65 lb. (postcards); Curtis Tuscan Terra Pebble 80 lb. cover (invitation)

Colors Poster: four, process and three, match; Invitation: four, process and two, match

Type Hand-rendered

Printing Offset

Initial Print Run 1,000 of each

Concept This promotional campaign commemorating the seventy-fifth anniversary of an historic Des Moines hotel borrows images and relics from years gone by. To invite guests to the hotel's anniversary celebration, the designer created a custom package that looks like an old cigar box. Inside are reproductions of vintage photographs and postcards featuring historic sites and scenes of Des Moines and the hotel. The designer searched antique shops and flea markets for old buttons and skeleton keys to put in the boxes, adding to their heirloom look. To further promote the hotel to meeting planners, a commemorative poster depicting a smiling bellman was designed using the theme "A History of Hospitality." Hotel memorabilia, including postcards, a matchbook, valet tag and "Do Not Disturb" sign, were reproduced and tipped onto the poster, giving it a three-dimensional quality.

Cost-Saving Technique Hotel staff helped collate and assemble the invitations during down time to save on printing and bindery costs.

Distribution of Piece The poster was mailed to meeting and event planners to encourage them to book events at the hotel. The cigar box invitations were mailed to guests and local residents.

Response to Promotion Some invitation recipients said they spent up to half an hour browsing through the cigar box and its contents. The anniversary celebration was well-attended.

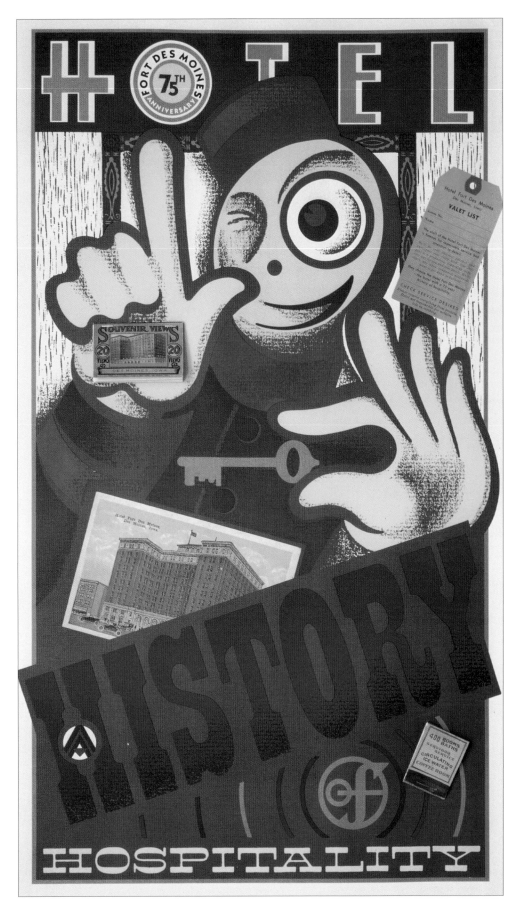

Hopper Papers

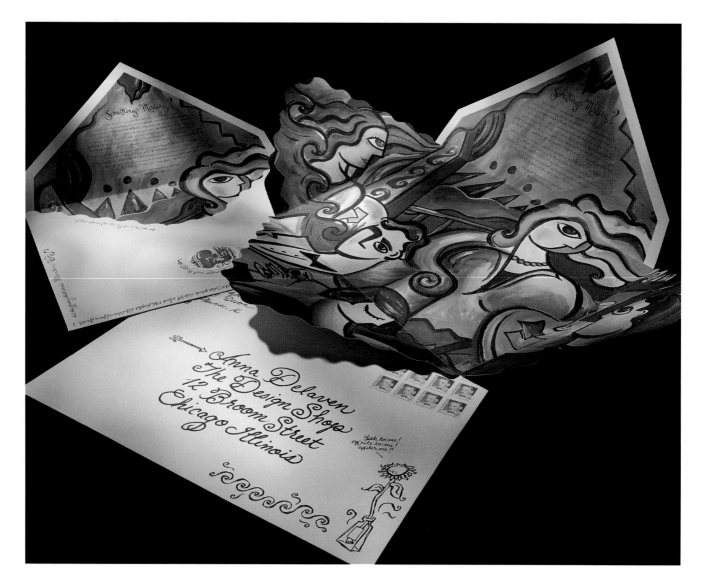

Piece is Invitation to paper promotion event

Art Director/Studio William L. Johnson/Pressley Jacobs Design

Designers/Studio William L. Johnson, Amy McCarter, Susie McQuiddy/Pressley Jacobs Design

Illustrator Christopher Baldwin

Client/Event Hopper Papers, Chicago, IL/Paper promotion

Paper Proterra Flecks, Chalk, 80 lb. cover

Colors Four, process

Type Calligraphy, Sabon

Printing Offset

Software QuarkXPress, Adobe Photoshop

Initial Print Run 500

Concept To entice people to come to a paper promotion featuring a new paper line, Pressley Jacobs developed this whimsical invitation that left potential attendees wanting to know more. The event's theme was "The Lost Art of Correspondence," and how to revive such personal communication. It was held at a trendy new Chicago restaurant whose decor inspired the design of the piece. The invitation consists of a large empty envelope that when opened displays the question "Something Missing?" followed by the details of the event. To find out just what is missing or lost—and how to regain it—readers are encouraged to attend the promotion.

Distribution of Piece The piece was mailed to creatives and vendors in the Chicago area.

Response to Promotion The event had a large turnout and since then, orders are up for the new line of paper.

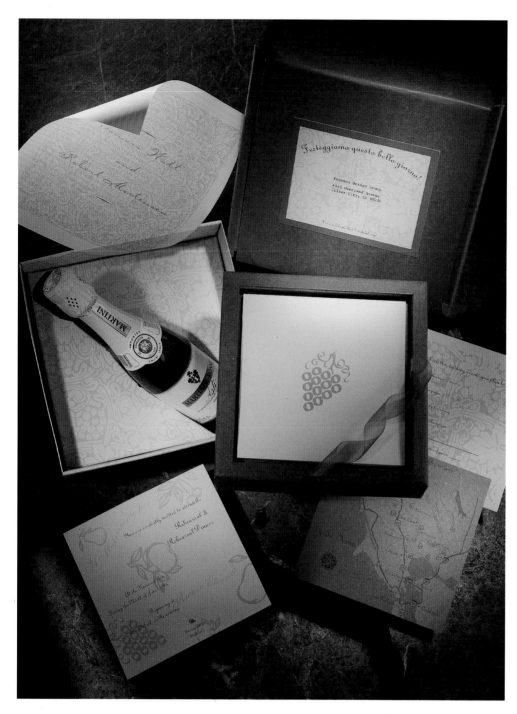

Piece is Invitation to a wedding
Art Director/Studio Stan Evenson/Evenson Design Group
Designer/Studio Eunwook Chung/Evenson Design Group
Client/Event Tamara Watt and Robert Mortensen/Wedding
Paper Genesis Birch (box); Neenah Buckskin and Genesis Birch (inserts); Neenah UV Ultra (opening page); Strathmore Crack and Peel Natural (label)
Colors Two, match
Type Linoscript, Camellia, Bernard Modern, Shelly
Printing Offset
Software QuarkXPress
Initial Print Run 300
Photography of Piece Jeff Sarpa

Concept An Italian wedding theme inspired this elaborate and sophisticated invitation. The piece consists of a hand-assembled box containing a tray with seven card inserts (including a map and invitations to various wedding events) and a reply envelope. The tray lifts out to expose a bottle of champagne custom-fitted into another tray at the bottom of the box. Using Italian architectural and winery images, the designer created a pattern that is used on the box, its trays and the various inserts. The burnished, antique look and feel of the Buckskin and Genesis Birch papers give the inserts a classic, Italian Renaissance look.
Cost-Saving Technique Each invitation was hand-assembled to cut production costs.

Maricopa Community Colleges

Piece is Poster for Maricopa Community Colleges lecture series
Studio After Hours Creative
Illustrator Jacque Barby
Client/Service Maricopa Community Colleges, Tempe, AZ/Education
Paper Productolith
Colors Four, process
Type OCR-B, OCR-A
Printing Offset
Software Adobe Photoshop, Adobe Illustrator
Initial Print Run 6,000
Cost $6,000

Concept This poster—primarily intended to communicate the focus of a lecture series for the college's honors students—pulls together elements representative of the theme of the series: "Science, Humanity and Technology." The photographic image of a person represents humanity; the binary code look of the copy and the gears are indicative of technology; and the genetic code is symbolic of science. The study and evolution of each emanates from the mind, which is illustrated by the halo of light projecting from the person's head. The various images are positioned and layered to create a dizzying effect that cleverly conveys the complexity and expansiveness of the topics covered in the lectures. To avoid a too-technical look, the designers used a soft, earthy color palette and incorporated natural elements like leaves.
Distribution of Piece The piece was mailed to college students.

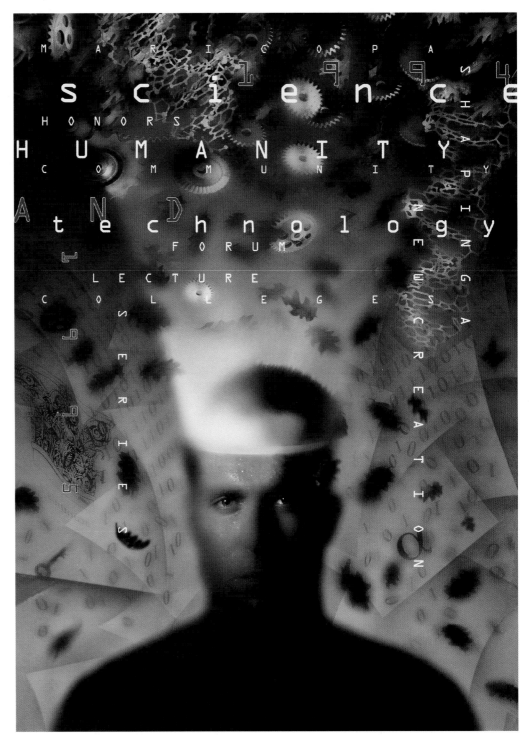

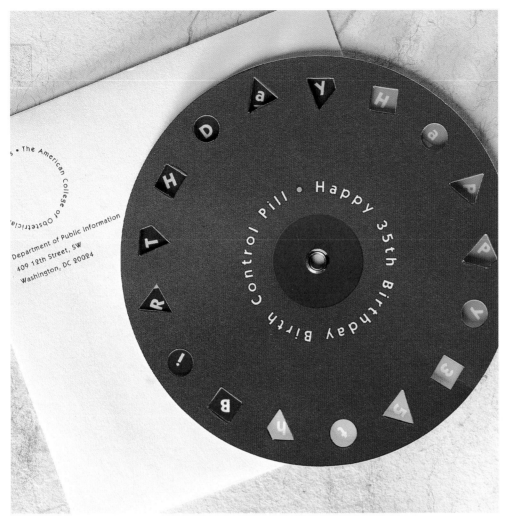

Piece is Invitation to the American College of Obstetricians & Gynecologists' birthday party for the birth control pill

Designers/Studio Gretchen East, Judy Kirpich/Grafik Communications, Ltd.

Client/Service The American College of Obstetricians & Gynecologists (ACOG), Washington, DC/professional affiliation for health care practitioners

Paper Dull Uncoated 80# Cover

Colors Four, match

Type Kabel

Printing Silkscreen

Software QuarkXPress, Adobe Illustrator

Initial Print Run 500

Concept The doctors who received this invitation probably wished the real birth control packs connoted as much fun and festivities. The design for this piece was based on the round containers that birth control pills are often packaged in. Two cards cut in circles were snapped together in the center to form a wheel. The top of the card reads "Happy 35th Birthday Birth Control Pill," with letters placed in a circular fashion (much like the ACOG logo on the outer envelope). Geometric figures are cut out along the edge of the card to expose the message underneath. In one position, the message reads "Happy 35th Birthday." When the wheel is moved slightly in either direction, the rest of the message, "Birth Control Pill," appears. The invitation itself is printed on the back side of the wheel.

Special Visual Effect The geometric cutouts and the bright colors give the piece the look of a roulette wheel, enhancing the association with fun and celebration.

Distribution of Piece The invitation was sent to doctors and other guests.

San Francisco Film Society

Piece is Identity materials and commemorative poster for an international film festival

Art Directors/Studio Primo Angeli, Carlo Pagoda/Primo Angeli Inc.

Designers/Studio Marcelo De Freitas, Paul Terrill, Primo Angeli (identification), Primo Angeli (poster)

Computer Illustrators Marcelo De Freitas, Paul Terrill (poster)

Client/Event San Francisco Film Society, San Francisco, CA/38th San Francisco International Film Festival

Paper Eloquence Silk Cover (poster); standard letterhead stock (letterhead)

Colors Four, process; four, match

Type Kabel (identification materials)

Printing Offset

Software Adobe Illustrator, Adobe Photoshop

Initial Print Run 10,000

Cost $75,000

Photography of Piece June Fouche

Concept Charged with creating an identity for the San Francisco Film Society and its international film festival, as well as a poster commemorating one hundred years of cinema, Angeli focused on the international concept and the San Francisco location. The poster is a collage whose elements exude a sense of movement from place to place, location to location. A pictogram of a director in motion and at the center of the film-making process is the central element, and the trademark figure used for the identity materials. A piece of film and an image of a landmark building in San Francisco serve as the poster's background.

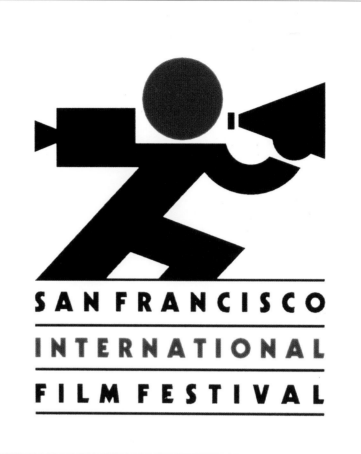

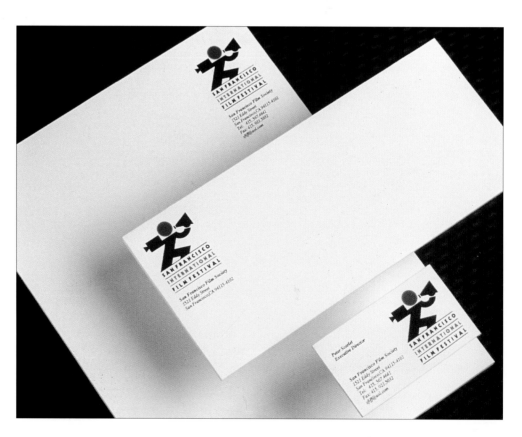

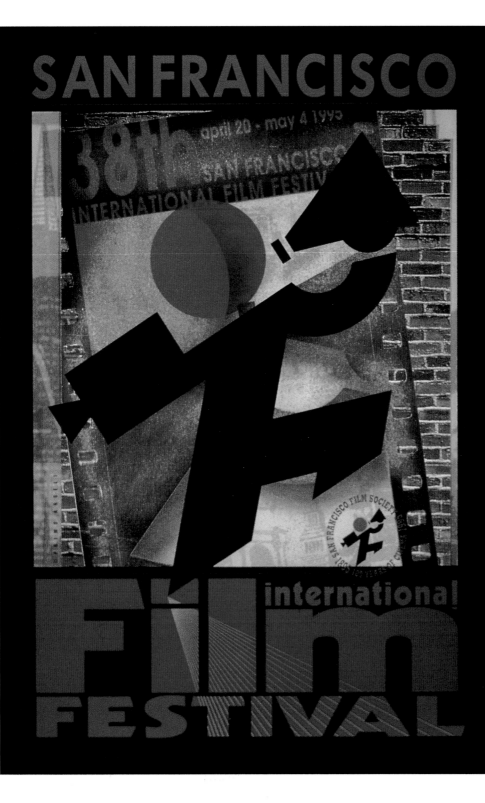

Special Visual Effects The textured look in the poster was created by combining "industrial age" materials with computer age technology. The collage background was pieced together and then sprayed with WD-40. This technique allowed for the blending of colors by hand, as with acrylics. The collage was then photographed and rescanned into the layout. The San Francisco Film Society trademark was superimposed at an angle.

MRSA Architects and Planners

Piece is Announcement of new marketing director for MRSA Architects

Art Director/Studio Carlos Segura/Segura Inc.

Designer/Studio Carlos Segura/Segura Inc.

Illustrator Carlos Segura

Client/Service MRSA Architects and Planners, Chicago, IL/Architectural design

Paper Mohawk Ultrafelt

Colors Two, match

Type Beowolf

Printing Offset

Software QuarkXPress, Adobe Photoshop, Adobe Illustrator

Initial Print Run 1,000

Photography of Piece Greg Heek

Concept The spirit of cooperation inspired the design of this announcement of a new staff person. Using the theme "We are all a part of something," the piece successfully demonstrates how different ideas and varied resources can be drawn together to create a single valuable vision. On one side of the brochure is an illustration of arrows in a circular pattern and lines going off in all directions, resembling an architectural drawing. The cover folds so that the edge of the inside page is exposed, displaying the theme and another illustration of lines pointing in all directions, yet retaining the circular shape. A four-sentence announcement that introduces the new marketing director is placed in the center of the page, giving it a clean, organized appearance. This simplistic approach aptly portrays the successful convergence of staff resources to produce a focused, effective union.

Special Visual Effect The brochure was inserted in a translucent wax paper envelope, and sealed with a piece of blueprint paper that repeated the arrow pattern from the cover.

Distribution of Piece The brochure was mailed to the firm's clients.

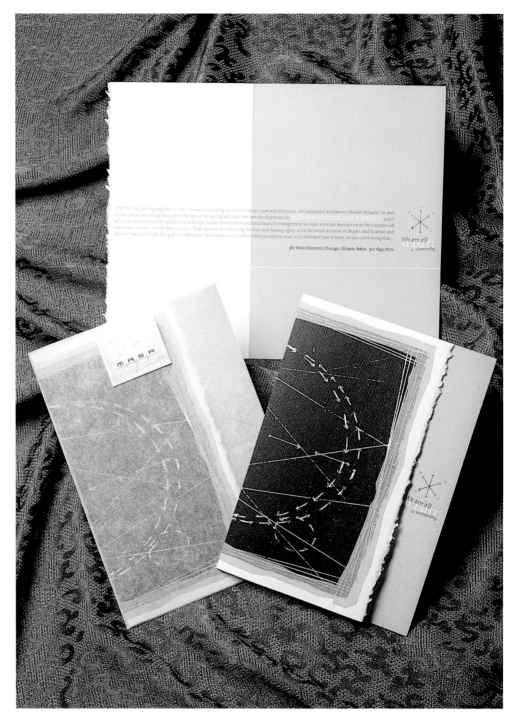

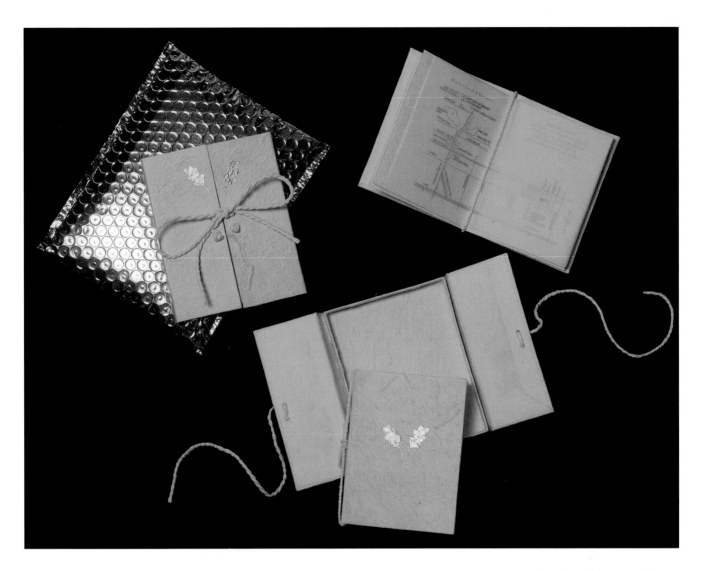

Piece is Wedding invitation

Art Director/Studio Dominic Pangborn/Pangborn Design, Ltd.

Designer/Studio Dominic Pangborn/Pangborn Design, Ltd.

Client/Event Karen M. Parenti/Wedding

Paper Mulberry Paper

Colors One

Type President

Printing Offset

Initial Print Run 250

Cost $3,000

Photography of Piece Gordon Alexander

Concept The sophisticated design and captivating packaging of this wedding invitation reflected the elegant celebration being planned. Designed as a gift in itself, the invitation consists of an announcement booklet placed in a box that's tied with a white cord. The box was then mailed in festive metallic gold bubble wrap—packaging that the designer specifically chose to intrigue recipients and entice them to investigate the contents. The gold leaf design on the piece signifies new life and springtime, which is when the wedding took place.

Distribution of Piece The invitations were mailed in the gold bubble wrap to friends and relatives.

Response to Promotion The studio received numerous calls and notes complimenting them on the design.

Big Brothers & Sisters

Piece is Poster for a bowling fund-raiser

Art Director/Studio Sonia Greteman/Greteman Group

Designers/Studio Sonia Greteman, James Strange/Greteman Group

Illustrator James Strange

Client/Event Big Brothers & Sisters, Wichita, KS/Bowling fund-raiser

Paper Speckeltone Kraft

Colors Six, match

Type Franklin Gothic

Printing Offset

Software MacroMedia FreeHand

Initial Print Run 1,000

Cost Design and printing donated

Concept Getting bowling "on the brain" of the general public was the goal of this poster hyping a bowling fund-raiser for the local Big Brothers & Sisters. Bowling icons, such as a bowling pin, bowling shoe and score sheet, are placed around the central illustration of a robotic head. Its brain is in the shape of a bowling ball, while the eye borrows its shape from the triangular setup of the bowling pins. Catchy phrases like "visualize a strike," "smiles aplenty" and "ignore bowling shoe aroma," are placed strategically around the head to stress fun and amusement.

Cost-Saving Technique All design and printing services were donated.

Distribution of Piece The poster was hung in local businesses to encourage widespread participation.

Response to Promotion The funds generated were the most in the event's ten-year history.

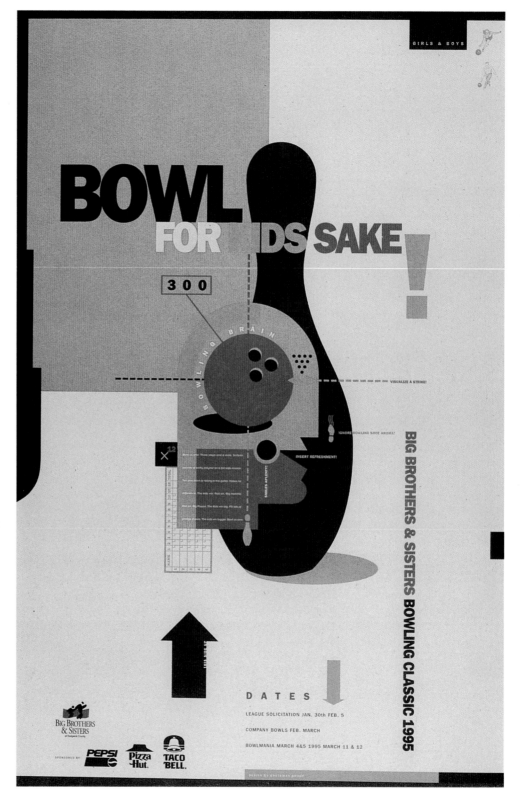

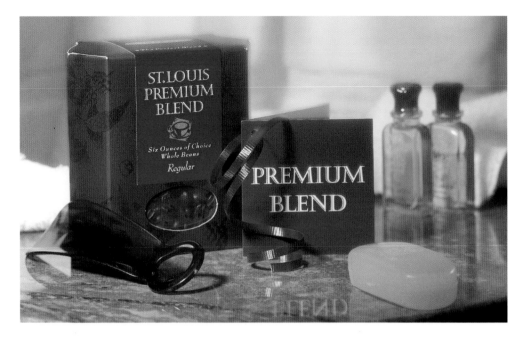

Piece is Promotion for St. Louis as a convention destination

Art Director/Studio Eric Thoelke/Phoenix Creative

Designer/Studio Eric Thoelke/Phoenix Creative

Client/Event St. Louis Convention and Visitors Commission, St. Louis, MO/Convention of convention planners

Paper Centura Gloss

Colors Four, match; two, process

Type Castellar, Bernhardt Modern

Printing Offset

Software QuarkXPress

Initial Print Run 1,000

Cost $15,000

Photography of Piece Bruton-Stroube Studios

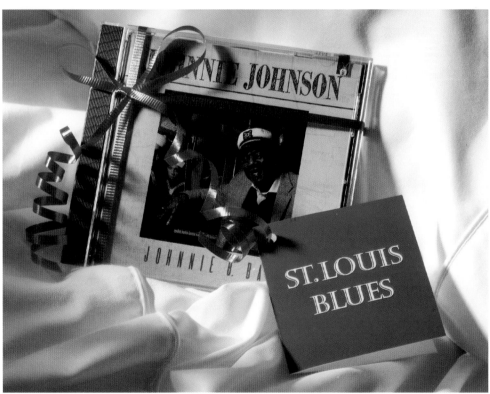

Concept Communicating key attributes about St. Louis as a convention-friendly city to a select group of convention planners in St. Louis required an unconventional approach. This inexpensive campaign packaged items representing the city's sights and sounds with cleverly written cards explaining St. Louis' attributes as a conventioneer's paradise. The accordion-fold cards featured a riddle on the first panel followed by non sequiturs on the second and third, and an answer on the last panel. For example, the card accompanying a box of St. Louis premium coffee beans asks, "18 Holes of Golf?," "A Morning Jog?" or "Thirds on Pancakes?" and then craftily suggests on the last panel that convention-goers should come to the city a day early to indulge in the city's delights.

Cost-Saving Technique The cards, accompanying gift tags and another job for the same client, were gang printed to cut costs.

Distribution of Piece A different gift package was left in each convention planner's room on each of four consecutive nights.

Morris County Parks Commission

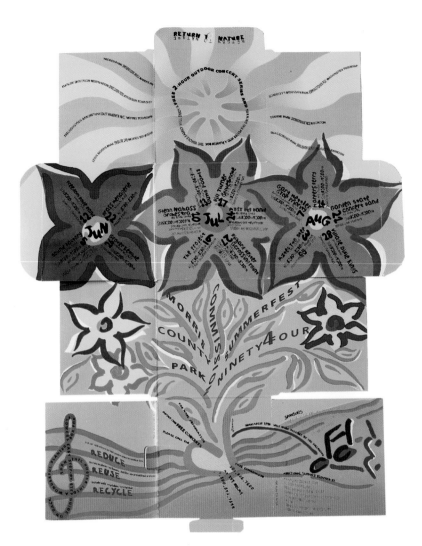

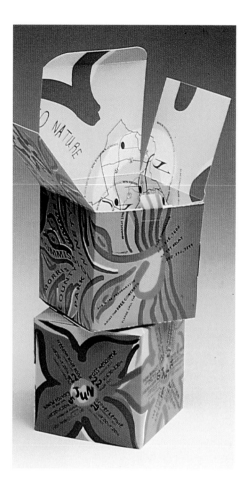

Piece is Poster promoting free summer concerts

Art Directors/Studios Mike Quon/Mike Quon Design Office and Richard Puder/Richard Puder Design

Designers/Studios Mike Quon/Mike Quon Design Office and Lee Grabarczyk/Richard Puder Design

Illustrator Mike Quon

Client/Event Morris County Parks Commission, Morristown, New Jersey/Free summer concerts

Paper 18 pt. Carolina coated one side

Colors Four, process

Type Child's Play, Frutiger

Printing Offset

Software Adobe Illustrator, MacroMedia FreeHand

Initial Print Run 3,500

Cost $4,000

Concept Morris County parks, their free summer concerts and preservation of the environment are all promoted in this cheerful poster, which is made to be folded into an equally vibrant flower box. The piece was designed to lure residents to county parks for an evening of free music. It was also created to spark interest in getting back to nature and taking care of the environment. Printed on recyclable paper stock, the poster includes a suggestion to fold it into a box, line

it and plant flower seeds. To avoid the appearance of a mundane schedule of events, the designers placed the concert performances in the wildflower petals and used the remaining structure of the flowers to highlight other details.

Cost-Cutting Technique The paper for the poster was donated.

Distribution of Piece The poster was distributed in the parks at concerts, and at special kiosks, local banks and hotels.

Response to Promotion Interest in and awareness of the parks commission and its activities has increased.

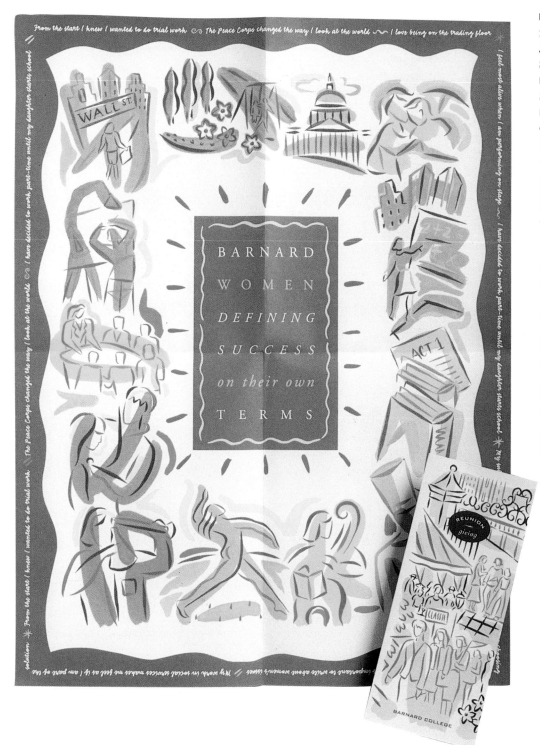

Piece is Poster for school's annual fund-raising campaign

Art Director/Studio Victoria Stamm/Platinum Design

Designer/Studio Victoria Stamm/Platinum Design

Illustrator Paula Munck

Client/Event Barnard College, New York, NY/Annual fund-raising campaign

Paper Simpson Coronado SST Recycled

Colors Four, process

Type Emmascript, Adobe Garamond

Printing Offset

Software QuarkXPress

Initial Print Run 25,000

Concept This poster was the focal point of Barnard College's annual fund-raising campaign. It was designed to motivate alumnae and other potential donors to support the college through gifts and contributions. Playing off the campaign's tag line of "Defining Success on Their Own Terms," the designer chose upbeat, lively illustrations (in a style similar to Henri Matisse paintings) to represent various professional settings and vocations chosen by alumnae. "Quotes"—created to sound like they came from Barnard graduates—espousing the value of education and its pivotal role in the success of its alumnae, are placed around the perimeter of the poster.

Cost-Saving Technique To avoid the high cost for revisions, the illustrations were enhanced in-house.

Distribution of Piece The poster was sent by mail to alumnae and previous and potential donors.

Response to Promotion Barnard exceeded its annual fund-raising goal.

Q101 Radio/Counting Crows

Piece is Concert poster for Counting Crows

Art Director/Studio Carlos Segura/Segura Inc.

Designer/Studio Carlos Segura/Segura Inc.

Client/Event Q101 Radio, Chicago, IL/Radio promotion: Free trip to Counting Crows concert in Spain

Paper Butcher

Colors Two, match

Type Antique Block

Printing Offset

Software Adobe Photoshop, QuarkXPress

Initial Print Run 1,200

Cost $1,200 (approx.)

Concept Despite a limited budget, the designers of this piece were able to create a hip concert poster that captures the style of the band and the ambience of the concert site. The piece was designed for a radio station promotion: a free trip giveaway to see the band Counting Crows at their concert in Barcelona, Spain. Playing off the name of the band and the location, the traditional singer's lead-in: "one, two, three, four," is featured prominently in Spanish. A screened photo of the band serves as the background.

Distribution of Piece The poster was distributed as an invitation to a party being held by the radio station where the winner of the trip to Barcelona was announced.

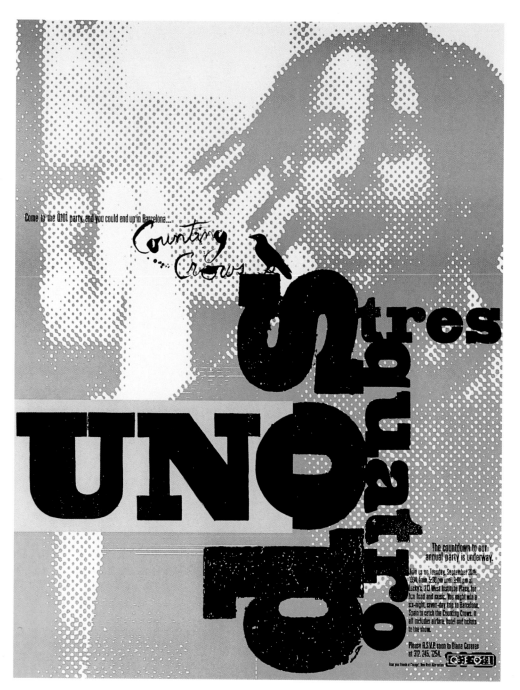

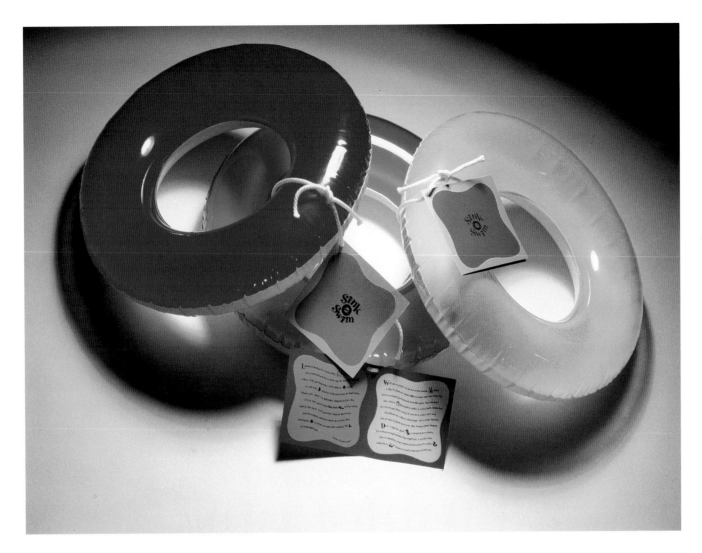

Piece is Invitation to studio's ten-year anniversary party

Art Director/Studio Christie Lambert/Lambert Design Studio

Designer/Studio Joy Cathey Price/Lambert Design Studio

Illustrator Joy Cathey Price

Client/Event Lambert Design Studio, Dallas, TX/ten-year anniversary party

Paper Brite Hue

Colors One (colored construction paper plus black ink)

Type Pixie Font

Printing Laser printer

Software Adobe Illustrator

Initial Print Run 40

Cost $30 (floats and rope)

Photography of Piece Richard Reens

Concept To celebrate ten years in the design business (or, put another way, ten years of "keeping their heads above water"), Lambert created this simple, playful invitation to an anniversary party held at their president's lakefront home. Since you either sink or swim in the graphic design business, the invitation was attached by rope to a small inner tube, intimating that Lambert has been able to stay afloat in a competitive business for ten years. The sink-or-swim theme is continued on the inside of the invitation where clients are invited to help Lambert "shove off" for the next ten years.

Cost-Saving Techniques The red, blue and yellow paper used for the piece was from a batch used for a previous job. The invitations were laser printed and hand-assembled.

Distribution of Piece The invitations were sent by mail and hand delivered.

Response to Promotion Recipients loved the floats and some still have them hanging in their offices.

Paper and Printing Promotions

Piece is Promotion for recyclable Potlatch papers

Art Director/Studio Kevin B. Kuester/The Kuester Group

Designer/Studio Bob Goebel/The Kuester Group

Photographers Joe Paczkowski, David Guggenheim, Photonica, John Payne, Jim Sims, Gallen Mei, John Holt, Dennis Dannehl, Harry de Zitter, Scogin Mayo, Anthony J. Couture, Steve Niedorf, Chuck Kuhn, Scott Barrow Inc., Kirk McGregor, Terry Heffernan, Marc Yankus

Client/Service Potlatch Corp., Northwest Paper Division, Cloquet, MN/Paper manufacturer

Paper Northwest, Mountie C1S, Mountie Matte, Makers' Matte

Colors Four, process; one, match; plus a varnish

Printing Offset

Software QuarkXPress, Macro-Media FreeHand, Adobe Photoshop

Initial Print Run 60,000

Concept To introduce an existing line of papers that had been re-manufactured to be recyclable, the designers used old standby tools—like the pocketknife, a pair of scissors and a wrench—to emphasize the products' long-standing reliability and quality. The promotion included materials for both paper merchants and printers. A kit of "tools" containing paper samples, as well as a pocketknife displaying the company name, was distributed to paper merchants. A folder with paper samples and an explanation of their new recyclable attributes was sent to printers. Photos of tools and a tag line that reads: "The more things change, the more they remain the same," reinforces the premise that the papers' quality and reliability hasn't changed, but only been enhanced.

Special Production Technique The placement of type and the subtle use of arrows lead the reader through multiple flaps and inserts. The pocketknife in the merchants'

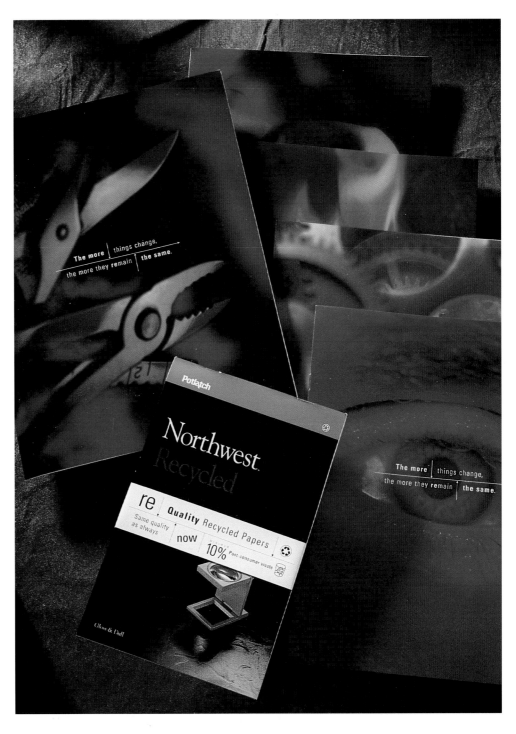

kit of tools was mounted into a piece of cardboard with a photograph of its various blades serving as background.

Distribution of Piece The materials were distributed through Potlatch paper merchants to printers. Some were sent by request to designers and marketers.

B&G House of Printing

Piece is Capabilities booklet for B&G House of Printing
Art Director/Studio Steve Curry/Curry Design
Designer/Studio Jason Scheideman/Curry Design
Illustrator Jason Scheideman
Client/Service B&G House of Printing, Gardena, CA/Offset printing
Paper Simpson Environment (cover); Gil Clear (fly sheets); Volare (section tabs); Quintessence Gloss (inside pages)
Colors Six, plus two foil stamps
Type Franklin Gothic, Futura Demibold
Printing Offset
Software Adobe Photoshop, QuarkXPress, MacroMedia FreeHand
Initial Print Run 5,000
Cost $19,500

Concept What better way to tout a printer's new prepress capabilities than with a detailed explanation of their operations and a showcase of their printing work? This handy, 6 ¼" square spiralbound booklet is divided into three sections, each designated with a rounded black tab. A technical explanation of the printer's prepress operations appears in the first section, highlighted by various bleeds and other high-end printing techniques. Printing services and capabilities are discussed in the second section, and the third section consists of a calendar—an added touch of practicality to this dynamically informative piece.

Special Production Technique The cover of this piece features a French fold and incorporates a variety of production techniques. The *B* and *G* were blind embossed. The "house of printing" is a two-color foil stamp and the ampersand is a single-color foil stamp. The

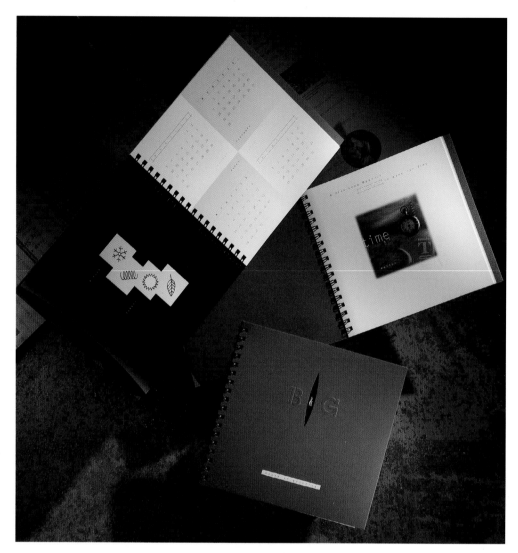

oblong shape around the ampersand was die cut.

Special Visual Effect Each section of the booklet begins with a photo representative of the contents of that section. Equally symbolic images are printed in a dull tinted varnish overlapping the photos.

Distribution of Piece The booklets were mailed and delivered in person.

Response to Promotion The printer reports business has increased by more than 15 percent since the distribution of this booklet.

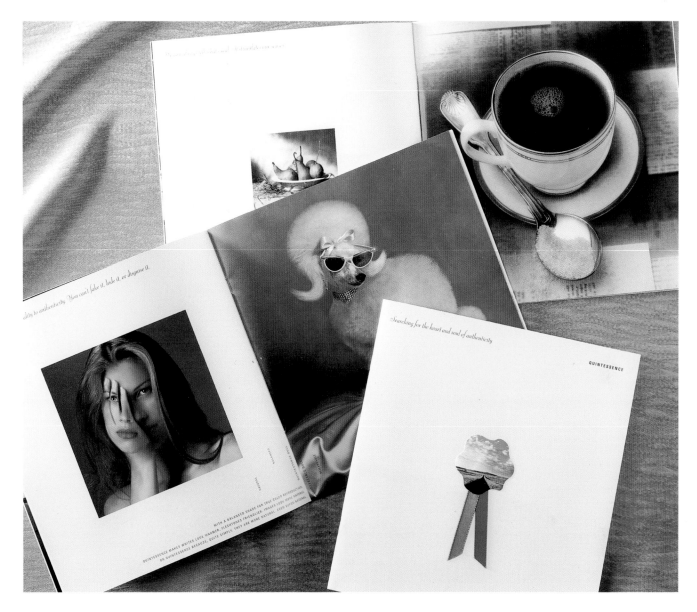

Piece is Paper promotion for Quintessence papers

Art Director/Studio Kevin B. Kuester/The Kuester Group

Designer/Studio Bob Goebel/The Kuester Group

Photographers Image Bank, Guy Kloppenburg, Tom McCavera, John Engstrom, Rosanne Olson, Laurie Rubin, Geof Kern, Gerald Bybee, Charles Shotwell, Mark Edward Atkinson, T. Shimada, Marc Norberg, Jon Roemer, Keyvan Behpour, Elizabeth Fall, John Payne, Gary Hush

Client/Service Potlatch Corp., Northwest Paper Division, Cloquet, MN/Paper manufacturer

Paper Quintessence Dull (cover); Quintessence Gloss (cover tip-in); Quintessence Dull and Gloss (inside)

Colors Four, process; two, match; plus a varnish

Printing Offset

Software QuarkXPress, Macro-Media FreeHand, Adobe Photoshop

Initial Print Run 60,000

Concept The meaning of authenticity—what's real, true and honest—is the theme of this promotion for a paper stock. The opening page asks: "What's real these days?" What fol-lows are photos of the things that stir warm, fuzzy feelings, such as a worn pair of boots, a cup of coffee and a teddy bear. They reinforce the idea that Quintessence papers produce true color and reliable results. Script type used for the copy contributes to the sense of serenity and genuine honesty.

Special Visual Effect The die-cut "Open Road" photo tipped on with satin ribbon on the cover is intend-ed to represent a blue ribbon award for authenticity.

Distribution of Piece The piece was distributed through paper mer-chants to designers and printers.

Monadnock Paper Mills

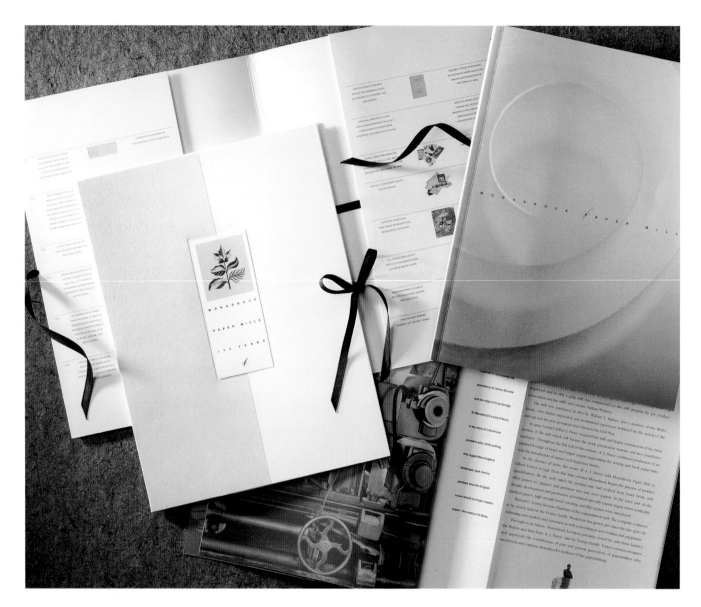

Piece is Commemorative brochure for a paper mill

Designers/Studio Jeff & Adrienne Pollard

Illustrator Brian Cronin

Photographers Jim Coon, Thomas Gibbons, Bennington Historical Society

Client/Service Monadnock Paper Mills Inc., Bennington, NH/Paper manufacturer

Paper Monadnock vacuum filter media and Astrolite (jacket); Monadnock Dulcet Smoother Cover 100 lb. (tip-on); various Monadnock papers (inside pages and insets)

Colors Two, match; four, process

Printing Offset, engraving, letterpress

Initial Print Run 7,500

Concept This commemorative piece for a paper mill offers a look at major events in the company's history as well as a thoughtful, classic presentation of its current services and capabilities. The inside flaps of the jacket cover provide a time line of events highlighting the company's 175 years in business. Snippets of American history are also included. What follows is a thorough recounting of how the mill got started, how its operations have changed over the years and how it delivers quality products and services today in an environmentally friendly manner. This piece required a time-honored look, which is achieved through the use of soft, muted colors and understated photography.

Special Production Technique This booklet aptly shows the various products and capabilities of the paper mill. An engraved label was tipped onto the jacket cover. The cover itself was created by laminating a gray technical/specialty paper to a premium text and cover printing paper. The jacket was die-cut with two small holes through which a green ribbon was threaded to tie the piece together. A different paper was used for each of the inside pages, which are French gate-folded. These alternate with smaller inset pages of the mill's technical specialty papers, which also have the French gate fold and which are letterpressed.

Distribution of Piece The brochure was mailed and delivered in person to key customers and prospective clients.

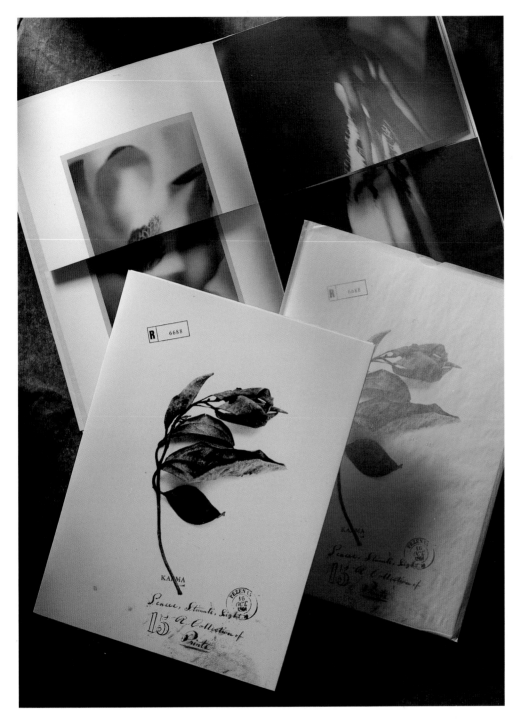

Piece is Paper promotion for Karma papers

Art Director/Studio Kevin B. Kuester/The Kuester Group

Designer/Studio Kevin B. Kuester/The Kuester Group

Calligrapher J.A. Molloy

Photographer Don Freeman

Client/Service Potlatch Corp., Northwest Paper Division, Cloquet, MN/Paper manufacturer

Paper Karma Natural (cover); Karma Natural and Bright (inside)

Colors Two, match; one, process, plus a varnish

Type Various

Printing Offset

Software QuarkXPress, Macro-Media FreeHand, Adobe Photoshop

Initial Print Run 50,000

Concept The warm, rich qualities of Karma papers are conveyed through the use of sensual photos, nostalgic images and elegant calligraphy. The paper is used for the three-fold binder and the booklet of Don Freeman photographs it contains. Freeman's work is characterized by a sense of spirituality and immortality, and his ability to capture the meaning, or karma, of his subjects. This piece promotes Karma papers as possessing the same enduring qualities and as being crafted to capture images that are alive with emotion, meaning and romance.

Special Visual Effects The photo pages are cut in half for two reasons: First, allowing the photos to be compared and contrasted encourages the viewer to realize that inspiration can come from a variety of sources. Secondly, it allows a comparison of the various shades of Karma paper. To give the booklet the look of a photographer's portfolio, tissue paper was bound in the front and back.

Distribution of Piece The piece was distributed through paper merchants to printers and designers.

Potlatch Northwest Papers

Piece is Promotional booklet for Potlatch Northwest papers

Art Director/Studio Kevin B. Kuester/The Kuester Group

Designer/Studio Bob Goebel/The Kuester Group

Photographer Judy Olausen

Client/Service Potlatch Corp., Northwest Paper Division, Cloquet, MN/Paper manufacturer

Paper Northwest Gloss and Dull

Colors One, match; one, process; plus two varnishes

Type Various

Printing Offset

Software QuarkXPress, Macro-Media FreeHand, Adobe Photoshop

Initial Print Run 50,000

Concept To promote the consistent quality, reliability and on-press performance of Northwest papers, the designers used a character that most buyers of the paper could relate to—the printer. Touting the printer as an everyday hero who's resourceful, innovative and conscientious, this piece would soften even the most skeptical paper buyer. A minibooklet (3" x 5") entitled "A Pocket Guide to Everyday Heroes," is inserted in a vinyl pocket protector, which is then inserted in a flap on the front cover of the folder. The booklet describes the printer as an ordinary person who does extraordinary things when it comes to making the work look great. Plugs for Northwest papers as a high-quality tool the printer can use to perform heroics are interspersed throughout.

Special Visual Effect The pocket in which the vinyl protector was inserted was formed through a two-level embossing process that raised the pocket and created indentations for stitching.

Distribution of Piece The piece was distributed through paper merchants to printers.

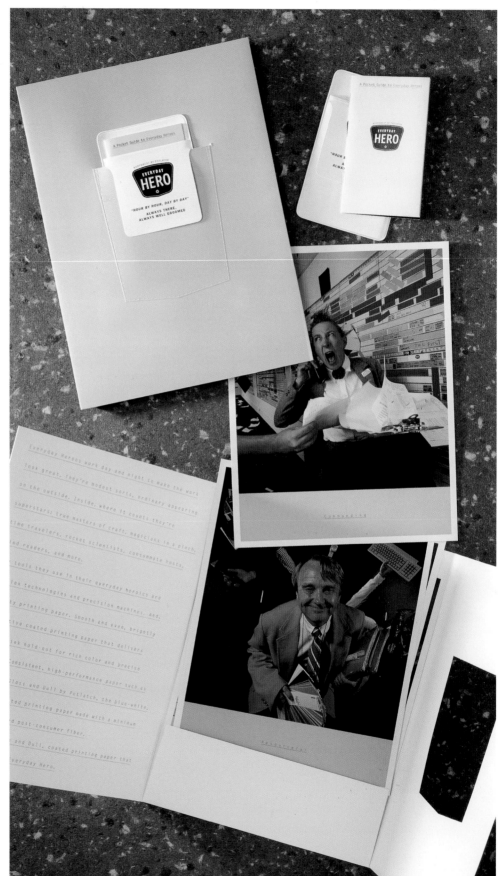

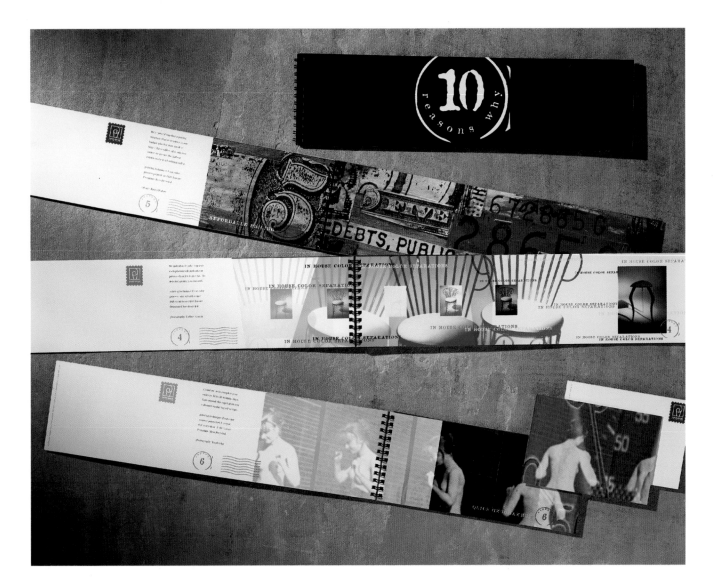

Piece is Promotional booklet for Paper Chase Printing

Art Directors/Studio Hal Apple, Karen Walker/Hal Apple Design

Designers/Studio Karen Walker, Sepi Banibashar/Hal Apple Design

Illustrator Karen Walker

Photographers Jason Ware, Saul Lieberman, Delbert Garcia, Muybridge, Hector Prida

Client/Service Paper Chase Printing, Los Angeles, CA/Printing and film work

Paper Encore Premium Gloss Recycled 110 lb.

Colors Two, match; four, process

Type Attic

Printing Offset

Software Adobe Photoshop, Adobe Illustrator, QuarkXPress

Initial Print Run 2,000

Photography of Piece Jason Ware

Concept Combining the practical and logical with the quirky and provocative is the focus of this promotional booklet. The piece couples a straightforward list of reasons for using the client's printing services with quirky photos and images to illustrate the company's capabilities and its sensitivity to quality, detail and costs. The unconventional format (the spiral-bound booklet is nearly 16 inches long) and arresting photos (including a series of photos of a nude woman turning around, intended to illustrate the company's speedy turnaround) quickly grab the attention of the viewer.

Special Visual Effect A collage was assembled by hand to illustrate the company's pricing structure.

Cost-Saving Technique Several photographers donated the use of their photos in exchange for samples of the piece. The paper was donated by Spicer Paper Inc.

Distribution of Piece The piece was distributed by direct mail in groups of twenty to thirty at a time to designers and agencies.

Response to Promotion When called, recipients responded positively.

Potlatch Vintage Papers

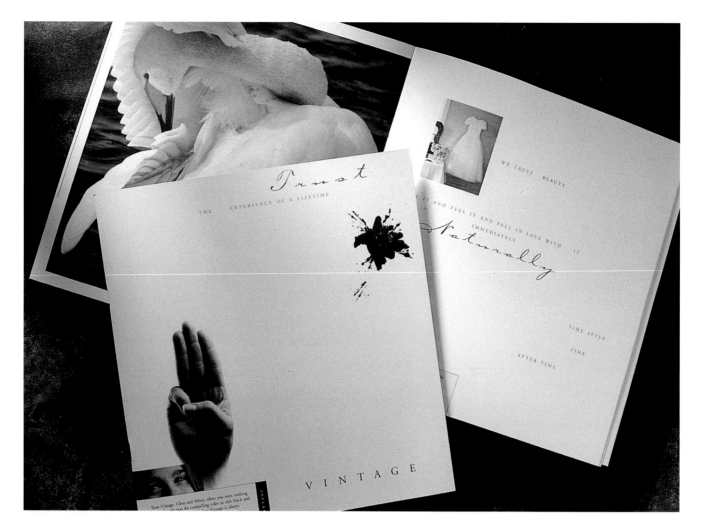

Piece is Promotional brochure for Potlatch Vintage papers

Art Director/Studio Kevin B. Kuester/The Kuester Group

Designer/Studio Tim Sauer/The Kuester Group

Photographers Brad Guice, Leo Tushaus, Marc Norberg, Lars Topelmann, Maria Muller/Graphistock, Miko Lajczyk, Luca Zampedri/ Nonstock, Brian Fewell/Greg Booth & Associates, Chris Collins Studio, Rick Rusing, Teiji Saga/Pacific Press Service, Jeremy Samuelson, Tom Ryan, Stefano Bianchi, Craig Cutler, Dan Picasso

Client/Service Potlatch Corp., Northwest Paper Division, Cloquet, MN/Paper manufacturer

Paper Vintage Gloss, Vintage Velvet

Colors Five, match; four, process; plus gloss and dull varnishes

Printing Offset

Software QuarkXPress, Macro-Media FreeHand, Adobe Photoshop

Initial Print Run 60,000

Concept Using the concept of trust, the designers of this piece were able to emphasize their client's ability to deliver reliable paper products that produce top quality and consistent on-press perfor-mance. The concept is defined through an eclectic mix of photos complemented by thoughtful and compelling copy that's placed to subtly move the reader forward to the next page. Key words related to the development of trust—such as performance, experience, instinct, taste and touch—are emphasized. Each spread in the booklet con-tains images that reflect the mean-ing of these key words. For example, two perfect blueberries stacked one on top of the other and a half-peeled orange illustrate how we can always trust our sense of taste and "...what's fresh, perfect and unblemished."

Distribution of Piece The piece was distributed through Potlatch paper merchants.

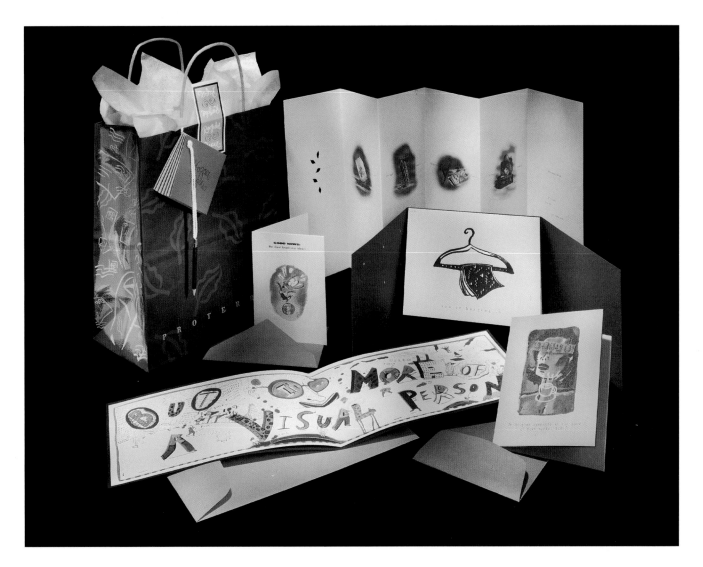

Piece is Bag of greeting cards for Hopper Papers

Art Directors/Studio Wendy Pressley-Jacobs, William L. Johnson, Amy W. McCarter/ Pressley Jacobs Design

Designers/Studio Barbara Bruch, Jennifer Kahn, Susie McQuiddy, Mark Myers, Patrick Schab/Pressley Jacobs Design

Illustrators Gary Baseman, Leslie Cober, Emily Lisker, Hal Mayforth, Craig Ward

Photographer James Imbrogno

Client/Service Hopper Papers division of Georgia-Pacific, Chicago, IL/Paper manufacturer

Paper Proterra papers

Colors Match and process (varies with each piece)

Type Various

Printing Offset (greeting cards); flexography (bag)

Software QuarkXPress, Adobe Photoshop, MacroMedia FreeHand

Initial Print Run 15,000

Concept A bag of unique, specially designed greeting cards was developed to demonstrate the qualities of the Proterra paper line and to promote comraderie within the design profession. Since the promotion was being distributed primarily to "creatives," the cards contained messages specifically geared to this audience, such as a congratulations card from one designer to another on a job well done. The messages are lighthearted but are printed on muted papers (in shades of cream, maroon, etc.), which lends a professional, businesslike image. A small booklet describing the papers used for each card and envelope is attached.

Special Visual Effect A small pencil is attached with the booklet to the bag to help promote the concept of communication among professionals and peers within the industry. The side flaps of the bag are illustrated with drawings of envelopes and other images of correspondence through written communication.

Special Production Techniques The congratulations card was printed in black, opaque white and black thermography; the finish included drill holes and glue assembly. The small seed pattern on the thank-you card was die-cut.

Distribution of Piece The bag of cards was distributed through paper reps to individuals associated with the creative market.

Response to Promotion The piece garnered exposure for the Proterra paper line among those who received it, and among the secondary audience of those who were sent the greeting cards.

Objects of Myth and Mystery

Piece is Booklet for The Hennegan Company
Art Director/Studio Stan Brod/Wood Brod Design
Designer/Studio Stan Brod/Wood Brod Design
Photographer Corson Hirschfeld
Client/Service The Hennegan Company, Cincinnati, OH/Printing
Paper Fox River Confetti: green 80 lb. cover (envelope); brown 80 lb. cover (cover); purple 80 lb. text (title sheet); tan 28 lb. writing (alternating type sheets); photos printed on Eloquence 110 lb. text
Colors Four, plus gold metallic; gold foil stamping and embossing
Type Times Italic
Printing Offset
Software Adobe Illustrator
Initial Print Run 10,000

Concept Photos of ancient artifacts from around the world, and the mysterious, sometimes mystical environments in which they are found, serve as the focal point of this promotion. Corson Hirschfeld's photos capture the cultural qualities and natural settings of various mythic objects, ranging from turkey tail points that were used as arrows or spears to a ceremonial mask from Nigeria. Likewise, the rich, warm, textured papers and colors used in this piece evoke the same sense of myth, mystery and ancient times. The forty-page booklet is bound in a four-panel cover, and presented in an envelope embellished with elaborate die-cuts. A description of each object is placed in a gold-bordered box so that the ensemble resembles a museum exhibit.

Special Production Techniques A number of special printing techniques were used, including stochastic screening, foil stamping, and die-cutting. For the envelope to this piece, the designer used motifs from the photographed art to devise a primitive-looking pattern, which he then cut out by

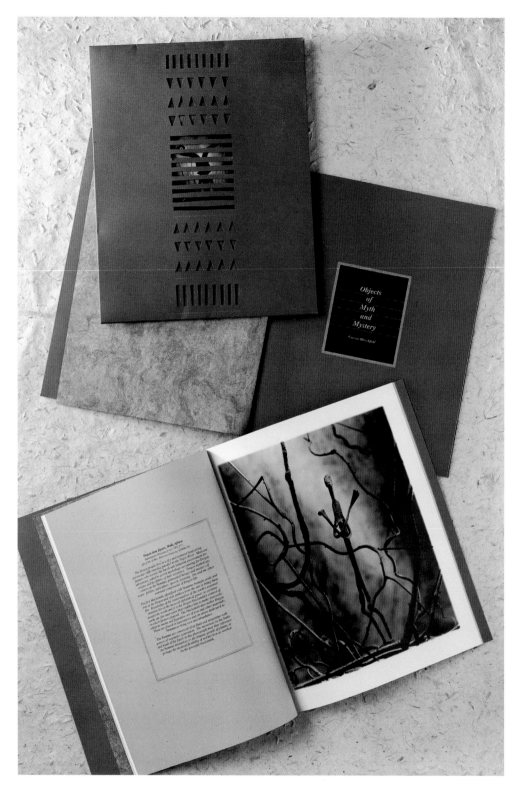

hand. The printer reproduced it as a die for the envelope.
Distribution of Piece Distributed by the printer to designers, photographers, museums and other printers.

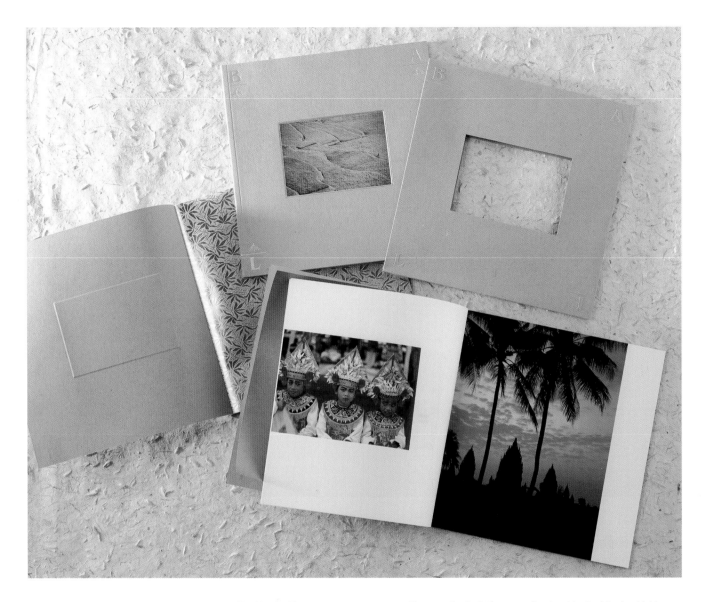

Piece is Booklet for The Hennegan Company

Art Director/Studio Stan Brod/Wood Brod Design

Designer/Studio Stan Brod/Wood Brod Design

Photographer Steve Murray

Client/Service The Hennegan Company, Cincinnati, OH/Printing

Paper Speckletone Chipboard cover 80 lb. (slip case and cover); ornamental foil and UV Vellum Columns (slipsheet pages)

Colors One, match; four, process

Type Benquiat

Printing Offset, with foil stamping, embossing and die cuts

Initial Print Run 7,000

Concept Photographs depicting the colorfully lush and ornamental regions of Bali and Java are used to promote this client's quality printing and reproduction services. An 8" x 8" booklet contains beautiful photos by Steve Murray that convincingly illustrate the sites, sounds and personality of these islands and their inhabitants. The contrast of the photos with a natural-looking, unobtrusive paper creates a lively effect that invites the reader to participate in the experience.

Special Visual Effect A page of ornamental foil was inserted in the front and back of the booklet to reflect the ceremonial traditions and opulence of the islands.

Special Production Technique The cover shows a photo of bright green rolling fields outlined in gold; each letter of the word "Bali" is also embossed in gold and placed in one corner. The booklet was inserted in a case that was specially die-cut so that the photo would show through, appearing as if it were framed.

Distribution of Piece It was distributed to designers, promotion people and other printers.

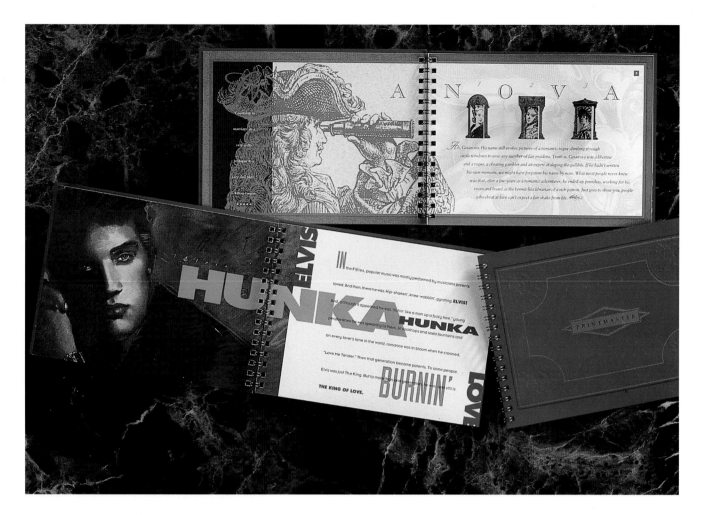

Piece is Brochure for PrintMaster

Art Director/Studio Sonia Greteman/The Greteman Group

Designers/Studio Sonia Greteman, James Strange, Karen Hogan/The Greteman Group

Client/Service PrintMaster, Wichita, KS/Printing

Paper Variety of Simpson Confetti Cover

Colors Two, process (first spread); three, process (second spread); metallic (third spread); four, process (fourth spread)

Type Various

Printing Offset

Software MacroMedia FreeHand

Initial Print Run 500

Cost $10,000

Concept The topic of printing doesn't normally evoke passionate thoughts, but this little booklet takes a tongue-in-cheek look at the history of love to demonstrate how printing is a "labor of love" for this company. The bright red cover immediately suggests the passion with which the printer does its work. Dramatic designs and metallic inks used on the following pages depict other labors, or laborers, of love, including Venus, the goddess of love, the romantic rogue Casanova, and Elvis, whose songs about love stirred passion in millions. On the last page of the booklet is a fitting quote from John Ruskin: "When love and skill work together, expect a masterpiece."

Special Visual Effect The spiral-bound booklet is small and compact but communicates powerfully, just as this small printing company does.

Distribution of Piece The booklets were delivered during sales calls to designers.

Response to Promotion The printer reports that its client base has increased.

Piece is Promotion for Potlatch Quintessence Dull paper

Art Director/Studio Kevin B. Kuester/The Kuester Group

Designer/Studio Bob Goebel/The Kuester Group

Illustrators Frank Gehry, Kevin B. Kuester

Photographers Grant Mudford, Jeff Goldberg/Esto Photographics, Joshua White/Frank O. Gehry & Associates, Shawn Michienzi/Buzz Saw, Brian Drake/West Stock, Peter Wong, Wood River Gallery

Client/Service Potlatch Corp., Northwest Paper Division, Cloquet, MN/Paper manufacturer

Paper Quintessence Dull

Colors Four, process; one, match; plus two varnishes

Printing Offset

Software QuarkXPress, Macro-Media FreeHand, Adobe Photoshop

Initial Print Run 50,000

Concept This oversized booklet, with its unique (nonrectangular) shape, likens the development of Quintessence Dull paper to architect Frank O. Gehry's passion for creating oddly innovative and novel designs. As explained on the inside front cover, Gehry has pursued the development of a one-piece chair, where the structure and surface is completely integrated, for more than twenty years. The result of that pursuit is a newfangled collection of bentwood chairs that is featured in this booklet. The synthesis of Gehry's unconventional—sometimes wild—vision of molding ideas and notions into riveting, one-of-a-kind designs is presented through photos of his work and the objects and images that inspired him. Correlations are made between his passion for new and better styles and Quintessence paper's lustrous surface and refined quality.

Special Visual Effects The booklet is cut in an angular shape giving it the look of a modern piece of

architecture. A piece of corrugated cardboard that serves as the binding represents a new use for a basic material. The bentwood pattern in Gehry's chairs is reproduced as full-page bleeds on two inside pages. Inserted between them are two smaller-size cut pages of the same pattern. The ensemble looks like a section of one of Gehry's chairs and invites the reader to touch, feel and experience the Quintessence paper.

Distribution of Piece The piece was distributed through paper merchants to designers.

Appleton Conqueror Papers

Piece is Campaign for Appleton Conqueror papers

Art Director/Studio Frank Viva/Viva Dolan Communications & Design

Designers/Studio Frank Viva, Karen Satok/Viva Dolan Communications & Design

Illustrator Frank Viva

Client/Service Appleton Papers Inc., Appleton, WI/Paper manufacturer

Paper Conqueror

Colors Four, process; one, match

Type Monotype Gill

Printing Offset

Software QuarkXPress, Adobe Photoshop

Initial Print Run 7,000

Cost $40,000

Concept British and French posters from the 1930s inspired the look of this promotion for Conqueror papers. Because the papers are similar to many North American fine papers, the designers chose to emphasize their one differentiating quality—their British origins. The central element in the design is a bespectacled character wearing a derby hat. The "chap" appears in all campaign pieces, including a 5½" x 8½" folder of paper samples; a cardboard, tabletop display containing letterhead sample booklets; and a series of booklets with samples of additional Conqueror papers. Each piece incorporates some version of the character to illustrate the different types of paper. For example, the tabletop display for Conqueror letterhead is formed to look like an old-fashioned typewriter with the head of the character serving as a piece of paper. The tag line reads "Head and shoulders above the competition . . ."

Distribution of Piece The materials were distributed by paper merchants to graphic designers and other paper specifiers.

Response to Promotion The manufacturer reports a 20 percent increase in sales volume.

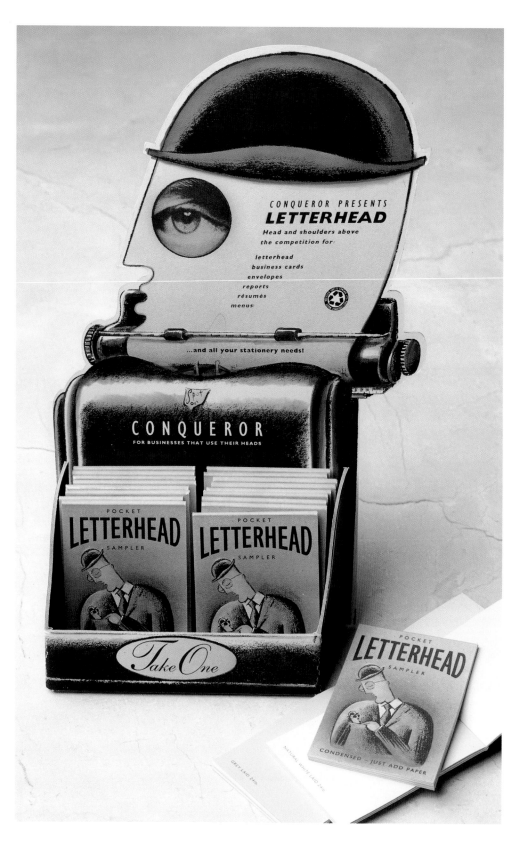

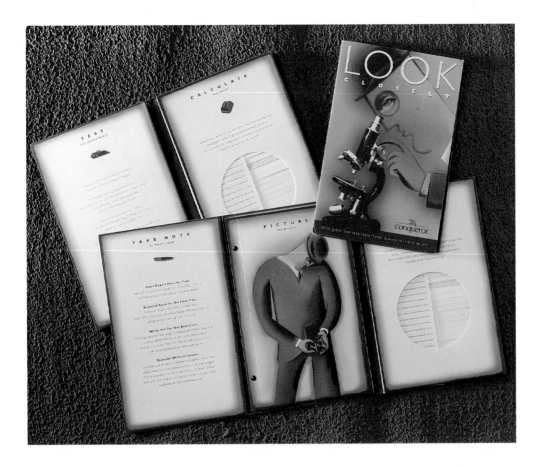

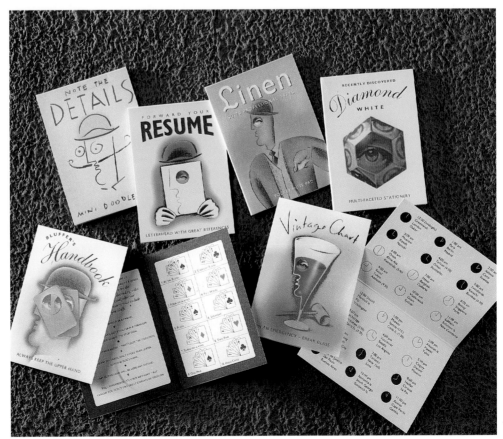

Curtis Creatives Papers

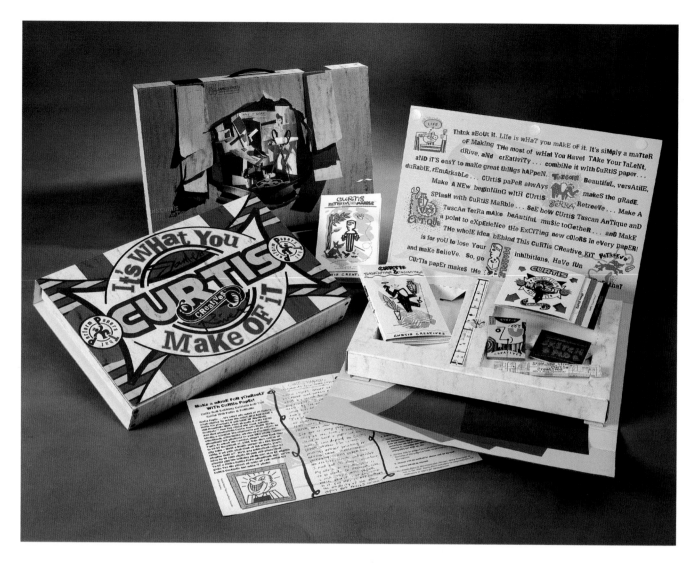

Piece is Promotional kit for James River Curtis Creatives papers

Art Director/Studio John Sayles/Sayles Graphic Design

Designer/Studio John Sayles/Sayles Graphic Design

Illustrator John Sayles

Photographer Bill Nellans

Client/Service James River Paper Corp., Southampton, PA/Paper manufacturer

Paper Curtis Marble, Retreeve, Tuscan Terra, Tuscan Antique

Colors Five, match; four, process

Type Hand-rendered and various others

Printing Offset

Initial Print Run 15,000

Concept This promotion is guaranteed to bring out the kid in everyone who receives it. The kit spotlights James River's midrange Curtis Creatives papers with the theme "It's What You Make Of It." The kit comes in a brightly colored corrugated box with a handle, reminiscent of a child's art box. Inside are crayons (whose colors were custom-made to match the names of the paper colors), pencils, rulers, paper samples and swatchbooks, and an engaging brochure that beckons the recipient to discover the versatility of Curtis papers. The brochure features dynamic spreads demonstrating the use of different inks on the papers, including metallic, fluorescent and opaque inks that urge recipients to "make it hot," "make it happen" and "make it yours." Another feature of the campaign is a contest inviting designers to make a name for themselves by submitting a self-promotional idea using Curtis papers. James River pays for the production of the winning promotion.

Distribution of Piece Company sales reps distributed the kits to designers, creative directors and paper buyers at paper shows, on sales calls and upon request.

Curtis Brightwater Papers

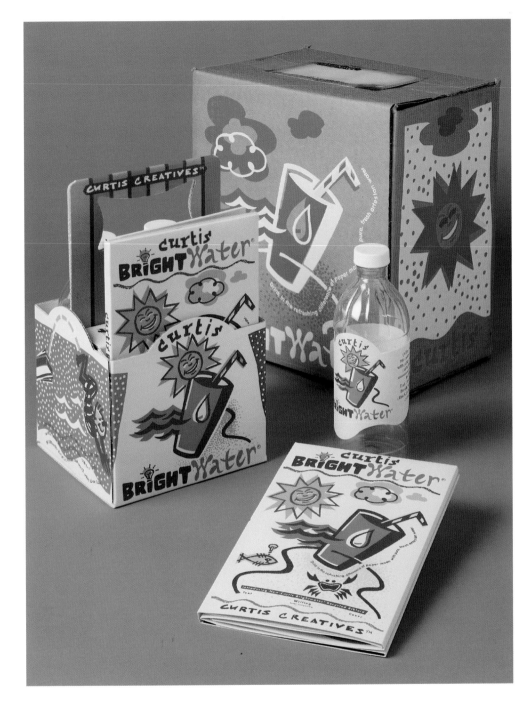

Piece is Campaign for James River Curtis Brightwater paper
Art Director/Studio John Sayles/Sayles Graphic Design
Designer/Studio John Sayles/Sayles Graphic Design
Illustrator John Sayles
Client/Service James River Paper Corp., Southampton, PA/Paper manufacturer
Paper Curtis Brightwater
Colors Five, match
Type Hand-rendered and various others
Printing Offset
Initial Print Run 10,000

Concept The name of this paper inspired the designer to create a splashy promotion with a water theme. To give paper buyers a taste of the paper—which is made from artesian well water—the designer created a soft drink-style carrier for the swatchbook that also includes two bottles of "Bright Water." The custom-made carrier, bottle labels and five-fold swatch-book all feature bright, bold water-related graphics to reflect the exciting possibilities with the Brightwater line of papers. The water theme is continued in the swatchbook copy with catchy phrases like, "Its unique shadow watermark and subtle texture bring a wave of exciting possibilities to any design."
Distribution of Piece Company sales reps distributed the packages to designers, creative directors and paper buyers.

Heritage Graphics

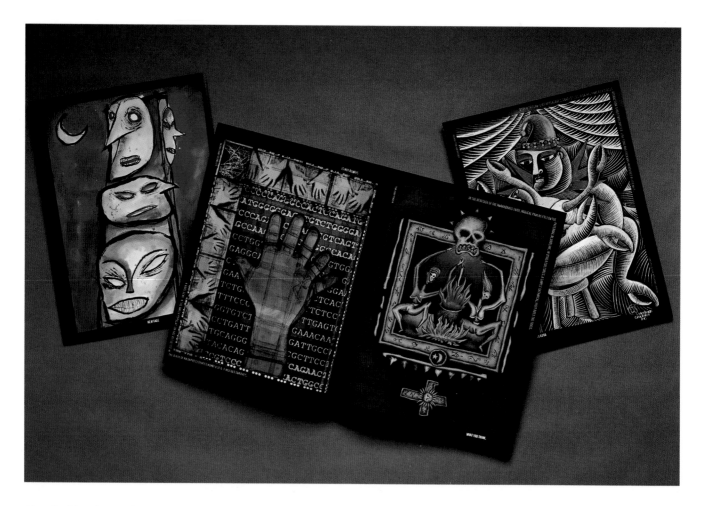

Piece is Advertisement for Heritage Graphics

Studio After Hours Creative

Illustrators Russ Wall, Brian Marsland, Rose Johnson

Photographer Bruce Racine

Client/Service Heritage Graphics, Phoenix, AZ/Printing

Colors Four, process

Printing Offset

Software QuarkXPress

Initial Print Run 10,000

Concept This insert for a magazine/resource guide clearly identifies the client as an innovative printer with an appreciation for the unusual and a determination to achieve the highest-quality printing possible. Playing off the client's name, the designers researched the "heritage" of various topics and selected a few that were exceptionally odd and which lent themselves to more dramatic depictions. For example, a genetic disorder inherent in the Amish population that causes many to have six fingers is illustrated by an "x-rayed" hand with six fingers and framed by pairs of five-fingered hands. This eye-catching promotion, done in bright, bold colors, not only provides provocative reading but also communicates the concept that there's more to this printer than one might expect.

Distribution of Piece The piece ran once as an insert in a magazine/resource guide that's distributed to design firms and ad agencies.

Response to Promotion The client has reported favorable feedback and reprinted the insert for marketing purposes.

Low-Budget Promotional and Self-Promotional Pieces

TeamDesign Petri Dishes/Comic Strip-Candy Promo

Piece is Self-promotion for handout at trade shows

Art Director/Studio Bob Grindeland/TeamDesign

Designers/Studio Karey Manor, Brett Lloyd/TeamDesign

Client/Service TeamDesign, Seattle, WA/Graphic design and multimedia

Paper Printer's floor stock

Colors Four, process

Type Silhouette (all caps); Helvetica Narrow (body)

Printing Digital offset

Software Aldus PageMaker, MacroMedia FreeHand, Adobe Photoshop

Initial Print Run 500

Concept To promote their expertise in designing for biotechnology firms, TeamDesign used a tool that most of its clients could identify with—a petri dish. A round, four-panel, accordion-fold brochure was fitted into the dish—microscopic images were printed on one side, and information about the studio, including its areas of specialization and a list of current clients, appears on the other side, along with four small photos of laboratory instruments.

Special Production Technique The piece went straight from disk to four-color process printing without the use of film.

Distribution of Piece The dish was handed out to attendees at a biotech industry trade show.

Response to Promotion The promotion received favorable responses with numerous requests for additional information.

Piece is Self-promotion for handout at trade shows

Art Director/Studio Paula Richards/TeamDesign

Designers/Studio Paula Richards, Ross Hogin/TeamDesign

Illustrators Paula Richards (technical illustration), Ross Hogin (comic)

Client/Service TeamDesign, Seattle, WA/Graphic design and multimedia

Paper Printer's floor stock

Colors Four, process

Type Helvetica (comics); custom (logo)

Printing Digital offset

Software Aldus PageMaker, Adobe Illustrator

Initial Print Run 1,000

Concept This promotion was developed in concert with TeamDesign's exhibit at two electronic communications trade shows. Their trade show booth featured global imagery in a fun, light-hearted, yet technologically sophisticated manner. A "Cyberstud" comic character, fashioned after the Batman and Robin comics, was created to promote TeamDesign and its expertise in the electronic interface area. A comic strip, similar to the size of bubble gum comics, along with a chocolate ball in globe wrapping were placed in a small plastic capsule and distributed to trade show attendees.

Special Visual Effect The cyberspace look continues on the flip side of the comic strip where the TeamDesign logo is placed. This side was exposed through the capsule.

Special Production Technique The comic strip was printed straight from the disk, without the use of film.

Distribution of Piece The capsules were handed out at two different trade shows.

Response to Promotion Promotion generated numerous requests for information on TeamDesign and its services.

Piece is Brochure for Housing Opportunities for Women

Art Directors/Studio Samuel G. Shelton, Jeffrey S. Fabian/KINETIK Communication Graphics

Designer/Studio Amy L. Gustincic/KINETIK Communication Graphics

Photographer Peter B. Vance

Client/Service Housing Opportunities for Women, Silver Spring, MD/Provider of nonprofit housing for homeless women

Paper Benefit

Colors Two, match

Type Futura, Matrix Script

Printing Offset

Software Adobe Photoshop, QuarkXPress

Initial Print Run 2,500

Concept The design for this modest yet professional-looking brochure was based on the services provided by this nonprofit organization. HOW builds and helps maintain group homes in the Washington D.C. area for homeless women. To generate both interest in the services they offer as well as increase fund-raising revenue, the designers created a piece that has a hand-constructed feel and emphasizes the humanitarian nature of HOW's work. The booklet consists of twenty-six pages hand-assembled in booklet form. The back cover folds over the front page, forming a one-inch flap that is stapled through. Screened photos of completed houses and volunteers working on homes are placed throughout with copy explaining the group's services and operations positioned over them.

Distribution of Piece The brochure was mailed to potential donors and volunteers.

Response to Promotion The piece served to educate its audience and has generated donations to the organization.

Rural Community Assistance Program (RCAP)

Piece is Calendar for the Rural Community Assistance Program

Art Directors/Studio Samuel G. Shelton, Jeffrey S. Fabian/KINETIK Communication Graphics

Designer/Studio Amy L. Gustincic/KINETIK Communication Graphics

Client/Service Rural Community Assistance Program (RCAP), Leesburg, VA/Nonprofit community assistance organization

Paper Benefit White 80 lb. Cover (cover); Benefit White (text)

Colors Two, match

Printing Offset

Software Adobe Photoshop, MacroMedia FreeHand, QuarkXPress

Initial Print Run 1,500

Concept Because RCAP strives to help those in poor rural communities, this calendar was suitably

designed to have less of a polished look. The use of distressed type, faded borders and somber colors emphasizes the poverty and roughness of the rural communities presented on the calendar pages. The look is brightened, however, by photos depicting hope and progress. Most are of community residents, young and old, just doing their daily routines, but in impoverished environments that most peo-

ple would not consider liveable. The photos are placed dominantly on each page to emphasize the needs of the people in them, although the monthly calendars are large enough for recipients to write notes. It's a practical way to raise awareness and interest in the organization's mission.

Distribution of Piece The calendars were mailed by RCAP to a predetermined mailing list.

Piece is Postcards for [T-26] Digital Type Foundry
Art Director/Studio Carlos Segura/Segura Inc.
Designer/Studio Carlos Segura/Segura Inc.
Illustrator Tony Klassen
Client/Service [T-26] Digital Type Foundry, Chicago, IL/Font developer
Paper Domtar
Colors Four, process
Type Tema Cantante, various others
Printing Offset
Software QuarkXPress, Adobe Illustrator, Adobe Photoshop
Initial Print Run 3,000

Concept As a developer of fonts marketed to graphic designers, this client needed to position itself as technologically advanced and creatively sophisticated. This eclectic mix of postcard designs conveys the company's cutting edge services and products. Using the theme "Change Your Face!" the postcards introduce new font releases. One card consists of an intriguing illustration of a mask. The [T-26] logo, a large, geometric *T*, is drawn in red over each eye. A second postcard shows a series of nine squares, resembling a bank of video monitors. The squares contain distorted photo images of different parts of the face and drawings of mechanical parts, giving it a high-tech, video-age appearance. Again, two of the *T* logos overlay the design. A sampling of the new fonts, as well as a brief description and how to order, are on the back of each of the cards. The third card promotes neckties designed exclusively for [T-26] to offer to friends and clients. Two of the hand-painted ties are photographed with a picture of the designer and his signature placed along the side.

Distribution of Piece The postcards were mailed to designers.

Response to Promotion [T-26] reports that sales for the new fonts have increased since the postcards were distributed.

Morrison Design & Advertising

Piece is Holiday gift for clients
Art Director/Studio Penny Morrison/Morrison Design & Advertising
Designer/Studio Penny Morrison/Morrison Design & Advertising
Illustrator Penny Morrison/Morrison Design & Advertising
Client/Service Morrison Design & Advertising, Houston, TX/Graphic design and advertising
Colors Four, process
Type Matrix Bold
Printing Laser printed
Software Adobe Illustrator
Initial Print Run 45 bottles
Photography of Piece Frank Golden

Concept This holiday promotion is practical, useful, edible and fun. Keeping with its tradition of giving a homemade, edible gift to clients, prospects and suppliers during the holidays, Morrison opted for olive oil made from one of Mom's recipes. Snippets of rosemary cut from a friend's rosemary bush were put in the bottles giving them a festive holiday look. For the label, the designers honored Popeye's sidekick sweetie, Olive Oyle, who celebrated her fiftieth birthday in 1994. The gift is a soft sell of the studio's design work that helps convey its accessibility and practicality when it comes to the client's needs.

Cost-Saving Techniques Color copies of the labels were hand-applied to bottles. By using rosemary from a friend's rosemary bush, the designers were able to save about $75 in herb costs.

Distribution of Piece The bottles were hand-delivered to clients, prospective clients and generous suppliers.

Response to Promotion All those who received the gift want to stay on the studio's mailing list.

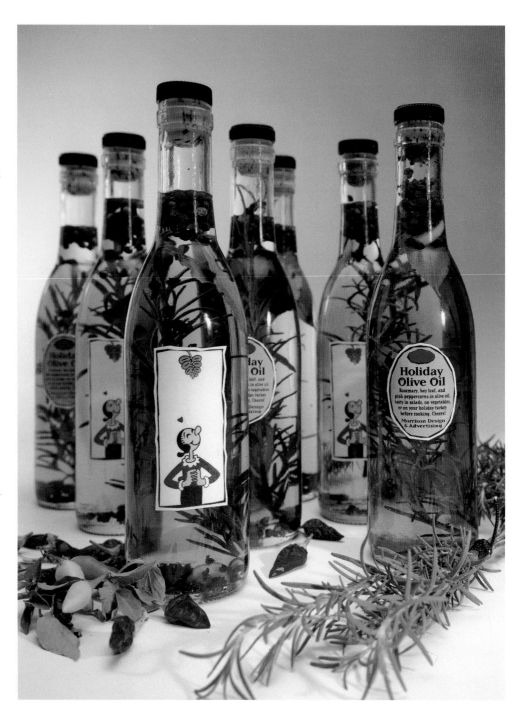

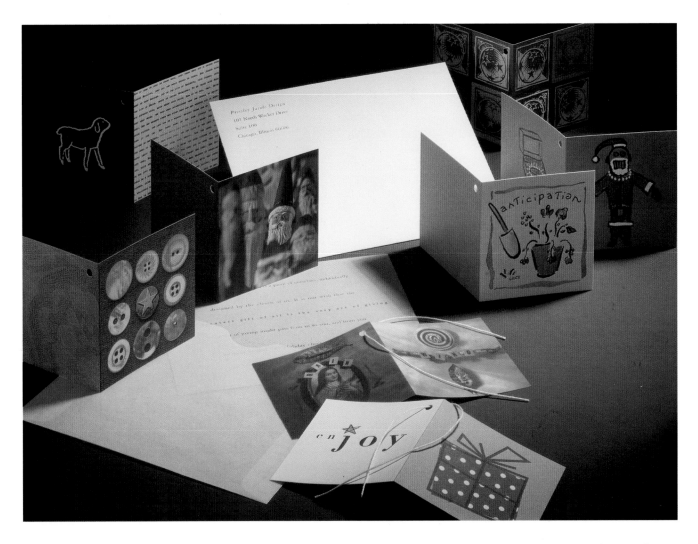

Piece is Holiday gift for clients

Art Director/Studio Susie McQuiddy/Pressley Jacobs Design

Designers/Studio Jennifer Kahn, Wendy Pressley-Jacobs, Jamie Gannon, Susie McQuiddy, Pat Schab, Amy McCarter, Barb Bruch, Craig Ward, William Johnson, Mark Myers, Kim Prickett/Pressley Jacobs Design

Illustrator Jacki Gelb

Photographers Jim Imbrogno, Kevin Anderson, Kippling Swehla

Client/Service Pressley Jacobs Design, Chicago, IL/Graphic design

Papers Weyerhaeuser Cougar Opaque 65 lb. cover, natural (cards); Hopper Proterra 80 lb. cover, lemon grass (insert card); Weyerhaeuser Cougar Opaque 70 lb. text, natural (envelope)

Colors Four, process

Type Garamond 3 and Gill Sans (insert card)

Printing Offset

Software QuarkXPress, Adobe Photoshop, MacroMedia FreeHand

Initial Print Run 800

Cost $1,200 (printing)

Concept Designers at Pressley Jacobs sent these one-of-a-kind gift tags as personal holiday greetings to clients, suppliers and friends. Each designer created his or her own card, basing the design on their ideas about the holiday season, from whimsical to religious to warmly sentimental. The cards were hole-punched and distributed as a set, including strings with which for attaching them to gifts. A simple holiday greeting card from Pressley Jacobs accompanied the tag set.

Cost-Saving Techniques Paper used for the Pressley Jacobs greeting card was donated by Hopper Papers, as was the photography for the gift tags. To save time and money, the studio created its own four-color separations in Photoshop for several of the cards and set up an in-house assembly line to collate the cards and prepare them for mailing.

Distribution of Piece The tags were mailed to clients, suppliers and friends.

Response to Promotion Many recipients of the tags complimented the studio on the design, format and practicality of the gift. Clients, suppliers and friends also had fun guessing which staff member designed each of the cards.

I & Company/Daniel Baxter Illustration

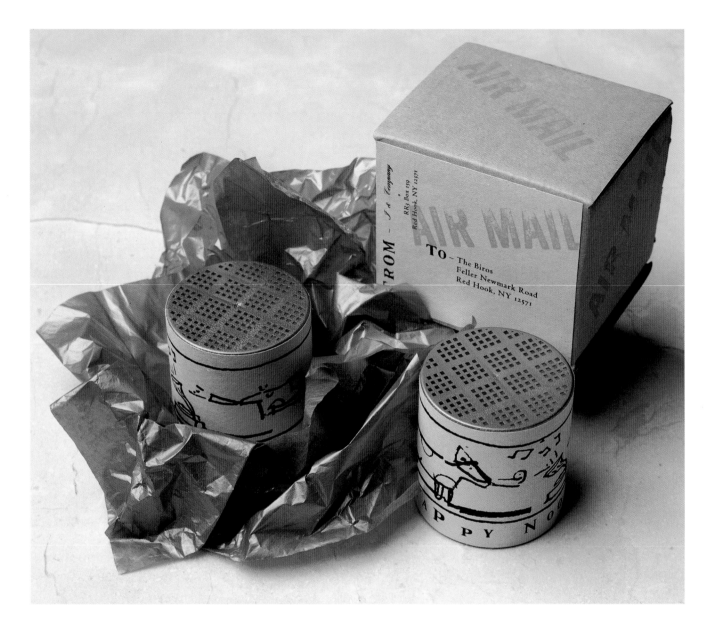

Piece is Holiday gift for clients

Designer/Studio Carol Neiley/I & Company

Illustrator Daniel Baxter

Client/Service I & Company and Daniel Baxter Illustration, Red Hook, NY/Graphic design and illustration, respectively

Paper Manila drawing paper

Colors One (black)

Type Englishe Schreibschrift, Centaur, Serifa, hand-drawn

Printing Laser printed

Software Aldus PageMaker, Adobe Photoshop

Initial Print Run 100

Cost $500

Concept Taking advantage of their location in New York's rural dairy country, I & Company created this whimsical bovine holiday greeting to amuse clients and remind them of the firm's services. An illustration of two cows wearing party hats and blowing party horns with the notation "Happy Noo Year," was glued to a cylindrical-shaped toy that lets out a loud "moo" when turned upside down. The studio's address and phone number are glued to the bottom. The toys were placed in small cardboard boxes with an airmail rubber stamp on them. Because the boxes were square, it wasn't real obvious which end to open, so many recipients heard the mooing several times before finally getting to the toy.

Cost-Saving Technique The illustration was laser printed and hand-glued to the toy. The piece was assembled in-house. Each box was hand stamped with the airmail insignia.

Distribution of Piece The boxes were sent by mail in batches to friends and existing and potential clients.

Response to Promotion The studio received many phone calls from clients who loved the toy and estimates they have generated a few thousand dollars in revenue.

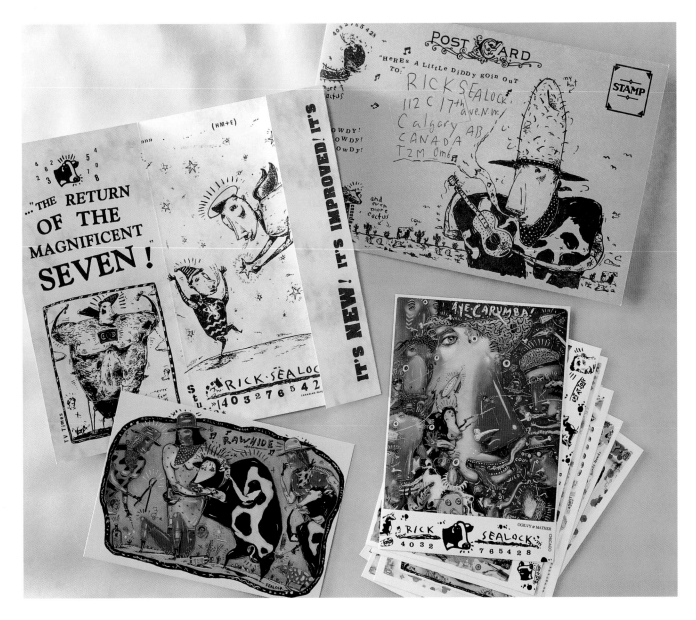

Piece is Self-promotional postcard set

Art Director/Studio Rick Sealock/Maverick Art Tribe

Designer/Studio Rick Sealock/Maverick Art Tribe

Illustrator Rick Sealock

Client/Service Maverick Art Tribe, Calgary, Alberta, Canada/Illustration

Paper Kraft (envelope); Cambric Cover Peppermint (folder); Cornwall Coated (postcards)

Colors Four, process

Printing Offset

Initial Print Run 750

Cost $1,673

Concept This zany collection of postcards was sure to get the attention of those who received it. Rick Sealock entertained clients with a self-promotional packet featuring seven of his award-winning illustrations. Inspired by the classic Western *The Magnificent Seven*, and a favorite restaurant called Joe's, Sealock invited clients to review his work or just have dinner with him at Joe's. The envelope features a Western character playing guitar in a desert setting. This character is repeated on the front of the inside folder, which opens to display the seven postcards with reproductions of illustrations completed for various clients. Sealock's quirky style is evident in the disproportionate characters in his designs, many of which are cows or figures modeled after cows.

Special Visual Effect The paper used for the folder has a dusty, worn look, reminiscent of old leather.

Cost-Saving Technique Sealock used photocopied type and images and hand-lettered other portions of the copy.

Distribution of Piece The packets were mailed and delivered personally to art directors, designers and friends (including Joe)!

Response to Promotion Sealock received phone calls almost immediately after distributing the packets. Some clients framed and hung the postcards. He estimates that the promotion generated between $20,000 and $25,000 in new revenue.

THARP DID IT

Piece is Self-promotional magazine reprints

Art Director/Studio Rick Tharp/THARP DID IT

Designers/Studio Rick Tharp, Colleen Sullivan, Laurie Carberry/THARP DID IT

Illustrator Ward Schumaker

Client/Service THARP DID IT, Los Gatos, CA/Graphic design

Paper Simpson Sundance Ecology White

Colors Two, match

Type ITC Century Condensed

Printing Offset

Initial Print Run 250

Cost $1,200

Photography of Piece Kelly O'Connor

Concept Over the past three years, Rick Tharp has annually contributed an article to *HOW* magazine on the current state of the design profession as he sees it. Tharp's style is witty and poignant, with a good dose of self-examination and lighthearted anecdotes about others in the profession. For example, he told a Japanese writer that his creative inspiration comes from "garbage." The writer took him literally, so he continued with the story: "When in San Francisco, I spend Friday evenings going through the dumpster behind Primo Angeli's studio. I got caught once by Primo when he was leaving his office. In response to his obvious question I

asked, 'So, where do you get your ideas from, Mr. Angeli?' He said, 'I don't know.'" The articles have been reprinted as these New Year's greeting cards. Designed as booklets with three punched holes, the cards also contain whimsical illustrations by Ward Schumaker.

Cost-Saving Technique All design is done by staff designers. The pages are delivered printed, scored and drilled by the printer. The booklets are then collated and grommetted by staffers at THARP DID IT.

Distribution of Piece The booklets are mailed annually to friends, colleagues and associates.

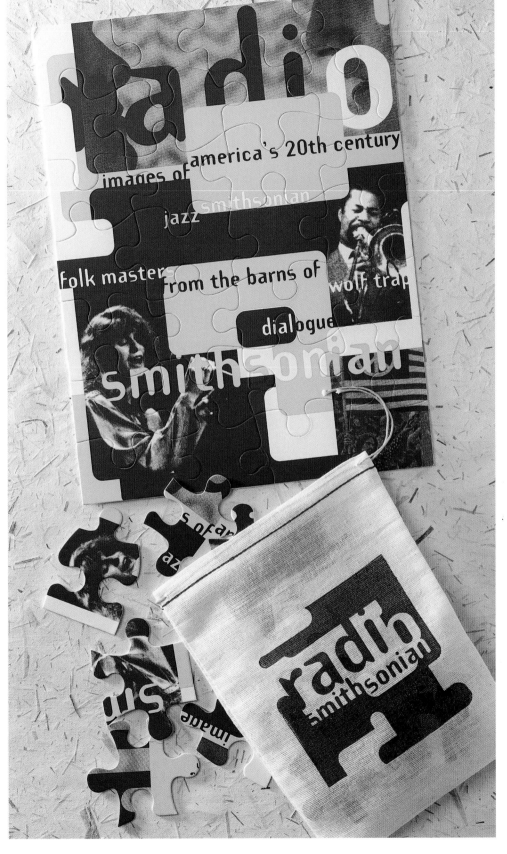

Piece is Trade show giveaway (jigsaw puzzle)

Art Directors/Studio Samuel G. Shelton, Jeffrey S. Fabian/KINETIK Communication Graphics

Designer/Studio Mimi Masse/KINETIK Communication Graphics

Client/Service Radio Smithsonian, Washington, D.C./Radio program producers

Paper Card index

Colors Two, match

Type Template Gothic

Printing Screen printed

Software MacroMedia FreeHand, QuarkXPress

Initial Print Run 1,000

Concept Working with a pre-existing ad campaign of "Radio Smithsonian helps program managers solve their programming puzzles," the designers created this trade-show giveaway. A drawstring bag made of cheesecloth, and displaying the Radio Smithsonian logo, contains puzzle pieces that when assembled make up an 8½" x 11" picture featuring images of America's twentieth century jazz and folk music culture. It's a fitting way to pique the interest of potential customers and promote the client as a problem-solver.

Distribution of Piece The puzzle bags were handed out to attendees at an industry conference/trade show.

DogStar Design

Piece is Self-promotional brochure

Art Director/Studio Rodney Davidson/DogStar Design

Designer/Studio Rodney Davidson/DogStar Design

Illustrator Rodney Davidson/DogStar Design

Client/Service DogStar Design, Birmingham, AL/Logo design and illustration

Paper Neenah Environment Alpaca (white), black and brown construction paper

Colors One (black)

Type Nicolas Cochin (body copy); Sans Black Condensed (captions)

Printing Laser printed

Software QuarkXPress, Macro-Media FreeHand

Initial Print Run 500

Cost $250

Concept This portfolio/mailer showcases six logos designed by DogStar that have received national and international recognition. To promote his award-winning work and expand his business, designer Rodney Davidson explains in story form the inspiration and creative process that went into designing each logo. The stories are personal and captivating, much like his illustrative and entertaining logo designs. The story that accompanies his studio's logo, for example, explains that the inspiration for the design came from his old college roommate who used to sing "I'll Sail Upon the Dog Star." He sketched what he thought a Dog Star might look like and got rave reviews from friends—even a request for a T-shirt sporting the logo.

Cost-Saving Techniques Each piece was printed on the laser printer, hand-assembled and bound with a thin black elastic band. Copyediting services were donated.

Distribution of Piece The piece was mailed and hand-delivered to advertising agencies, public relations firms and design studios.

Response to Promotion The promotion has generated more than $26,000 in revenue. One art director says she keeps it on her coffee table at home.

Piece is Ad for Accentrix Furniture, Antiques & Accessories
Art Directors/Studio Eric Thoelke, Kathy Wilkinson/Phoenix Creative
Designers/Studio Eric Thoelke, Kathy Wilkinson/Phoenix Creative
Photographer David McCarthy
Client/Service Accentrix Furniture, Antiques & Accessories, O'Fallon, IL/Home furnishings
Colors Four, process
Type Torino, Adobe Garamond
Software QuarkXPress, Adobe Photoshop

Concept The designers of this ad (one of a series) had only to look as far as this furniture store's name to come up with this catchy campaign. A newly designed logo that accentuated the "x" in Accentrix served as an integral part of the marketing campaign. An exaggerated version of it is placed prominently in each of three ads, each of which uses a pun that has the "x" sound in it, for example, "Beyond Xpectations," "X marks the spot," and "Go the Xtra mile." Silhouettes of the store's products are then placed strategically around the *X* for a sophisticated, balanced look.

Cost-Saving Technique Up to forty pieces of furniture and accessories were photographed in a day's time (to save on photography time/costs). The photos were later scanned, stripped and airbrushed as needed.

Distribution of Piece The ads ran weekly in local Sunday paper supplements and were placed in special targeted publications.

Response to Promotion Because the store is located in a distant suburb of St. Louis, most customers don't just happen on to it. They have to be actively looking for it. The store owners report that traffic has increased significantly and this is attributed directly to the marketing campaign.

Addison Centre Theatre

Piece is Brochure for Addison Centre Theatre

Art Directors/Studio Shawn Freeman, Todd Hart, Elizabeth Malakoff, Joe Ortiz/Focus 2

Designers/Studio Shawn Freeman, Todd Hart, Elizabeth Malakoff, Joe Ortiz/Focus 2

Photographers Marissa Wallace, Phil Hollenbeck

Client/Service Addison Centre Theatre, Addison, TX/Professional theater

Colors Two, match

Type Flomotion

Printing Offset

Software QuarkXPress, Adobe Photoshop, MacroMedia FreeHand

Initial Print Run 30,000

Cost $35,000

Concept The design of this piece reflects the unique physical structure and thoughtful performances of an acclaimed Texas theater. The facility was designed so that it could be "stripped back to the bare building" for each production in order to maximize the relationship between the audience and the performance, making each production a totally new experience. This unstructured, nontraditional approach is conveyed in the brochure that promotes the theater's upcoming performances, activities and philosophy. A cardboardlike binder measuring 7" x 7½" opens to display two flaps of pages that subsequently open from the center. The pages, which can be flipped through simultaneously, serve to reinforce the sense of no set structure, and contain photographic images representing the theater's transformation and announcements about upcoming performances.

Distribution of Piece Two batches of the piece were mailed. Some pieces were hand-delivered.

Response to Promotion Ticket sales and interest in the theater have increased.

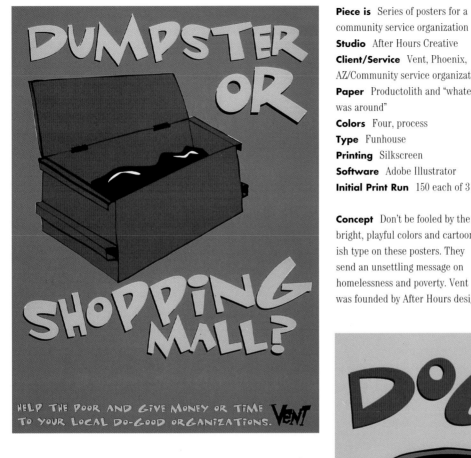

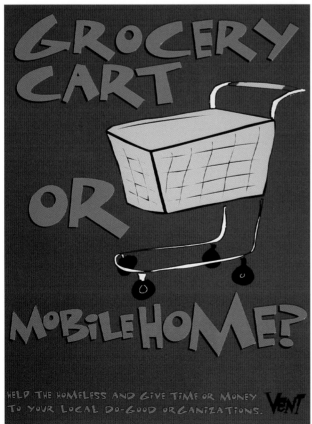

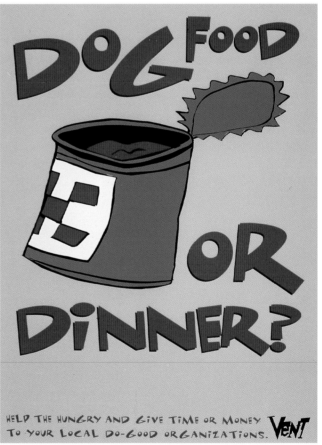

Piece is Series of posters for a community service organization
Studio After Hours Creative
Client/Service Vent, Phoenix, AZ/Community service organization
Paper Productolith and "whatever was around"
Colors Four, process
Type Funhouse
Printing Silkscreen
Software Adobe Illustrator
Initial Print Run 150 each of 3

Concept Don't be fooled by the bright, playful colors and cartoonish type on these posters. They send an unsettling message on homelessness and poverty. Vent was founded by After Hours designers as a social platform on the needs of the homeless. In creating these posters, the designers utilized ordinary objects like trash bins, dog food cans and shopping carts that don't mean much to most people but when coupled with pointed commentary, speak volumes on the way homeless people live. These boldly designed posters involve the viewer immediately and matter-of-factly encourage them to help the hungry and the homeless.

Cost-Saving Technique The three posters were silkscreened simultaneously using the same inks.

Distribution of Piece The posters were posted on walls and in buildings around the Phoenix area.

Ultimo

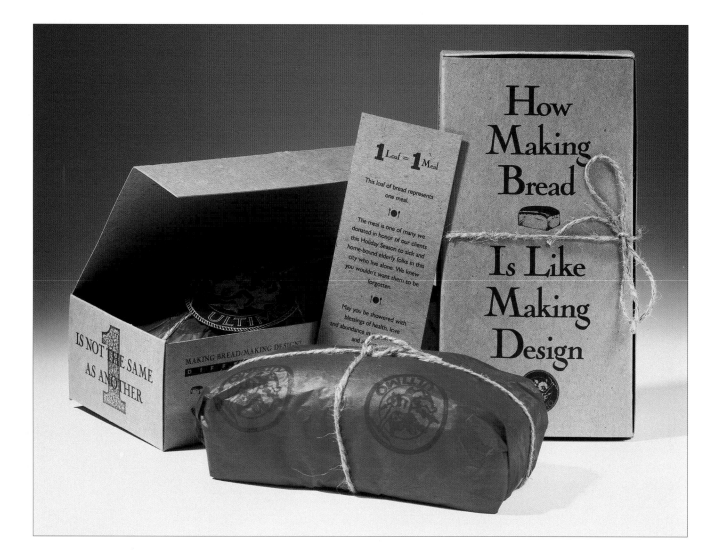

Piece is Self-promotional holiday gift

Art Director/Studio Clare Ultimo/Ultimo Inc.

Designers/Studio Clare Ultimo, Jo Anne Obarowski/Ultimo Inc.

Client/Service Ultimo Inc., New York, NY/Graphic design

Paper Chipboard

Colors Two, match

Printing Laser printed

Software QuarkXPress, Adobe Illustrator

Initial Print Run 250

Cost $3,500

Photography of Piece Cynthia Brown

Concept A simple loaf of bread, packaged in a modestly designed cardboard box, makes a fitting and filling holiday gift, as well as a thought-provoking statement. On the light-hearted side, the piece compares making bread with making design. What appear to be recipe tips printed on the outside of the box are actually tongue-in-cheek jabs at making design, such as "Bread always has a crust of some kind/Some designers get crusty when they're on their 12th revision." On the more serious side, a puzzling message of "1 can make a difference" is printed on the end

of the box. As explained in a card inserted in the box, one loaf of bread is equal to one meal for many elderly residents of New York City. The card further explains that in honor of their clients and in the true spirit of the holidays, the studio has donated meals to the Isaacs Center for the elderly.

Distribution of Piece The loaves were hand-delivered to clients and friends.

Response to Promotion The piece generated many positive responses and additional donations to the Isaacs Center.

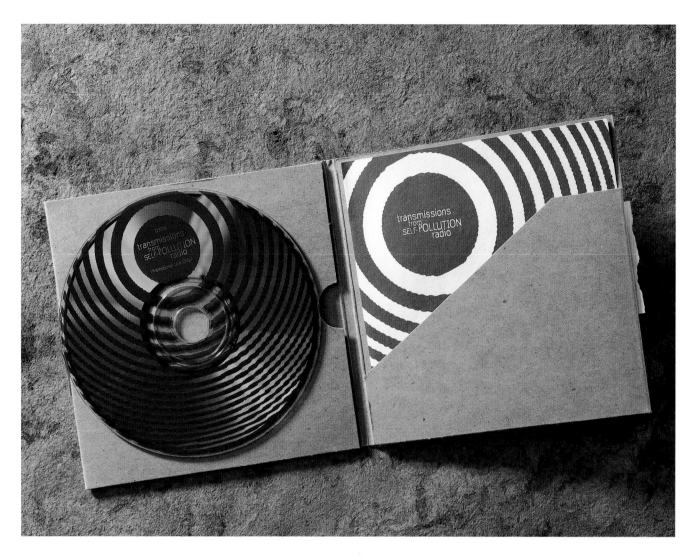

Piece is Promotional CD
Art Director/Studio Carlos Segura/Segura Inc.
Designer/Studio Carlos Segura/Segura Inc.
Photography Bettman Archive
Client/Service Q101 Radio, Chicago, IL/Radio station
Paper Calumet Cauton (cardboard CD carrier)
Colors Two, match
Type Imperfect
Printing Offset
Software QuarkXPress, Adobe Photoshop
Initial Print Run 1,500

Concept With a title like "Transmissions from self-pollution radio," this promotional CD produced by a Chicago alternative rock radio station had to send some jolting vibes to its listeners. The CD was offered to listeners as a way to promote an upcoming Pearl Jam concert. The designers—working with the rowdy image associated with alternative rock—went for a bootleg look in the design of the piece. An unmarked cardboard CD holder is taped with a label that pictures a bell emitting sound waves to an ear. The label is positioned so that the bell and title of the CD are on the front and the ear is folded onto the back. The sound wave look is repeated on the CD and on the insert that lists the tracks included to create a dizzying, psychedelic effect.

Distribution of Piece The CDs were given away to listeners.

Response to Promotion The station's ratings increased during the promotion.

Promotion and Self-Promotion for Illustrators and Photographers

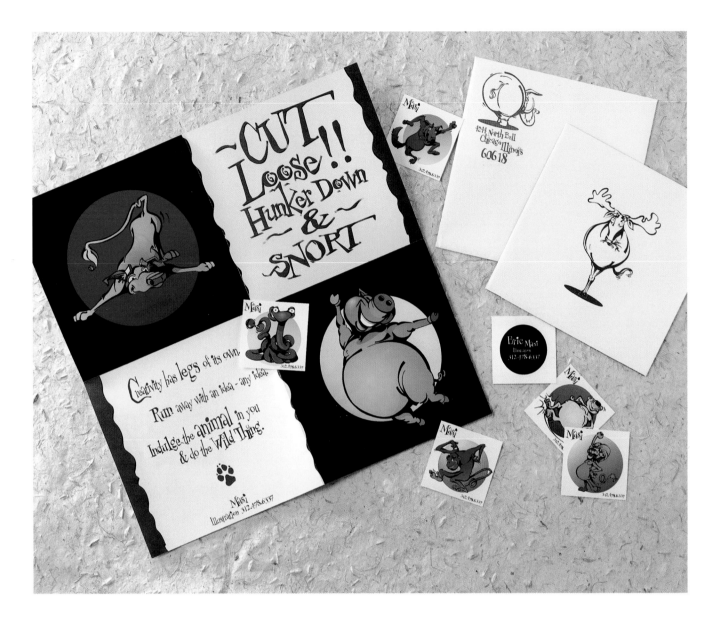

Piece is Self-promotional cards and miniposter

Designers/Studio Eric Masi, Kevin Masi/Masi Graphica

Illustrator Eric Masi

Client/Service Masi Graphica, Chicago, IL/Design and illustration

Paper Centura Gloss Text (poster); Centura Gloss Cover (cards)

Colors Four, process

Type Cappio Extra Frisky

Printing Offset

Software QuarkXPress, Adobe Illustrator

Initial Print Run 2,000

Cost $1,200

Concept To stimulate business, Masi created a set of cards and a miniposter (12½" x 12½") with cartoonlike animals on them inviting clients to do something a little wild—like use Masi's illustration and design services. The cards, which measure 2¼" square, feature Dr. Seuss-inspired characters cutting loose and getting funky. The cards accompany the folded poster, which has more wild characters and offers encouragement to "Do the Wild Thing!" The promotion was mailed in an envelope with an illustration of a rhino's rear end.

Special Visual Effect The small cards quickly grab the recipient's attention because they normally tumble out of the envelope—hinting at Masi's wild and funky design and illustration style.

Distribution of Piece Mailed to art directors and designers.

Response to Promotion The promotion generated a number of illustration jobs and about $10,000 in revenue.

VanderSchuit Studio

Piece is Ads for VanderSchuit Studio

Art Director/Studio Jose Serrano/Mires Design

Designer/Studio Jose Serrano/Mires Design

Photographer Carl VanderSchuit

Client/Service VanderSchuit Studio, San Diego, CA/Photography

Colors Four, process

Type Helvetica Black, New Baskerville

Printing Offset

Software QuarkXPress

Cost $1,500 per ad

Concept As the saying goes, a picture paints a thousand words, and this series of four ads featuring the work of a San Diego photography studio speaks volumes about its capabilities. The clean, simple design of these ads clearly illustrates the power of a single photograph. By reproducing one photo dominantly in each of the ads, accentuated with only the studio's name and address, the designers focused on the talents and skills of the studio. The photographs themselves comment on the marriage of technology and human emotion.

Distribution of Piece The ads were placed yearly in talent showcase books and bimonthly in magazines for distribution to an audience primarily composed of art buyers, art directors and designers.

Response to Promotion The photography studio received portfolio inquiries and a number of new jobs as a result of the ads.

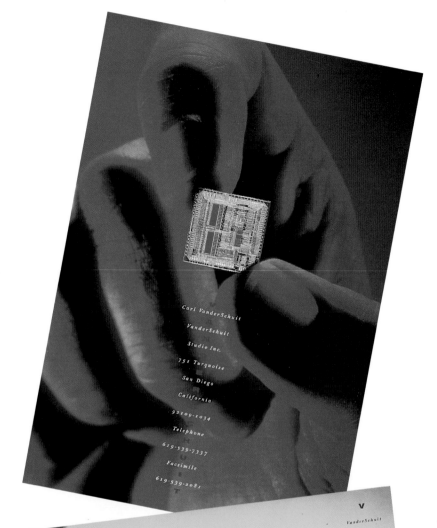

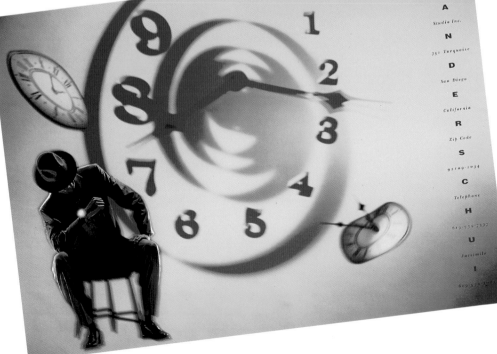

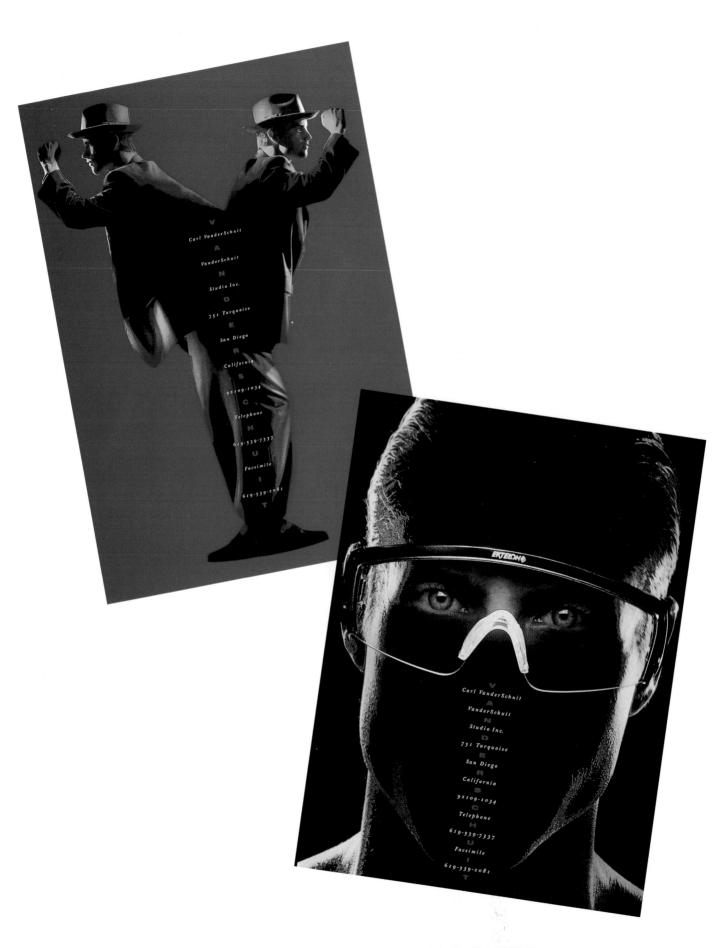

Carl VanderSchuit

VanderSchuit
Studio Inc.

751 Turquoise

San Diego

California

92109-1034

Telephone

619·539·7337

Facsimile

619·539·2081

Jock's Pocket Color Book

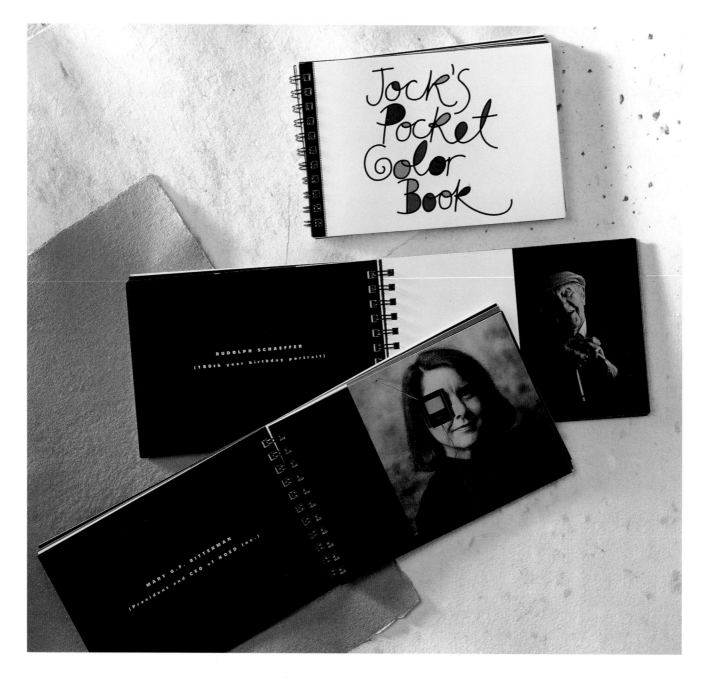

Piece is Miniportfolio for Jock McDonald Photography
Studio Craig Frazier Design
Photographer Jock McDonald
Client/Service Jock McDonald Photography, San Francisco, CA/Photography
Paper Champion Kromekote (cover); Warren 120 lb. Lustro (inside)
Colors Eight, match (inside and out)

Type Franklin Gothic
Printing Offset
Initial Print Run 3,000
Cost $20,000

Concept This miniportfolio should quell any doubts about McDonald's ability to shoot color portraits. That, he says, is what inspired him to have this "pocket color book" created. The book borrows its format from the small photo albums that many people carry to showcase certain events or subjects, like the grandkids. Inside are portraits of a variety of subjects, ranging from a tobacco worker grinning widely behind a big cigar to boxer Evander Holyfield smiling politely at ringside to a cherubic "babyGap" baby decked out in sunglasses and beads. Each portrait appears on its own page with identification on the facing page. The photographer himself is featured on the second-to-last page followed by a portrait of a screaming baby with the copy, "Don't cry. Call Jock McDonald."

Distribution of Piece The booklets were mailed once to graphic designers and art directors.
Response to Promotion The photographer reports that he has received more color photography work.

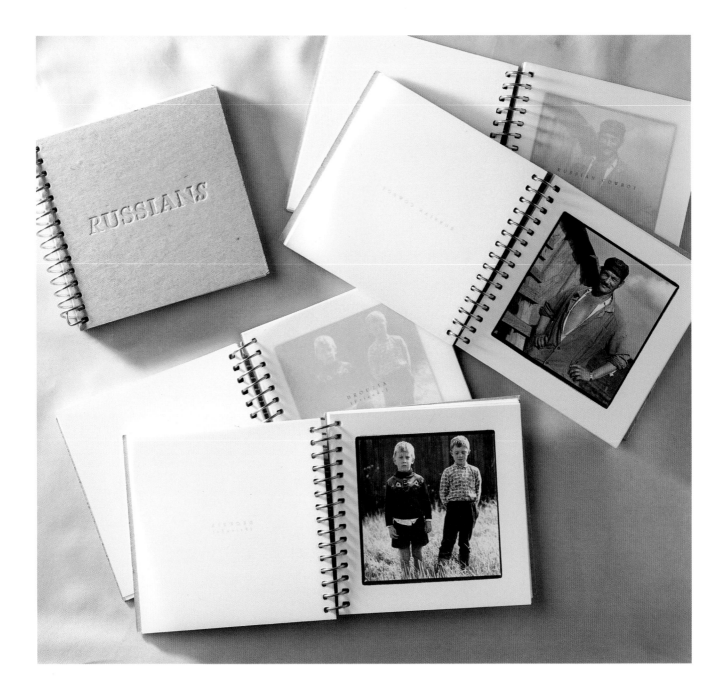

Piece is Book of black-and-white portraits

Art Director/Studio Jock McDonald/Jock McDonald Photography

Designer Michael Cruz

Photographer Jock McDonald

Client/Service Jock McDonald Photography, San Francisco, CA/Photography

Paper Chipboard (cover); Starwhite Vicksburg Archiva Plus (inside pages); vellum (fly sheets)

Colors One, match

Printing Offset

Initial Print Run 1,000

Cost $20,000

Concept A prerevolution visit to the Soviet Union resulted in this touching collection of portraits. Entitled simply "Russians," which is imprinted on a stark, unadorned chipboard cover, this 6¼" square, spiralbound book of black-and-white portraits captures the past, present and future of rural Russian society. Sharp, vivid photos of children, farm workers and others aptly display the photographer's talents to create a telling story with the snap of a picture. Each photo is placed on a separate page and preceded by a sturdy sheet of fly paper with the subject identified not by name, but by what the photographer sees. For example, a male farm worker is a "Russian Cowboy," a young boy wearing a military cap and holding a gun is the "Past Present and Future." The photographer writes about his experiences in the country in a four-page introduction and one-page conclusion. His impressions of and respect for the Russian people is evident throughout.

Distribution of Piece The books were hand-delivered to existing clients.

Pierre-Yves Goavec

Piece is Booklet for Pierre-Yves Goavec

Designers/Studio David Collins, Judy Kirpich/Grafik Communications, Ltd.

Type Illustrator David Collins

Copywriters David Collins, Judy Kirpich

Photographer Pierre-Yves Goavec

Client/Service Pierre-Yves Goavec, San Francisco, CA/Photography

Paper Vintage Velvet 100 lb. Cover (cover and interior); photographic filter (fly sheets)

Colors Four, process

Type Berkley (modified); Myriad

Printing Offset

Software Adobe Photoshop, Adobe Illustrator, QuarkXPress

Initial Print Run 3,500

Concept A simple, unobtrusive cover design contrasts sharply with the provocative series of photos and text inside this keepsake-type booklet for a San Francisco photographer. The promotion exhibits the photographer's knack for photographing colored light projections. Each full-page photo is offset with a page of type that also looks as if it were a projection. The copy describes the photographer's style through seeming contradictions like "shadows without darkness," "intensity without harshness," and "definition without edges."

Special Visual Effect The addition of a photographic filter paper at the front and back of the booklet was an extra incentive for recipients to keep the promotion on file.

Cost-Saving Techniques The entire brochure (except for the photography) was created on the computer and the colors were built out of four process colors with no varnish. The piece was printed on a four-color press with only a 12" x 12" sheet size.

Distribution of Piece Booklet was mailed to graphic designers.

Piece is Poster/Call for Entries
Art Director/Studio John White/White Design
Designer/Studio Jerry Lofquist/White Design
Client/Service American Institute for Graphic Arts (AIGA), Los Angeles chapter, Los Angeles, CA/Professional association for graphic designers and illustrators
Paper Potlatch Karma Bright White
Colors Three, match; plus dull and gloss varnishes
Type Typewriter Type, Adobe Garamond, Adobe Garamond Expert
Printing Offset
Software Adobe Illustrator, Adobe Photoshop, QuarkXPress
Initial Print Run 750
Cost All materials and services donated

Concept This poster not only serves as a call for entries for an AIGA-sponsored T-shirt contest, but helps educate those who see it on the ideals of tolerance and equality. It was distributed to Southern California art and design schools. Key words are emphasized in the design to introduce the contest's theme of tolerance and to mimmick the headlines that appear too often in Los Angeles area newspapers. The words "one race" are reversed out of the striking dark background and immediately grab the viewer's attention. Details on the contest are arranged unobtrusively along the sides so that the theme remains the dominant element of the design.
Distribution of Piece The posters were mailed to Southern California art and design schools.

Scott Hull Associates—Double Impact

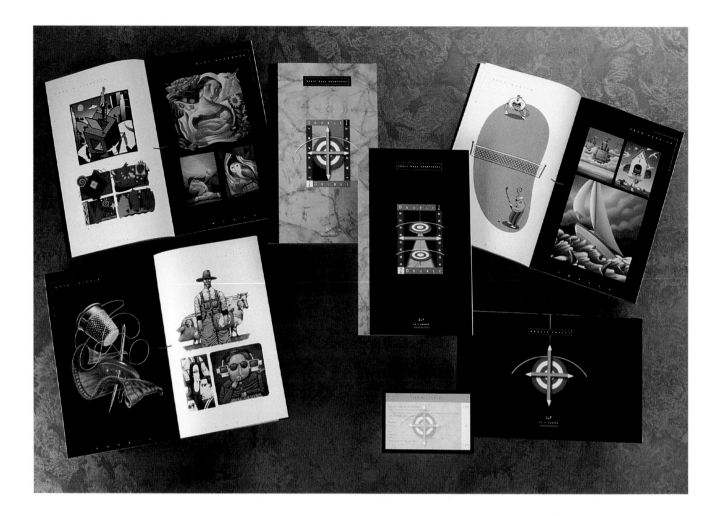

Piece is Self-promotional mailer

Designer/Studio Steve Gabor/Salvato & Coe Associates

Illustrators Scott Hull Associates (various)

Client/Service Scott Hull Associates, Dayton, OH/Artists' representative

Paper Mead Signature Dull

Colors Six

Type Triplex, Helio Type, Franklin Gothic

Printing Offset

Software Adobe Photoshop, MacroMedia FreeHand

Initial Print Run 15,000

Concept Exposure with impact was the goal of this brochure featuring the work of artists represented by the client. This was the first of two brochures being mailed to buyers of illustration, so its theme of "Double Impact" is even more appropriate. The 7½" x 12" booklet features a bold cover design. The dominant element is a bull's-eye illustration with pencils crossed over it, immediately focusing the viewer and pulling them inside. As Hull says, you only have fifteen seconds to grab your fifteen minutes of fame, so a design that immediately involves the customer is crucial. The illustration is repeated on the inside front cover and on the solid black envelope in which the brochure was mailed. Inside the brochure are samples of twenty-two artists' work.

Distribution of Piece The brochures were sent bulk mail to designers, art directors and other art buyers.

Response to Promotion The piece generated interest and phone calls about the talent represented.

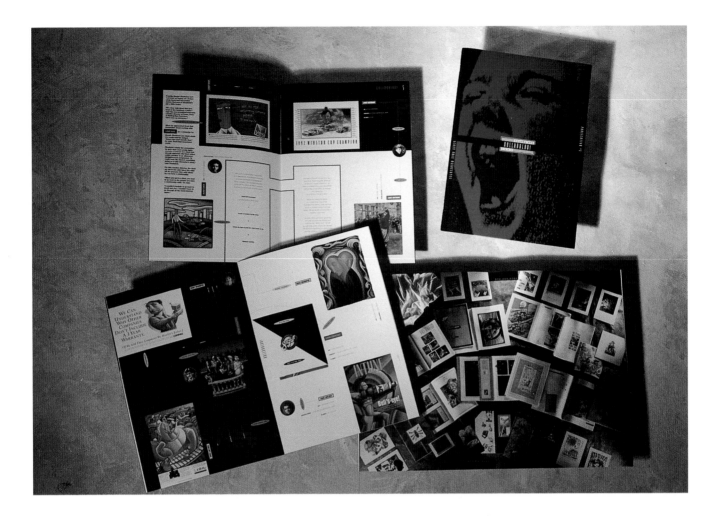

Piece is Self-promotional brochure

Designer John Walker

Illustrators Scott Hull Associates

Photography AGI Photographic Imaging

Client/Service Scott Hull Associates, Dayton, OH/Artists' representative

Paper SD Warren Lustro Dull

Colors Six

Type Senator (cover); Helvetica (inside pages)

Printing Offset

Software MacroMedia FreeHand

Initial Print Run 15,000

Concept This brochure commands the attention of art buyers. Themed around the word "hullabaloo," the cover features a vibrant screened image of a person screaming. If that doesn't grab the attention of its audience, the striking design and telling testimonials from satisfied clients on the inside will. Each spread in this oversized booklet incorporates numerous elements, including the work of the artists, a photo of each and snippets of commentary from clients who have utilized the talent represented by Hull. It has an uproarious effect but is balanced by the use of white space and clean lines.

Distribution of Piece The brochures were sent bulk mail and some delivered in person to art directors, designers and art buyers.

Response to Promotion The piece helped strengthen Hull's presence in the marketplace.

Scott Hull Associates—Striped Cover Brochure

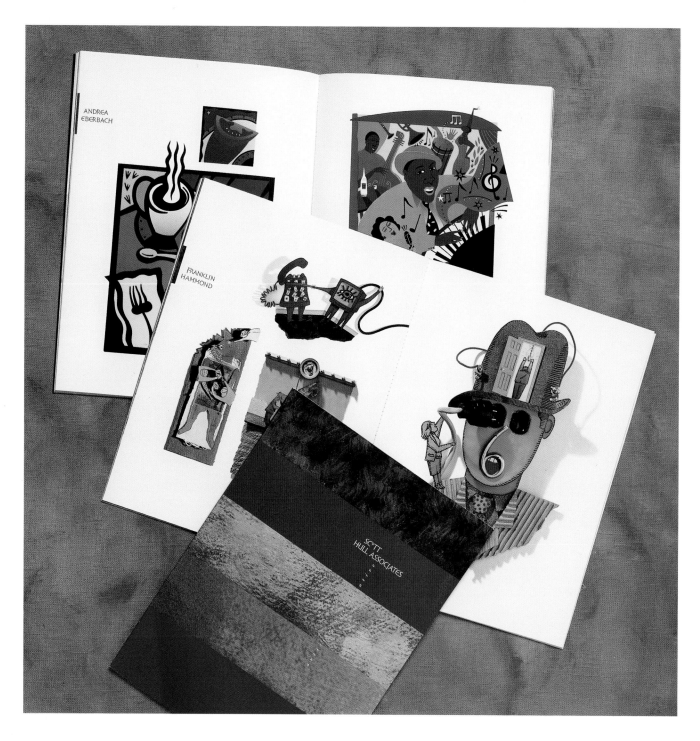

Piece is Self-promotional brochure

Designer/Studio Laura Jones/Anthony Littleton Design

Illustrators Scott Hull Associates

Client/Service Scott Hull Associates, Dayton, OH/Artists' representative

Paper SD Warren Lustro Dull

Colors Five

Type Sophia, Garamond, Cafeteria

Printing Offset

Software Aldus PageMaker

Initial Print Run 27,000

Concept The work of the artists represented takes center stage in this forty-eight-page promotional booklet. A rainbow of bright colors on the cover makes a simple statement about the artistic nature of what the brochure contains. The quality and service provided by the company is explained in a brief introduction. Each subsequent spread is devoted to showcasing the work of one of the artists represented. The thoughtful layout and skillful placement of elements on each page truly allows the product to shine.

Distribution of Piece The brochures were mailed to designers, art directors and corporate marketing staffs.

Response to Promotion The piece has generated a number of new projects.

Part Six

Promotional Pieces for Clients

Xinet

Piece is Software packaging for Xinet Inc.

Art Directors/Studio Earl Gee, Fani Chung/Earl Gee Design

Designers/Studio Earl Gee, Fani Chung/Earl Gee Design

Illustrator Robert Pastrana

Client/Service Xinet Inc., Berkeley, CA/Software developer

Paper Springhill 18 pt. SBS C1S

Colors Four, process; one, match; plus overall aqueous coating

Type Mona Lisa Solid (title); OCRA (sales messages); Caslon 540 (address)

Printing Offset

Software QuarkXPress, Adobe Illustrator, Adobe Photoshop

Initial Print Run 3,000

Cost $22,500

Photography of Piece Kirk Amyx

Concept The functionality and advanced features of the client's server software program are communicated in this unusual but functional packaging. The designers of this piece were charged with developing a package that would "stand out" on retailers' and end users' shelves and be sturdy enough to withstand mail handling. Drawing on the cubist style, they created a trapezoid-shaped box that unfolds to display another similarly shaped box. A tray containing a CD-ROM and user's manual slide out of the inner box. The restaurant waiter was chosen as the ideal metaphor for a software that "serves" two computers. The geometric man/machine character comes complete with exhaust vents, media slot, printout/towel and a tray of files. The table is decorated with a "bouquet" of cables.

Cost-Saving Technique The outer wrapper, package sleeve, CD-ROM tray and manual cover were laid on a single press sheet, allowing for cost savings in film and color consistency in all pieces.

Distribution of Piece The packages could be purchased by mail.

Response to Promotion The president of Xinet reports that the packaging has generated increased awareness of his company and its product, positive feedback from the target audience and strong sales. The design studio is doing more work for Xinet, including product brochures and trade ads.

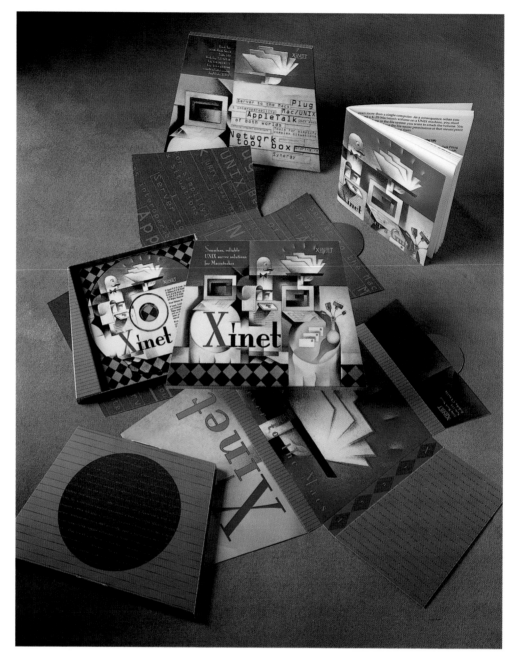

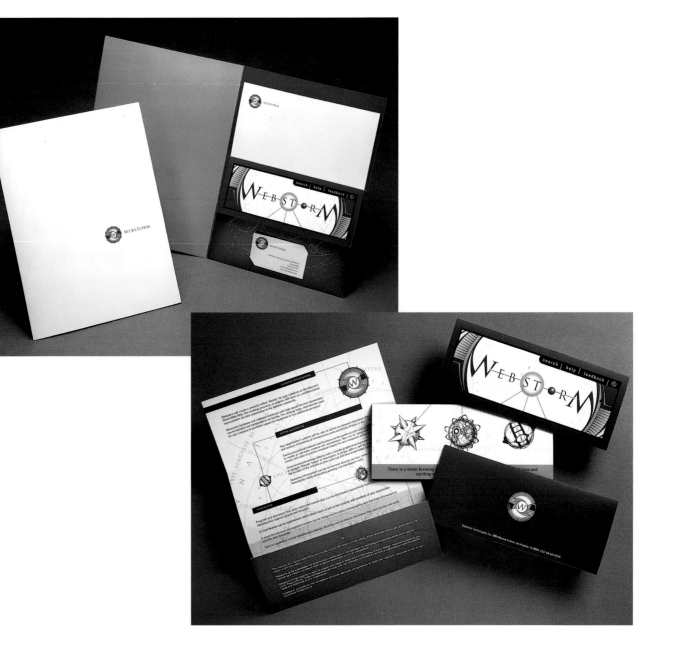

Piece is Media kit and brochure for Webstorm

Art Director/Studio Richard Wilks/Studio Wilks

Designer/Studio Richard Wilks/Studio Wilks

Illustrator Richard Wilks

Client/Service Webstorm, Los Angeles, CA/Internet access provider

Paper Karma

Colors Five, match

Type Trajan, Univers

Printing Offset

Software Adobe Illustrator, Adobe Photoshop, QuarkXPress

Initial Print Run 10,000

Concept The World Wide Web and how it works is still rocket science to most people, but this media kit and brochure for an access provider delivers information about the service in an easy-to-read, humanistic manner. The company name, Webstorm, and its logo, which borrows its look from Latin compass symbols, are the only elements on the white folder cover, suggesting the "calm before the storm." The media kit folder opens to expose an inside front cover in bright gold and the back cover and flap in a brilliant blue, patterned with a Latin map. A three-fold, 8½" x 14" brochure is inserted. The first panel you see when you open the brochure contains three high-tech global icons and copy that warns: "There is a storm brewing on the horizon called the Internet..." The text inside the brochure explains the client's services and is printed in black over the same Latin map pattern.

Distribution of Piece The media kit was mailed and delivered in person to existing and prospective clients.

Response to Promotion Both the client and the studio have received added exposure, attention and new business.

Chateau Ste. Michelle

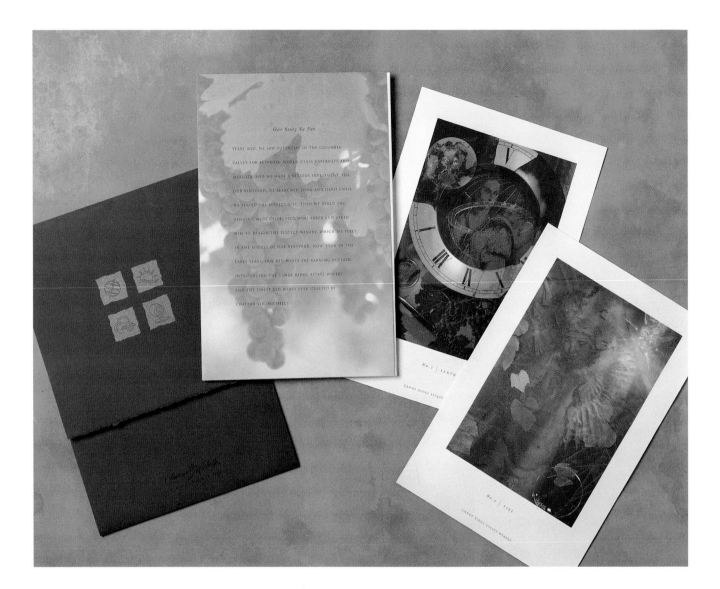

Piece is Brochure for a winery

Art Director/Studio Janet DeDonato/TeamDesign

Designer/Studio Renae Bair Dekker/TeamDesign

Photographers Patience Arakawa, Mel Curtis

Client/Service Chateau Ste. Michelle/Winery

Paper Simpson Teton (cover); Simpson Starwhite Vicksburg (brochure); Curtis Parchment Patapar (flysheet)

Colors Four, process; two, match

Type Adobe Garamond

Printing Offset

Software MacroMedia FreeHand, Aldus PageMaker

Initial Print Run 2,000

Concept The art and craft of winemaking is reflected in this elegant promotion for a newly opened winery. Consisting of a series of framable prints packaged in a classic, burgundy-color portfolio, the piece exudes a sense of refinement and prestige. The prints, entitled "Earth," "Fire," "Air" and "Water," represent the elements used to make fine wine. The photography carefully blends these elements, just as fine wine consists of a careful blend of elements. A two-fold brochure features a photo of a lush grapevine and information on the new winery.

Special Visual Effect The opening insert is a statement about the winery's philosophy on making great wines and is printed on a sheet of parchment paper, adding to the refined, elegant look of the piece.

Distribution of Piece The package was distributed to officers and managers of wine distribution and wholesale companies.

Response to Promotion The client was so pleased with the prints that they are now selling them in their gift shop.

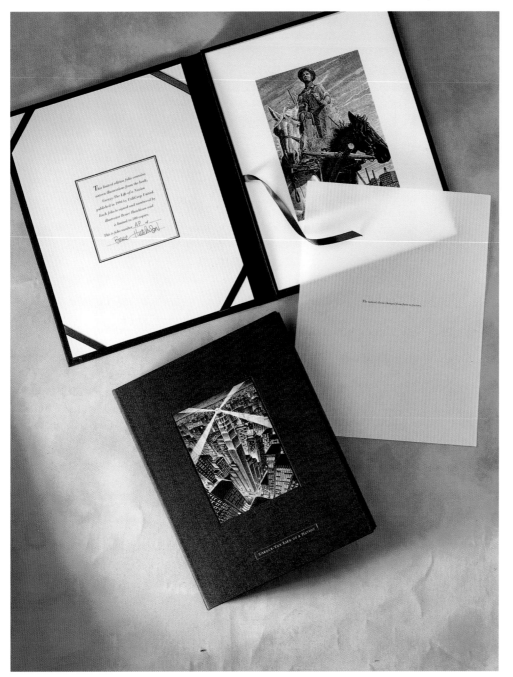

Piece is Books and folios to be used for marketing and as corporate gifts

Art Director/Studio Mark Sackett/Sackett Design Associates

Designers/Studio Mark Sackett, Wayne Sakamoto, James Sakamoto/Sackett Design Associates

Illustrator Bruce Hutchison

Client/Service Utilicorp United Inc., Kansas City, MO/Gas and electric utility

Paper Simpson Teton Tiara White Cover 88 lb. (portfolio sheets); Neenah UV Ultra II Columns 17 lb. and 36 lb.

Colors Four, process; two, match; plus a varnish

Type Bodoni Regular and Italic

Printing Offset

Software QuarkXPress

Initial Print Run 4,000 books; 500 folios

Concept This elaborate, nostalgic look at the history of utilities suggests the permanence, reliability and stability of the client company. "Energy—The Life of a Nation" is a 128-page hardbound book that chronicles the client's operations and the history of electricity and other forms of energy. Pen-and-ink illustrations are used to highlight especially significant events, and each is preceded by a sheet of fly paper with a caption for the illustration. The publication is bound in an elegant, navy blue cloth and inserted in a case covered in the same material. A limited edition portfolio of the illustrations in the book—numbered and signed by the illustrator—is fashioned in the same way.

Distribution of Piece The pieces were used as corporate gifts and general marketing materials.

Smith Sport Optics

Piece is Trade show booth
Art Director/Studio Jack Anderson/Hornall Anderson Design Works
Designers/Studio Jack Anderson, David Bates, Cliff Chung/Hornall Anderson Design Works
Client/Service Smith Sport Optics Inc., Ketchum, ID/Sunglass manufacturer
Printing Flexo (box)
Software MacroMedia FreeHand

Concept The design of this trade show booth and the featured merchandising program relies on the pureness and natural materials of the outdoors to promote the client's line of sunglasses. From the fiberboard used for the booth itself to the natural wood chairs, the strength and durability associated with the great outdoors is evident. Merchandising props and displays, such as a sandblasted rock and a wooden sunglass tree, are used to showcase the various products. The theme is continued in the packaging for the sunglasses. The boxes are constructed of a flecked cardboard with old-fashioned metal fasteners and tape left exposed. The warm, back-to-nature quality of the campaign provides a sharp contrast to the pristine, austere environments of the client's competitors.
Cost-Saving Technique Natural materials were used to construct the packaging, while actual river rocks were used for point-of-purchase displays.
Response to Promotion The client has a product that stands out among its competitors, and the design studio has received numerous awards, including an Addy for the sunglass packaging, and a Lulu from the Los Angeles Advertising Women's Association for identity materials.

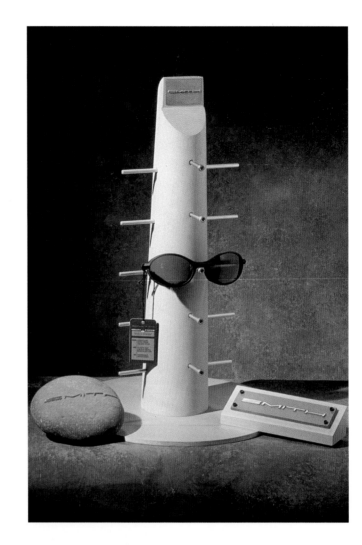

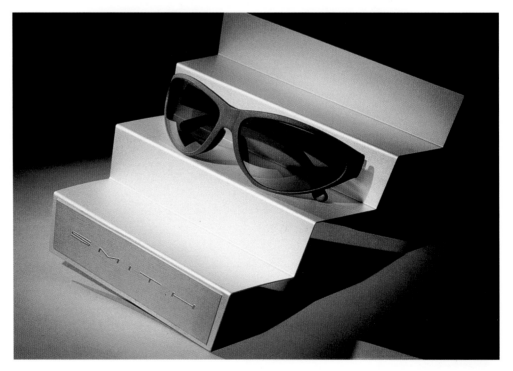

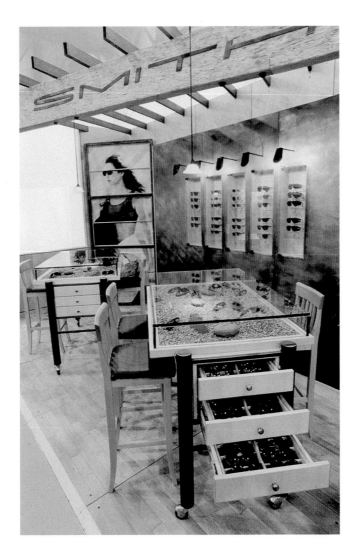

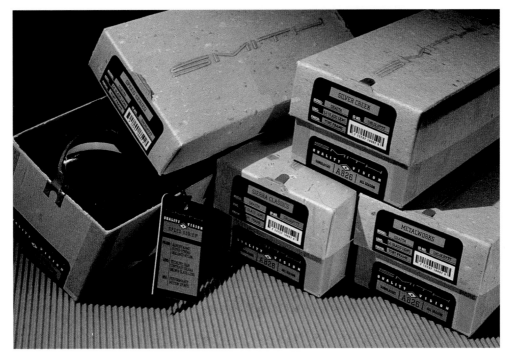

Intellectual Capitalism

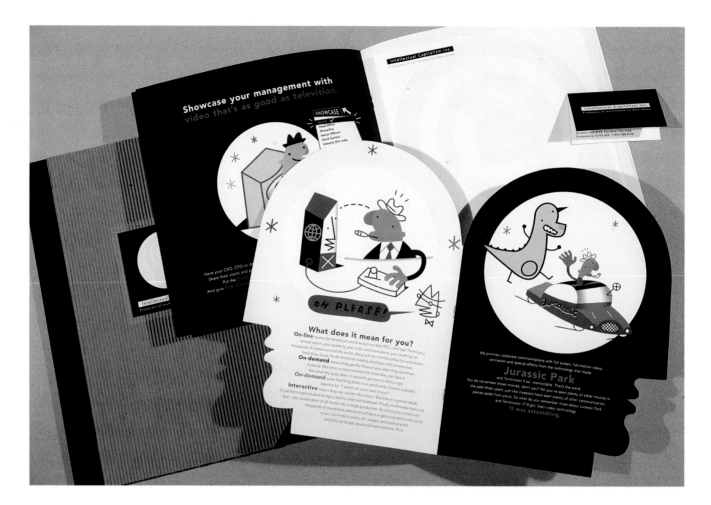

Piece is Brochure for firm offering financial services

Art Director/Studio Frank Viva/Viva Dolan Communications & Design

Designers/Studio Frank Viva, Julie Opatovsky/Viva Dolan Communication & Design

Illustrator J. Otto Seibold

Client/Service Intellectual Capitalism Inc., Toronto, Ontario, Canada/Multimedia financial information services

Paper San Remo Matte

Colors Four, process

Type Aviner

Printing Offset

Software QuarkXPress, Adobe Illustrator

Initial Print Run 5,000

Cost $65,000

Concept The high-tech, cutting-edge feel of this binder is balanced by whimsical illustrations that help explain the client's sophisticated financial information services. The sturdy binder is covered in a black book cloth with corrugated cardboard overlayed to give it a high-tech industrial feel. The company's logo—the shape of a robotic head

with a "C" circled and positioned as the brain—is attached to the cover. An inside brochure is cut out in this same shape. In laymen's terms, and with the help of comic illustrations, it explains the client's interactive, multimedia financial information services. A second brochure using the same type of illustrations targets a segment of the client's market.

Distribution of Piece The binders were sent by direct mail to various corporations.

Piece is Images for postcards and posters

Art Director/Studio Mike Salisbury/Salisbury Communications

Designer/Studio Mike Salisbury/Salisbury Communications

Photographer Mike Salisbury

Client/Service Tavarua Island Surf Co., Tavarua Island, South Pacific/Surfing resort and clothing

Paper Neenah Environment

Colors Four, process

Type Hand-lettered

Printing Offset

Initial Print Run 1,500

Cost $15,000

Concept The remoteness and native authenticity of Tavarua Island in the South Pacific inspired these designs, which were reproduced as posters and postcards. Drawing on the colors and foliage of the tropics, the leaf design communicates the serene, simple and laid-back atmosphere of the island, contrasting sharply with the razzle-dazzle of most popular surfing locations. A photo of two native women and a man defines the somewhat uninhibited, carefree culture of the island.

Special Production Technique The designs were reproduced from 35mm prints taken by Salisbury and then reshot onto Polaroid film, giving them a worn, well-traveled look.

Cost-Saving Technique Salisbury traded his design and photography services for a stay on the island.

Distribution of Piece The pieces were mailed to clients, surfers and clothing buyers.

Response to Promotion The island is sold out for two years and the clothing line has maintained brisk sales.

Gotcha

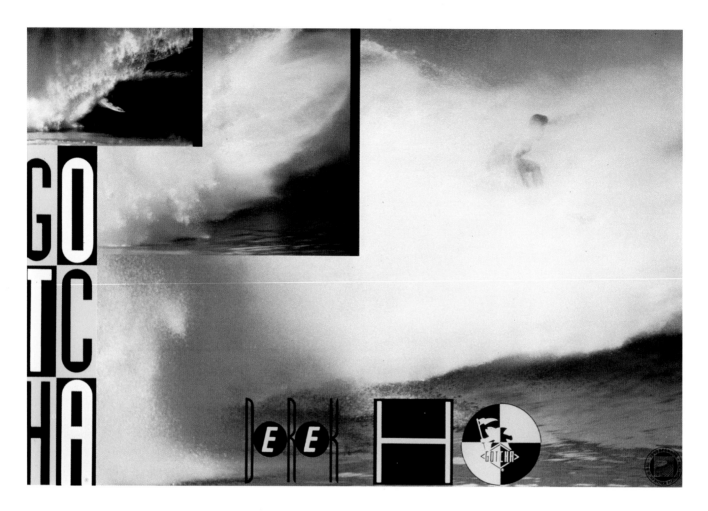

Piece is Poster and ad for Gotcha Sportswear

Art Director/Studio Mike Salisbury/Salisbury Communications

Designer/Studio Mike Salisbury/Salisbury Communications

Illustrator Brian Sisson

Client/Service Gotcha Sportswear Inc., Irvine, CA/Surfwear and other clothing

Colors Four, process

Type Hand-lettered

Printing Offset

Initial Print Run Magazine has about 100,000 circulation

Cost $25,000

Concept Unusual use of sequence photography creates action and excitement in this poster for a California retailer of surfing equipment and clothing. The designer's goal was to capture and sell the athleticism of surfing. This is achieved through a series of photos of thundering surf with surfer Derek Ho (the "Michael Jordan" of surfing) emerging successfully from its wrath. The client name is spelled out in a column of alternating black and yellow blocks along the side of the piece, which also connotes movement and energy. The same colors are used in the unusual hand-lettered treatment of the surfer's name along the bottom of the poster.

Distribution of Piece The piece ran once as a magazine ad. Posters were distributed through direct mail and at trade shows to retailers and consumers. They were also used as in-store promotions.

Response to Promotion This is one in a series of promotions Salisbury has done for Gotcha since it was founded ten years ago. The company has gone from a small operation working out of a garage to a $2 million enterprise.

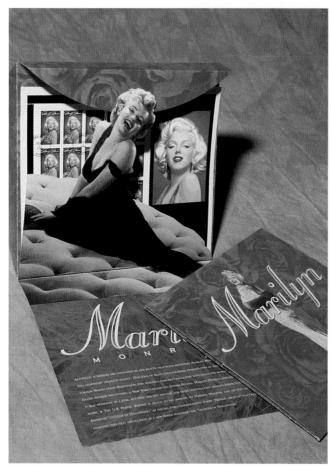

Piece is Brochure/invitations introducing new U.S. postage stamps

Art Directors/Studio Terry McCaffrey, Supon Phornirunlit, Andrew Dolan/Supon Design Group

Designers/Studio Debbi Savitt, Eddie Saibua, Anthony Fletcher, Mimi Eanes/Supon Design Group

Client/Service U.S. Postal Service, Kansas City, MO/Stamp promotions

Paper Kromekote, Environment, Benefits and various others

Colors Four, process

Printing Offset

Software Adobe Illustrator, Adobe Photoshop, QuarkXPress

Concept Introduction of new U.S. postage stamps was a fanfare event for four stamps announced by these thoughtfully designed invitations. Each stamp was introduced at its own first-day issue ceremony, and these promotions, two of which are shown here, served as the invitation for each event.

The languid motion and peaceful colors of the sea are captured in the Wonders of the Sea invitation. The word "SEA" is die-cut on the front cover and exposes a turquoise pool of water on the next page; a photo of a dolphin embossed across the "A" appears to be leaping out of the water.

The Marilyn Monroe stamp promotion has an entirely different feel. Constructed to resemble a woman's clutch purse, the piece unfolds amidst a background of pink roses and wispy feathers to expose a cutout of the star in a sexy black gown and poised atop a plush ottoman.

Each of the invitations had its respective stamps affixed, either directly on a page of the brochure or to a card insert, and cancelled with the first-day issue mark. For many, these invitations to the first-day issue ceremonies are a collector's item, even without the commemorative stamps.

Distribution of Piece The invitations were mailed to guests and were featured in direct mail catalogs that were distributed to stamp collectors.

Response to Promotion The Marilyn Monroe invitation sold approximately five hundred per hour at Planet Hollywood on the first day of issue.

Sheen Industries

Piece is Capabilities brochure
Art Director/Studio Jack Anderson/Hornall Anderson Design Works
Designers/Studio Jack Anderson, Leo Raymundo/Hornall Anderson Design Works
Illustrator Anita Lehmann
Client/Service Sheen Industries Inc., Seattle, WA/Manufacturer of leather goods
Paper Simpson Gainsborough Black (cover); Simpson EverGreen Natural White (text)
Colors Four, process
Type Gill Sans
Printing Offset
Software MacroMedia FreeHand

Concept The primary objective of this capabilities brochure was to create an introductory piece that fully illustrates the client's new patented leather-tanning process. Lehmann's colorful renderings accompanied by a simple but thorough explanation of the company's capabilities (in English, French and German), accomplishes the job. The piece consists of a black binder with the company's name embossed on a rectangular piece of leather and affixed to the front. The patent number for the new leather-tanning process is the only other element on the cover. A two-page insert features the process and the types of products it produces in an environmentally safer way. On the inside covers, a couple of the illustrations are silkscreened for a more textural effect.

Distribution of Piece The brochure was distributed to individual manufacturers of leather goods, as well as other members of the leather goods industry.

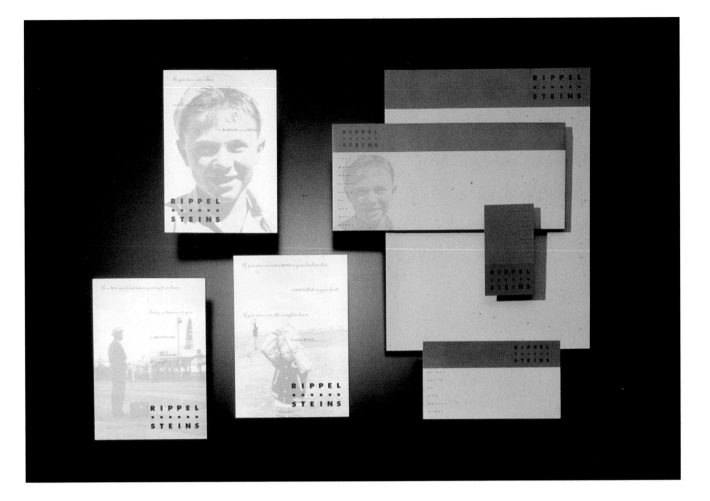

Piece is Identity program
Art Director/Studio Rick Vaughn/Vaughn Wedeen Creative
Designer/Studio Rick Vaughn/Vaughn Wedeen Creative
Photographers Donald B. Hamilton, John E. Kell
Client/Service Rippel Steins, Santa Fe, NM/Men's clothing retailer
Paper Confetti
Colors Four, match
Printing Offset
Initial Print Run 1,000

Photography of Piece David Nufer

Concept Nostalgic images from yesteryear are meant to play on the emotions of the men who shop at this upscale clothing store. Photos of a fresh-faced sailor, a young boy combing his hair and a businessman looking over an airfield, inspire thoughts of boyhood adventures and enchanting memories of growing up. The soft tones used and the thoughtful copy on childhood, adolescence and young adulthood, evoke a sense of maturity and responsibility, yet they still keep with the idea that there's a little boy in every man. Realizing that and using it as the concept for its identity successfully establishes the retailer as being in touch with its customers.

Distribution of Piece The postcards were sent regularly to select customers.

Duffens Optical

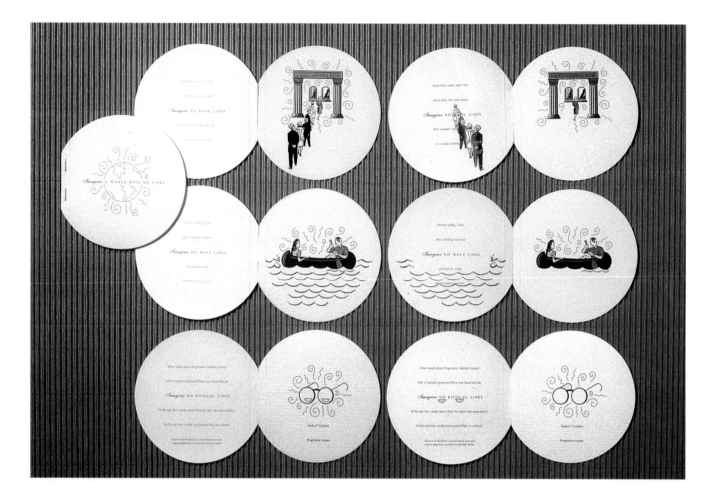

Piece is Booklet promoting no-line bifocals to optometrists

Art Director/Studio Sonia Greteman/The Greteman Group

Designers/Studio James Strange, Sonia Greteman/The Greteman Group

Client/Service Duffens Optical Inc., Topeka, KS/Bifocal lenses

Paper Carnival Groove

Colors Two, match

Type Arrow Shelly

Printing Offset

Software MacroMedia FreeHand

Initial Print Run 1,500

Cost $10,000

Concept This entertaining booklet touts the benefits of no-line bifocals to its target market of optometrists. Using as starting points the shape of the eye and the absence of lines in the client's eyeglass products, the designers constructed this round booklet and focused on the product's main selling point through parodies on lines. The tag line, "Imagine a World With No Lines," is illustrated on the cover with a drawing of a globe and squiggly lines emanating from it. On the inside pages are fun ideas on what the world would be like without lines, i.e., no bank lines, no static lines and no bifocal lines. Each suggestion is accompanied by a two-part illustration, a portion of which is printed on the adjacent page and the rest on a clear overlay. This format adds to the fun and entertainment.

Distribution of Piece The booklets were sent by direct mail to optical shops and optometrists.

Response to Promotion The piece generated a 5 percent response to its back-page offer to contact one of the company's sales offices.

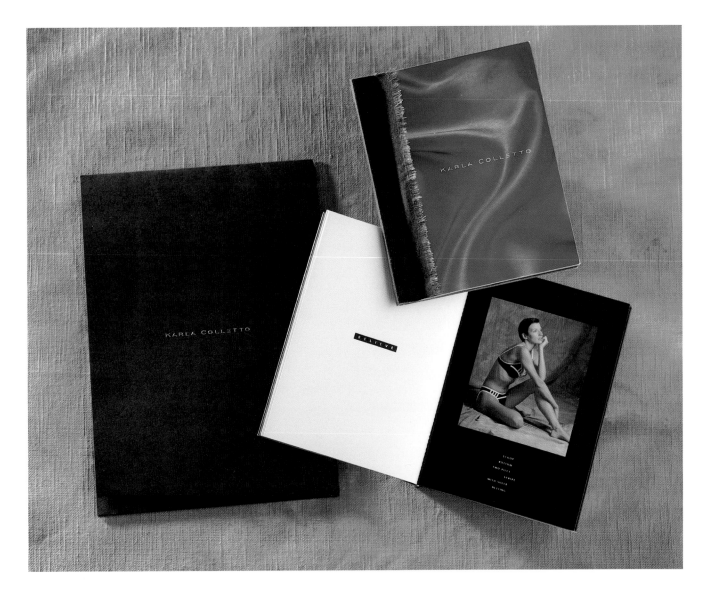

Piece is Brochure for Karla Colletto swimwear

Designers/Studio Melanie Bass, David Collins, Judy Kirpich/Grafik Communications, Ltd.

Photographers Steve Biuer (cover); Heidi Niemala (interior)

Client/Service Karla Colletto, Fairfax, VA/Swimwear

Paper Quintessence

Colors Three, match; four, process; plus a varnish

Type Hand-drawn (cover); Frutiger (interior)

Printing Offset

Software QuarkXPress, Adobe Illustrator, Adobe Photoshop

Initial Print Run 1,000

Concept The sensual and quietly elegant style of the client's swimwear inspired this equally sensual and gracefully designed showcase of her work. The 5¾" x 7" booklet contains seven full-color photos of swimsuits, each on their own spread with a single pointed word of description on the adjacent page. Warm brown, orange and gold tones used for both the model backdrops and the brochure's design, exude a classic and demure ambiance. The cover is constructed of a French gate fold featuring a photograph of layered cloth with colored light reflected on it.

Special Production Technique The brochure is hand-collated by the client and bound on the sewing machine with a piece of black cloth, giving it a handmade feel.

Distribution of Piece The brochures were distributed by direct mail.

Chronicle Books

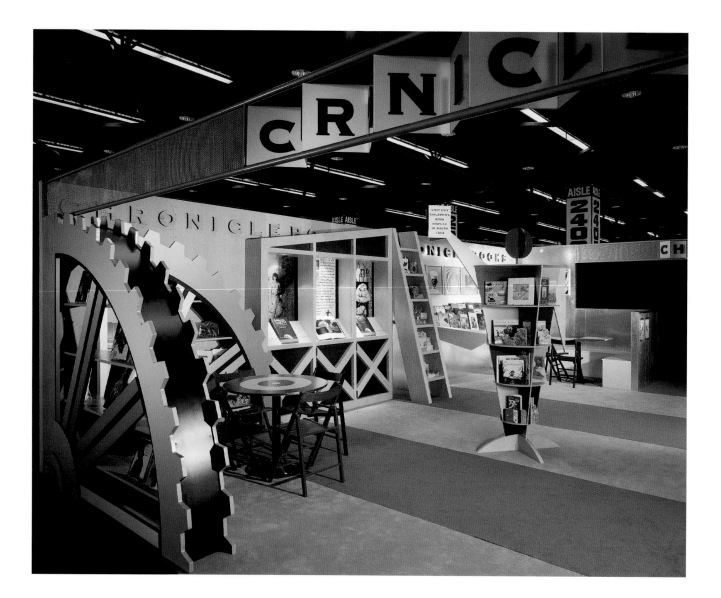

Piece is Trade show exhibit for Chronicle Books

Art Director/Studio Earl Gee/ Earl Gee Design

Designer/Studio Earl Gee/Earl Gee Design

Fabricator Barr Exhibits

Client/Service Chronicle Books, San Francisco, CA/Publisher of high-quality illustrated books

Type Copperplate 33BC

Software QuarkXPress, Adobe Illustrator

Cost $75,000

Photography of Piece Andy Caulfield

Concept Parting with traditional trade show booth configurations, the designer of this exhibit developed a unique bookstore-like environment that was both functional and alluring to trade show visitors. Functionally, the booth, which was constructed for the American Booksellers Association (ABA) show, needed face-out displays for new releases, shelves for hand-bound proofs, spine-out displays for backlist titles and three semiprivate conference areas. Ideally, the design would also support the publisher's recently launched "reading glasses" identity that signifies it as a publisher who "sees things differently." The solution was a radical departure from typical ABA booths, which feature rows of backlit light boxes of book covers. The exhibit's neutral color palette of light maple and galvanized aluminum highlights the publisher's colorful collection. Freestanding displays, including a gear, ladder, staircase and human figure, quietly personify work, progress, attainment and humanity. Unlike most booths where visitors walk either right through them or right past them, visitors here were "bouncing off" the freestanding displays and making their way through the publisher's various products.

Distribution of Piece The ABA show is held annually and attracts book publishers, sellers, editors and writers.

Response to Promotion Booth traffic and resulting book sales were up substantially from previous years. Also, the publisher noted that the design of the exhibit instilled in those who staffed the booth "a level of pride in being associated with and representing Chronicle."

Players Inc.

Piece is Media kit and invitation

Designers/Studio David Collins, Judy Kirpich/Grafik Communications, Ltd.

Illustrators David Collins, Richard Hamilton

Client/Service Players Inc., Washington, D.C./Licensing of NFL players

Paper Matrix

Colors Five—four, match, plus a varnish

Type Modified Agenley (logo); Bank Gothic (invitation)

Printing Offset

Software Adobe Illustrator, QuarkXPress

Initial Print Run 15,000

Concept This newly developed company, formed from the National Football League Players Association, sought an eye-popping, action-oriented look to raise awareness and recognition. Using the bold colors and image of the logo designed for the company, the designers created these energetic identity materials and an invitation to a Super Bowl party. The logo—a drawing of a football player in action—was enlarged and cropped dynamically for the cover of the media kit, motioning the viewer to "look in."

Distribution of Piece The kits were distributed at sports trade shows, sports conferences and through direct mailings to the sports community and media.

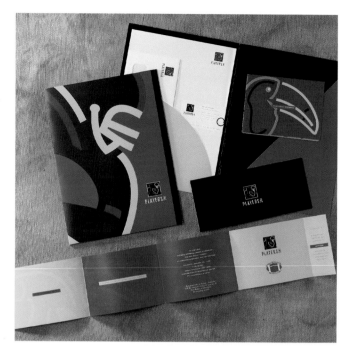

NFL Players Association

Piece is Identity materials

Designers/Studio David Collins, Melanie Bass, Gretchen East, Gregg Glaviano, Richard Hamilton, Judy Kirpich/Grafik Communications Ltd.

Illustrator Mike Benny

Client/Service National Football League Players Association, Washington, D.C./NFL players' union

Paper Matrix

Colors Four, process; one, match; plus two tint varnishes

Type Universe (modified)

Printing Offset

Software Adobe Illustrator, QuarkXPress

Initial Print Run 30,000

Concept The comaraderie and brotherhood of football is the focus of these identity materials for the NFL players' union. An illustration of a football game placed on a par-tially exposed flap of the media kit is the dominant visual element, which is repeated in various ways throughout the piece. The cover flap features the same image printed in a tint varnish on a black background and strategically positioned over the illustration so it appears as if you're looking at the game through a tinted window. The preamble from the NFLPA constitution is on the inside front cover. Behind the black folder flaps that contain press kit materials, the illustration is again printed in gold on a gold background. The repetition of the image reinforces the union's focus on its players and the teamwork involved in the union's operation.

Distribution of Piece The kits were distributed at press conferences and through direct mailings to the media, players' representatives and the players.

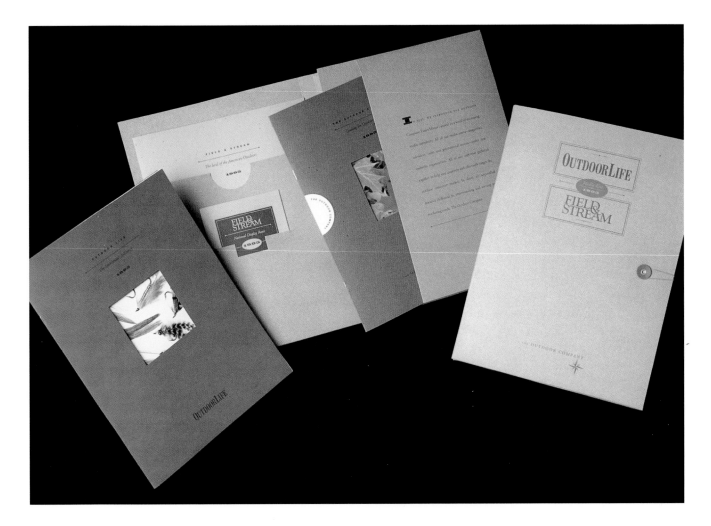

Piece is Media kit for *Field & Stream* and *Outdoor Life* magazines
Art Director/Studio Kathleen Phelps/Platinum Design
Designer/Studio Kathleen Phelps/Platinum Design
Client/Service Times Mirror Magazines, New York, NY/Publisher
Paper Neenah Buckskin (folder), Warren Lustro Recycled (interior), Fox River Confetti (brochure covers)
Colors Four, process
Type Adobe Garamond, Blackoak, Helvetica Black

Printing Offset
Software QuarkXPress, Adobe Photoshop, Adobe Illustrator
Initial Print Run 2,000

Concept Earthy tones and textures plus simple packaging connote a tranquil, outdoorsy feeling and convey the casual profile of the readership for these two magazines. Photos and images of fishing lures and leaves are natural backdrops for the understated cover designs of each brochure. The covers, which use a grainy, textured paper stock, have a square die-cut in the middle to reveal those images. Information on both magazines was packaged in a single folder to introduce a new division within the client company that joins its outdoor publications. The magazine's easily identifiable logos are on the front of the package.

Cost-Saving Technique The paper stock was efficiently utilized through gang printing.
Distribution of Piece The kits were distributed to potential advertisers by sales representatives.

US West Communications—Jazz It Up

Piece is Internal sales campaign
Art Director/Studio Steve Wedeen/Vaughn Wedeen Creative
Designers/Studio Steve Wedeen, Lucy Hitchcock, Dan Flynn/Vaughn Wedeen Creative
Illustrator Vivian Harder
Client/Service US West Communications, Phoenix, AZ/Telecommunications
Paper Lustro, Starwhite Vicksburg, Starliner
Colors Two, match; four, process
Type Coronet, Huxley
Printing Offset, Indigo
Software QuarkXPress, Macro-Media FreeHand
Initial Print Run 100
Photography of Piece David Nufer

Concept The high energy and snappy rhythms of New Orleans jazz inspired this internal sales promotion campaign. The promotion was one of a year-long series of campaigns developed to motivate the US West sales staff. The overall theme of the series— "Making Music Together"—was carried out in individual promotions like this one, in which the grand prize for outstanding sales performance was a trip to New Orleans during its renowned jazz festival. The design prominently features an illustration of a saxophone player blowing out explosive sounds from the end of his horn. Bright colors enliven the player figure and the powerful music he's creating. The image appears on all support materials, sometimes embellished with a black and tan striped pattern that resembles a piano keyboard. All materials except for the poster were packaged in the striped box.
Special Production Technique The boxes were silkscreened and feature a sticker tipped on in the middle. Some pieces were printed on an Indigo press (a plateless digital press that costs about a third of regular printing costs).

Response to Promotion Employee coaches found all materials to be exciting and innovative. A group of sales reps conducted an informal survey that indicated these materials really made a difference in their sales efforts.

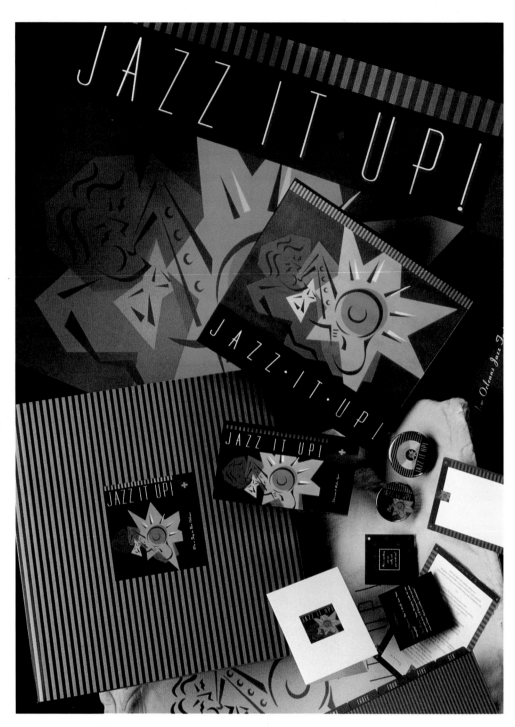

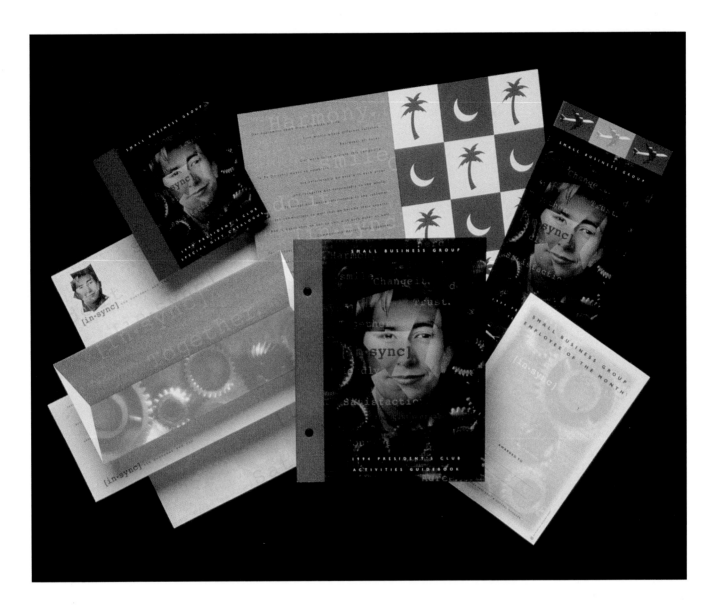

Piece is Materials for an employee recognition program
Art Director/Studio Rick Vaughn/Vaughn Wedeen Creative
Designer/Studio Rick Vaughn/Vaughn Wedeen Creative
Illustrators Rick Vaughn, Greg Tucker
Photographer Michael Barley
Client/Service US West Communications, Phoenix, AZ/Telecommunications
Paper Classic Crest
Colors Four, process
Type Courier
Printing Offset
Software QuarkXPress, Macro-

Media FreeHand, Adobe Photoshop
Initial Print Run 400
Photography of Piece David Nufer

Concept These pieces, created for US West's employee recognition program, promote the concept of teamwork and the building of better business and personal relationships. The program's theme, "In Sync," celebrates diversity and the importance of recognizing, accepting and serving the multifaceted needs of customers. This theme is represented by a face that's actually a conglomeration of parts from

many faces. Using photos scanned into the computer, the designers isolated different features and manipulated them into the image of a single face. The face is framed by an illustration of gears churning, which further suggests the importance of teamwork.
Distribution of Piece Materials were distributed by mail and in person to employees selected for the recognition program.
Cost-Saving Technique Because the quantity for the pieces was small, many items using the same colors and common paper stocks were gang printed.

Hamm's Building Trademark

Piece is Trademark/letterhead for attorney Rubin Glickman

Art Director/Studio Primo Angeli/Primo Angeli Inc.

Designer/Studio Philippe Becker/Primo Angeli Inc.

Client/Service Rubin Glickman, attorney/Legal services

Paper Corporate letterhead stock

Colors Two (black plus one match)

Type Kabel ("Bryant"); Goudy ("1550")

Printing Offset

Software Adobe Illustrator

Cost $25,000

Photography of Piece June Fouche

Concept This trademark was designed to highlight the art deco elegance of the Hamm's Building, in which the client's offices are located. The sharp, angular cubist features that characterize the 1920s and 1930s art deco style are reflected in the three-dimensional look of the building and blocklike lettering of the word "Bryant." The contrasting background design, which resembles rays of light emanating from the structure, builds on the cubist form but incorporates angles and subtle shading that are more symbolic of pure art deco style. This trademark design skillfully blends the architecture of the building with its environment, and clearly identifies the location of the client's office.

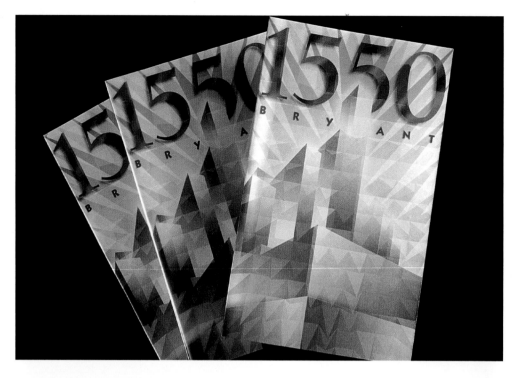

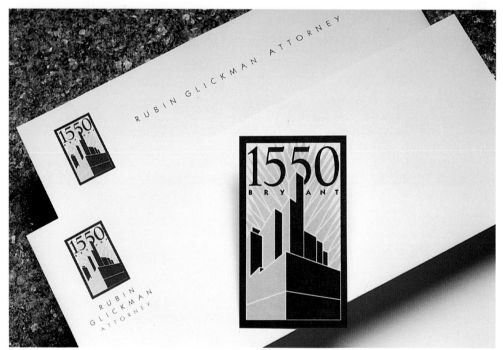

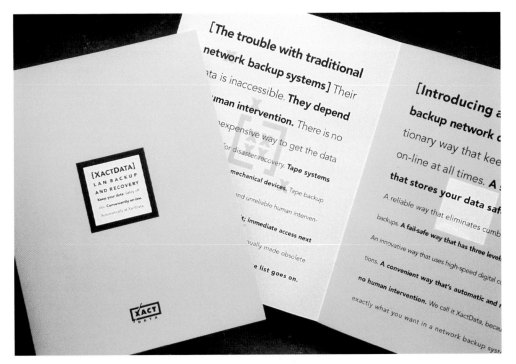

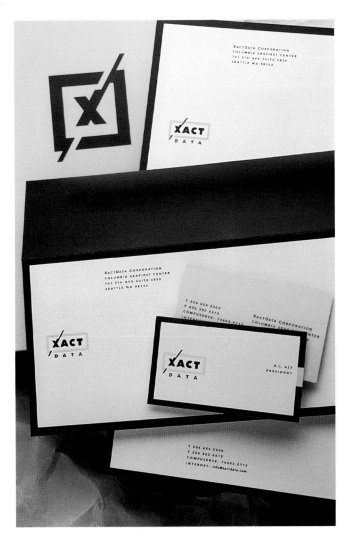

Piece is Identity program for XactData Corp.

Art Director/Studio Jack Anderson/Hornall Anderson Design Works

Designers/Studio Jack Anderson, Jana Wilson, Lisa Cerveny, Julie Keenan/Hornall Anderson Design Works

Client/Service XactData Corp., Seattle, WA/Electronic data back-up systems

Paper Strathmore Elements, Pin Stripe

Colors Two, process

Type Avenir

Printing Offset

Software QuarkXPress, Adobe Illustrator, MacroMedia FreeHand

Initial Print Run 5,000

Concept This identity program was designed to appear technical yet reader-friendly. The client wanted to convey the capabilities of its service—a backup system for computer networks—in a manner that was easy to understand. Although the client initially wanted to include full-color illustrations in its main capabilities brochure, a low budget limited the promotion to two colors. The design incorporates the company's logo—the letter *X* within a box—as an abstract representation of a system safely contained within a vault. The slash mark through the *X* breaking the border of the box illustrates the circulating movement of information into and out of the system. Different variations of the *X* in the box are used throughout the four-page brochure describing the client's services.

Distribution of Piece The brochure was distributed at trade shows and used for general sales promotion.

Entertainment Weekly

Piece is Poster
Art Director/Studio Victoria Stamm/Platinum Design
Designer/Studio Victoria Stamm/Platinum Design
Illustrator Stephen Kroninger
Client/Service *Entertainment Weekly*, New York, NY/Magazine
Paper Simpson Coronado SST Recycled
Colors Four, process
Type Template
Printing Offset
Software QuarkXPress
Initial Print Run 5,000

Concept On the surface, this poster announcing *Entertainment Weekly*'s five-year anniversary looks like it's been hanging in a New York City subway station for months. A closer look reveals its commemorative purpose. Although the designers were limited to using existing art—photos and illustrations that have appeared in the magazine and the number five—they craftily assembled the piece to reflect the pop culture focus and modern style of the magazine. Typography announcing the anniversary is placed inconspicuously as graffiti over the photos and in the areas in which the image is "torn away."

Special Visual Effect The typography was actually Xeroxed and taped to the collage to give it a worn, unaffected look.

Distribution of Piece The posters were mailed to current and potential magazine advertisers and the media.

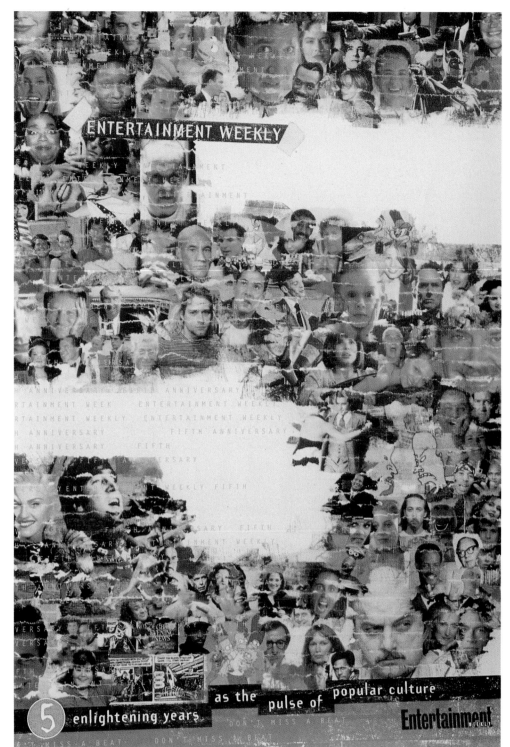

Piece is Annual report and real estate kit

Art Director/Studio Jack Anderson/Hornall Anderson Design Works

Designers/Studio Jack Anderson, Julie Lock, Mary Chin Hutchison, Jenny Woyvodich, Julie Keenan/Hornall Anderson Design Works

Illustrators Linda Frichtel (annual report); Julia LaPine (real estate kit)

Photographers Michael Baciu (annual report); Jim Fagiolo (real estate kit)

Client/Service Starbucks Coffee Co., Seattle, WA/Coffee roasters and specialty gifts

Paper French Duratone Packing Carton 145 lb.; Proterra Flecks 70 lb. Text Stucco (annual report); Colored Speckletone; EverGreen Matte Natural (real estate kit)

Colors Four, process

Type Sabon (annual report); Sabon and Reckleman (real estate kit)

Printing Offset

Software QuarkXPress, Adobe Photoshop

Concept In this annual report and accompanying real estate kit, the designers were inspired by Starbucks' belief that coffee roasting is an art form. The burnished look of the annual report cover, the warm, muted photo images of Starbucks stores, and the earthy tones of the flecked paper have an inviting, handcrafted appeal. The first twelve pages of the forty-page annual report feature four-color photos of customers at Starbucks stores and half-page inserts, highlighting a particular coffee blend.

The real estate kit contains nine inserts that detail the company's various types of retailing outlets. Each four-color brochure relies on photos of various sites accompanied by illustrations that convey the store's ambiance. For example, the urban bean stores, which are located in densely populated residential areas, feature an illustration of two socialites sitting at a table drinking coffee.

Special Visual Effect Starbucks wanted to emphasize that high quality could be achieved economically and in an environmentally safe manner. This was accomplished through the use of recycled paper and soy-based inks.

Distribution of Piece The pieces were distributed in corporate meetings to employees and shareholders.

Good Cents Environmental Home

Piece is Promotional campaign kit for home builders

Studio After Hours Creative

Photographer Art Holeman

Client/Service Good Cents Environmental Home, Atlanta, GA/Service company for home builders

Paper Multifect

Colors One, match; four, process

Type Berkeley, Gill Sans

Printing Offset

Software QuarkXPress, Adobe Illustrator

Initial Print Run 500

Cost $125,000

Concept A whole new way of constructing homes in an environmentally safe manner is the focus of this promotional campaign directed at home builders. The design of the kits unifies the basic home building tools (hammer, saw and tape measure) with elements related to the environment (water, leaves and grass) to signify a responsible relationship between the builder and the environment. This is accomplished through arresting images placed on the outside of the box and repeated on inside brochures. Additional nature photos further communicate the ease with which builders can construct an environmentally responsible home.

Cost-Saving Technique The same images and photos were used in various pieces to save costs and to unify the campaign.

Distribution of Piece The kits were distributed once through direct mail, while various brochures were sent three times.

Response to Promotion The campaign has generated close to 2,500 leads and has been recognized in a number of consumer publications.

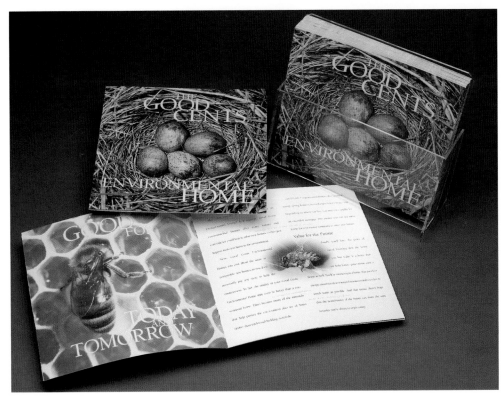

Catalyst Consulting Team

Piece is Brochure and inserts

Art Director/Studio Earl Gee/Earl Gee Design

Designers Earl Gee, Fani Chung/Earl Gee Design

Illustrator Earl Gee

Photographers Geoffrey Nelson, Lenny Lind

Client/Service Catalyst Consulting Team, Soquel, CA/Management consultants

Paper Simpson Equinox Spring Mist 80 lb. cover (brochure, folder); Simpson Equinox Spring Mist 70 lb. text (insert sheets)

Colors Four, process

Type Kunstler Script, Franklin Gothic Heavy (heads); Bembo, Rockwell Bold (text); OCRA (quotes)

Printing Offset

Software QuarkXPress, Adobe Illustrator, Adobe Photoshop

Initial Print Run 4,000

Cost $25,000

Concept This brochure portrays the client's services—organizational development and outdoor experiential learning programs—in the same systematic, scientific and dynamic manner in which the client does its consulting work. Inspired by pop-up books and die-cut greeting cards, a spiralbound format was devised for core information, with a die-cut interactive leaf shape functioning as a section of the cover and containing various inserts. The textured, uncoated paper and use of gradation softens the edges and generates a warm, approachable and more personal feeling. The systematic, scientific elements, such as chart and graph images, are integrated with outdoor photography to give a sense that amid the fun, outdoor experiences are highly organized activities that promote leadership, team-building skills and personal growth. Each spread contains a quote from an important Catalyst client.

Cost-Saving Technique The die-cut, leaf-shaped pocket allows the client to tailor their presentations with various inserts and saves them from having to reprint the entire brochure when new programs are introduced.

Distribution of Piece Mailed to potential clients.

Response to Promotion Response has been very positive, propelling Catalyst to a leadership position within their field.

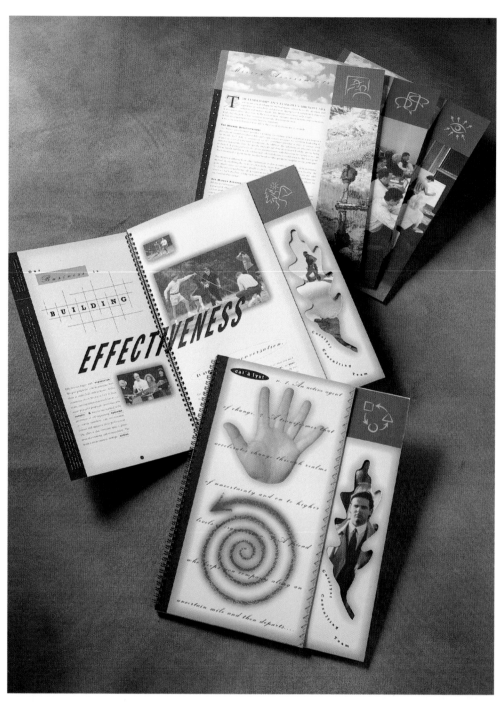

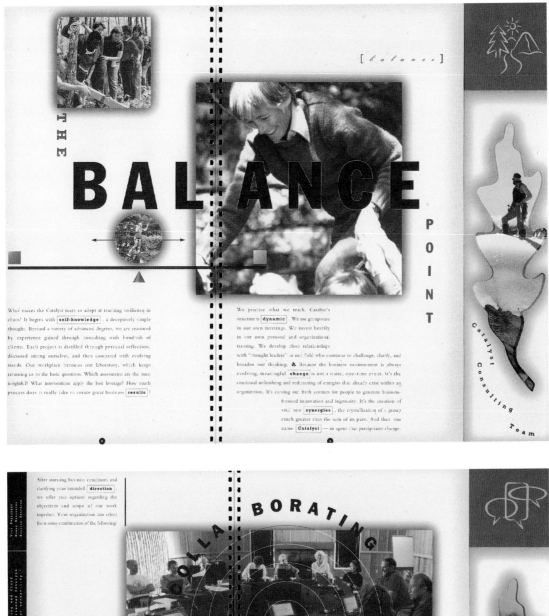

THE **BALANCE** POINT

What makes the Catalyst team so adept at teaching resilience in chaos? It begins with **self-knowledge**, a deceptively simple thought. Beyond a variety of advanced degrees, we are seasoned by experience gained through consulting with hundreds of clients. Each project is distilled through personal reflection, discussed among ourselves, and then compared with evolving trends. Our workplace becomes our laboratory, which keeps returning us to the basic questions. Which assessments are the most insightful? What interventions apply the best leverage? How much process does it really take to create great business **results**?

We practice what we teach. Catalyst's structure is **dynamic**. We use groupware in our own meetings. We invest heavily in our own personal and organizational training. We develop close relationships with "thought leaders" in our field who continue to challenge, clarify, and broaden our thinking. & Because the business environment is always evolving, meaningful **change** is not a static, one-time event. It's the continual unleashing and redirecting of energies that already exist within an organization. It's carving out fresh avenues for people to generate business-focused innovation and ingenuity. It's the creation of vital new **synergies**, the crystallization of a group much greater than the sum of its parts. And thus, our name **Catalyst** — an agent that precipitates change.

Catalyst Consulting Team

COLLABORATING FOR ACTION

After assessing business conditions and clarifying your intended **direction**, we offer you options regarding the objectives and scope of our work together. Your organization can select from some combination of the following:

Consulting Service
- Leadership and Team Development
- Vision and Strategy
- Planning for Organizational Change
- Training Curriculum

Training Programs
- Change and Transition
- Groupware Facilitation Skills
- Customer Quality Indexing
- Self-Directed Work Teams

Next, working together, we choose from a variety of theoretical models, learning methods, and approaches. All programs are **action-oriented**, based on the effective process of learning by doing. Our outdoor, experiential learning **simulations** are designed to emulate the unique business challenges facing your organization. They focus on key learnings and on **transferring** those learnings directly to the workplace. They also encourage groups to practice a fast cycle-time for learning. & Our clients come from a variety of industries which include high technology, banking, apparel, health care, insurance, government, publishing, utilities, and retail. Many have formed ongoing **relationships** with us. We travel throughout the U.S. as well as internationally to deliver our services.

Catalyst Consulting Team

Full Moon Foods

Piece is Product labeling and postcards for an organic foods market

Art Director/Studio Mark Sackett/Sackett Design Associates

Designers/Studio Mark Sackett, Wayne Sakamoto/Sackett Design Associates

Illustrator Mark Sackett

Client/Service Full Moon Foods & Mercantile, San Francisco, CA/Organic foods market and deli

Paper Potlatch Quintessence and Remarque 110 lb. cover gloss

Colors Two, match

Type Copperplate

Printing Offset

Software QuarkXPress

Initial Print Run 5,000 postcards, 8,000 business cards/product labels

Concept Promoting this start-up organic foods market on an economical basis was the goal of these materials. Using the high-quality, organic nature of the client's products as inspiration, the designers created a swirl pattern that's symbolic of how the products evolve from natural ingredients. The pattern is also suggestive of the client's name, Full Moon. The rich blue and gold colors signify quality and a classy sophistication.

Cost-Saving Technique Half of the business cards were printed blank on one side so they could double as in-store product price tags.

Distribution of Piece The postcards were handed out and placed on the store counter; the business cards were handed out and hung on products.

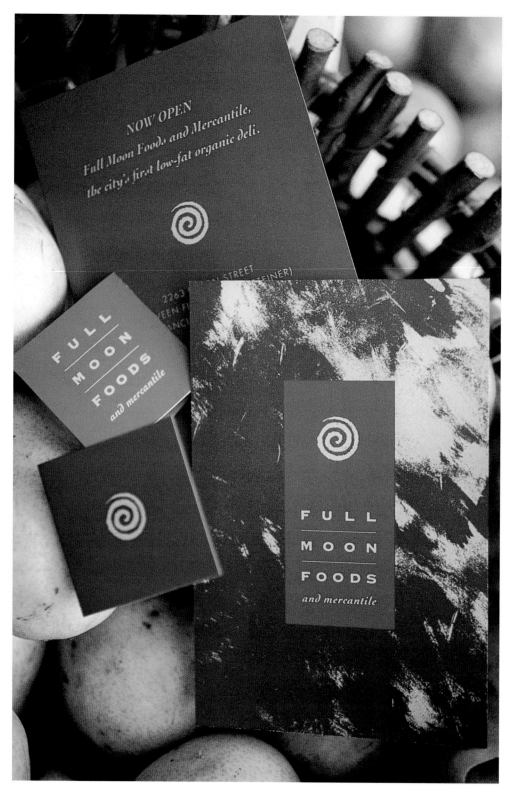

Piece is Packaging for a child's toy

Art Director/Studio Earl Gee/Earl Gee Design

Designer/Studio Earl Gee/Earl Gee Design

Illustrator Earl Gee

Photographer Sandra Frank

Client/Service Imaginarium, Walnut Creek, CA/Retail toy chain

Paper E-flute corrugated cardboard

Colors Four, process

Type Univers 85, 75, 65, 55 (logotype); Univers 85 (body text)

Printing Offset

Software QuarkXPress, Adobe Illustrator, Adobe Photoshop

Initial Print Run 5,000

Cost $9,000

Photography of Piece Kirk Amyx

Concept To establish a presence for the client's own line of toys in the Imaginarium stores, the designer created this playful, eye-catching packaging that emphasizes the interplay between the child and the toy. Both are incorporated into the product logotype, which is placed over a bright starburst that conveys a childlike energy and vitality. The movement, rhythm and energy of the product is captured in the clever use of various typeface sizes and weights that actually appear to be "hopping" on the package. The box's multicolored panels and checkerboard base provide a colorful family look for the product brand, while offering a multitude of display options.

Distribution of Piece The products appear on retail shelves in Imaginarium stores.

Response to Promotion Store personnel report brisk sales.

Museum of Junk

Piece is Identity program for a retail store

Art Director/Studio Supon Phornirunlit/Supon Design Group

Designer/Studio Steve Morris/Supon Design Group

Illustrators Steve Morris, Greg DeSantis

Client/Service Museum of Junk, Singapore/Retailer

Paper Speckletone Natural (letterhead); MOE Gloss (poster); Kraft Speckletone (tag and bag)

Colors Four, process

Type Baskerville

Printing Offset

Software Adobe Illustrator, Adobe Photoshop, QuarkXPress

Initial Print Run From 500 to 10,000, depending on the piece

Cost $28,000

Photography of Pieces Oi Jakrarat Veerasarn

Concept One person's junk is another person's treasure—and that's what the designers of these identity pieces sought to convey. The museumlike setting of the retailer's newly opened store set the stage for the design of collateral marketing and promotional materials. To communicate the nostalgic value of the gift items and collectibles sold in the client's store, a logo was developed that combines images of time, classic architecture and graceful craftsmanship. The Speckletone papers used for letterhead, gift bags and tags lends a time-honored antique feel to the pieces. Other merchandising components, like the airplane and robot posters, feature contemporary illustrations that provide a smart contrast to the antique look and further accentuate the mix of items sold in the store.

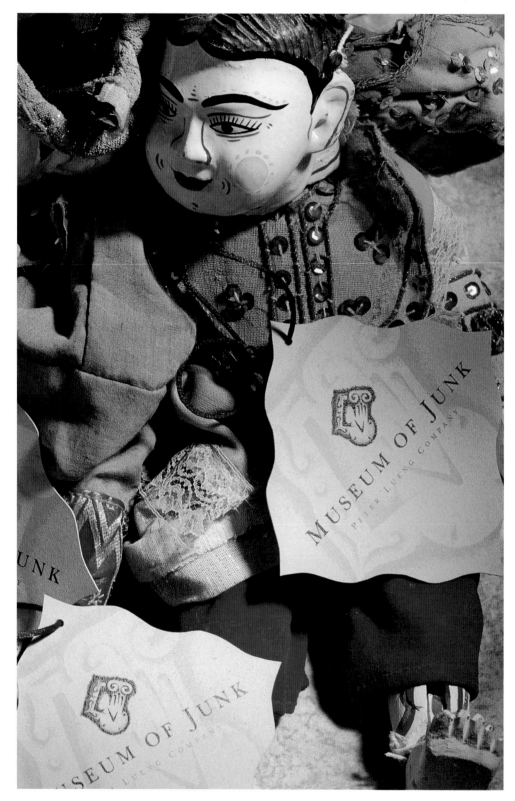

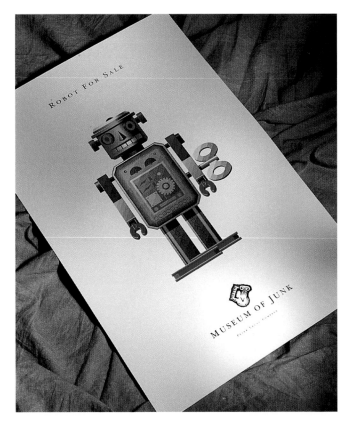

Capons Rotisserie Chicken

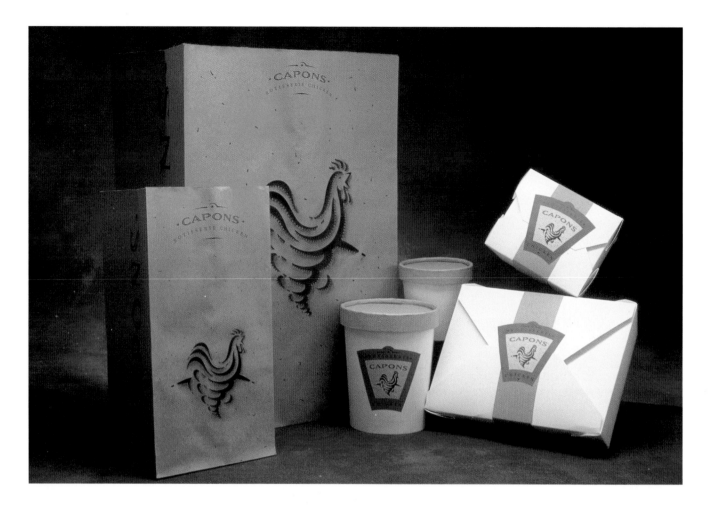

Piece is Identity program for a restaurant

Art Director/Studio Jack Anderson/Hornall Anderson Design Works

Designers/Studio Jack Anderson, David Bates, Cliff Chung/Hornall Anderson Design Works

Illustrators David Bates, George Tanagi

Client/Service Capons Rotisserie Chicken restaurant, Seattle, WA/Rotisserie chicken take-out restaurant

Paper Classic Laid Writing (stationery); laser-compatible Peppered Bronze (supporting materials)

Colors Three, match

Type Goudy, hand-customized

Printing Offset

Concept This identity program lends an upscale, high-quality image to the client's chain of take-out restaurants. The rotisserie style of cooking chicken and its availability on a take-out basis from quaint neighborhood stores inspired the design. Use of a spinning tornado design as the chicken's body depicts the quick, convenient take-out format of the restaurants. The zigzag edge of the stationery program is intended to represent the paper bags in which carryout food is normally packaged. Warm, full-bleed colors on the back of the stationery and packaging components further supports the chain's image; many of these elements are extended to signage as well.

Special Production Technique To emphasize the client's concern for the environment, recycled paper was used for the stationery components and packaging.

Response to Promotion The client has received positive feedback from customers and the studio has been recognized for the identity program by *PRINT*, Rockport Publishers, North American Corporate Design Review and others.

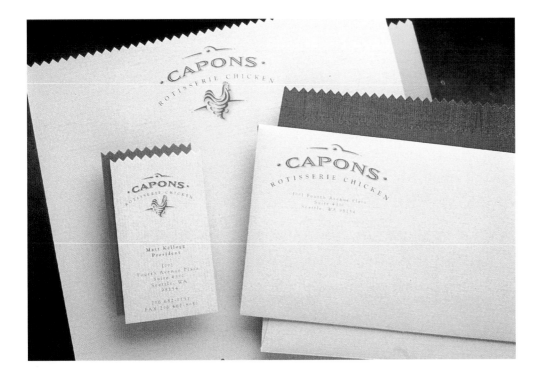

Ferris & Roberts

Piece is Brand design for a line of herbal teas

Art Directors/Studio Primo Angeli, Ron Hoffman/Primo Angeli Inc.

Designers/Studio Mark Jones, Jenny Baker/Primo Angeli Inc.

Illustrator Liz Wheaton

Client/Service Gourm-E-Co. Imports, Sterling, VA/Import/export

Paper High-gloss enamel-coated black bag with see-through window

Colors Four, process; two, match

Type Copperplate (logo); Times

Roman (other)

Printing Offset

Software Adobe Illustrator, Adobe Photoshop

Initial Print Run 15,000

Cost $10,000

Photography of Piece June Fouche

Concept This project included naming a line of herbal teas imported from England, then creating a brand design and packaging design. The age-old English tradi-

tion of drinking tea is emphasized in the logo, which features a crown on the ampersand in the product name. Brightly colored illustrations of the tea's flavors add an exotic spin to the label design, and also serve to tease the buyer's sense of taste and smell. The labels were produced in a single press run and then hand-applied to a basic black stock item bag with a see-through window that further entices the buyer to interact with the product.

Piece is Sales promotion for an advertising agency
Art Directors/Studio Sonia Greteman, James Strange/Greteman Group
Designer/Studio James Strange/Greteman Group
Illustrator Bill Gardner
Client/Service Menefee & Partners, Wichita, KS/Advertising agency
Papers Speckletone, White Beach
Colors Two
Type Berkley Book

Printing Offset
Software MacroMedia FreeHand
Initial Print Run 500
Cost $20,000

Concept To promote a company sales trip to San Francisco, the designer of these pieces relied on the region's wine-growing history and rich, natural beauty to lure customers and employees. The three-part invitation included a bottle of wine, a video highlighting the upcoming trip and an itinerary notebook that had space for notes and photos. The premade wine boxes feature designs suggestive of the region, such as a director and movie camera representing the area's film-making history, and a corkscrew indicative of the many renowned vineyards. Rich, dark olors were used on the printed pieces, and a simple wavy pattern along the sides represents the peaceful beauty of the Pacific coastline. The logo illustration of a tree that's native to the area

overlooking the beach, further promotes the provocative locale.
Cost-Saving Technique Two-color printing helped keep a lid on costs. The boxes were premade with the designs then burnt into the wood.
Distribution of Piece The invitations were mailed or handdelivered to customers and employees. They received one invitation/gift a month for three consecutive months.
Response to Promotion The trip had a high attendance rate.

MGM

Piece is Promotional book for a movie

Art Director/Studio Mike Salisbury/Salisbury Communications Inc.

Designers/Studio Mike Salisbury, Patrick O'Neal/Salisbury Communications Inc.

Photographers Joel D. Warren, Mike Salisbury, Bruce Birmelew

Client/Service MGM, Hollywood, CA/Motion pictures

Paper Neenah Environment

Colors Four, process

Type Bodoni, Helvetica, Gill Sans

Printing Offset

Software Aldus PageMaker

Initial Print Run 5,000

Cost $100,000

Concept Dramatic photo stills from the action/exploitation movie, "Blown Away," are the focus of this eighty-page promotional booklet. Traditionally, books like these follow humdrum documentary formats that simply detail with wordy copy and untouched photo stills how the movie was made. Salisbury chose to part with tradition by developing an exciting portrayal that looks more like an art and photography book rather than a promotion for a movie. Colorized (and otherwise enhanced) stills combine with haunting and intriguing black-and-white photos to dominate the design. Graphic typography helps sustain the energy and action theme of the movie but does not overpower the photos.

Special Visual Effect Salisbury rented an empty warehouse where he presented the layouts to the client. The spreads were hung on white walls so that the whole scene looked like a showing at an art gallery.

Distribution of Piece The booklets were mailed or hand-delivered to the press and movie distributors.

Response to Promotion The movie opened and generated close to $20 million in revenues.

GE/GNA Capital Assurance

Piece is Promotional kit for a financial services firm

Art Director/Studio John Hornall/Hornall Anderson Design Works

Designers/Studio John Hornall, Lisa Cerveny, Suzanne Haddon/ Hornall Anderson Design Works

Client/Service GE/GNA Capital Assurance, Seattle, WA/Annuities and insurance

Paper Carnival Purple, Thai Paper; Mica Slate; French Durotone Goldenrod; Mohawk Superfine Text

Colors Five, match

Type New Baskerville, Univers Condensed

Printing Offset

Software QuarkXPress, Macro-Media FreeHand

Concept Positioning the client as a service-oriented, premium financial services provider demanded a marketing tool that would be convincing to brokerage agencies. The resulting piece utilizes a tactile, three-dimensional format to highlight the client's reliable and personable service to agencies. The primary piece of the promotional kit is simply a box containing a brochure. The item that makes the package stand out is the clear acrylic cube inserted into the die-cut square in the center of the brochure. This cube, which can be kept and used as a desk ornament or paper weight, contains a "magic eye" image with the GE logo, tying in with the company's current advertising campaign. The attention to detail that's obvious in this piece, as well as the solidness of the cube, reflect the client's image as a provider of high-quality products and reliable service.

Distribution of Piece The promotional kit was distributed to a select group of brokerage general agencies.

Piece is Brochure aimed at potential investors

Art Director/Studio Gregg Glaviano/Grafik Communications, Ltd.

Designers/Studio Gregg Glaviano, Lynn Umemoto/Grafik Communications, Ltd.

Client/Service International Finance Corp., Washington, D.C./Investing

Paper Hopper Cardigan Fleece, Text and Cover

Colors Two, match

Type Copperplate, Garamond

Printing Offset

Software QuarkXPress

Initial Print Run 6,000

Concept A clean, organized design that utilizes lots of white space, photos and maps, provides good balance in this copy-intensive investment brochure. As a marketing tool aimed at potential investors in Russia's Volga region, the twenty-four-page brochure had to thoroughly explain the area's economic strengths and investment opportunities. Photos of business and industry, as well as maps of the region, provide a necessary break

from the text but are screened so as not to distract the reader from absorbing the information provided.

Special Visual Effect A light, overall screen was used on the last nine pages to set apart the fact section from the essay section. It gives the appearance of having two different papers in the book.

Distribution of Piece The brochures were distributed by hand to potential investors.

Response to Promotion The client reports that it has surpassed its goal for investors.

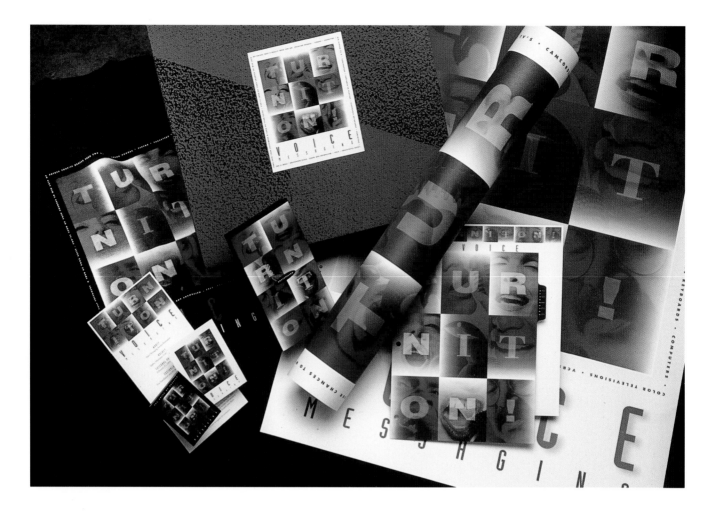

Piece is Internal sales campaign

Art Director/Studio Steve Wedeen/Vaughn Wedeen Creative

Designer/Studio Dan Flynn/Vaughn Wedeen Creative

Photographer Valarie Santagto

Client/Service US West Communications, Phoenix, AZ/Telecommunications

Paper Simpson, Monadnock

Colors Four, process

Type Futura Bold and Extra Bold, Industria, Garamond 3

Printing Offset, Indigo, Silkscreen

Software Adobe Photoshop, QuarkXPress

Initial Print Run 100

Photography of Piece David Nufer

Concept Like the "Jazz It Up" promotion featured on page 110, this is another Vaughn Wedeen project done as a part of US West's year-long series of internal sales campaigns themed, "Making Music Together." In keeping with the overall theme, this promotion is entitled "Turn It On," and is designed to generate sales for a voice messaging system. The challenge was to visually "show" a voice. This was accomplished by using photos of singers belting out a song. The photos are gradated to imply voice intonation and various pitches. The concept not only ties in with the voice messaging product but also supports the overall musical theme.

Distribution of Piece The materials were distributed internally to sales people.

Response to Promotion A group of sales reps conducted an informal survey that indicated these materials really made a difference in their sales efforts.

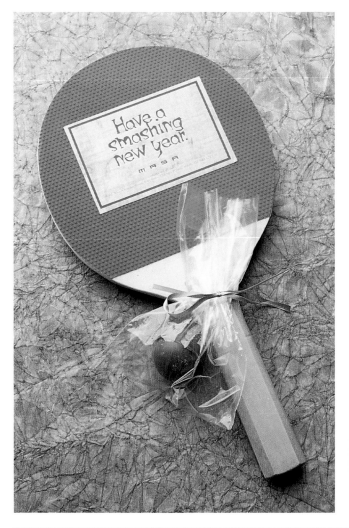

Piece is Holiday greeting
Art Director/Studio Carlos Segura/Segura Inc.
Designer/Studio Carlos Segura/Segura Inc.
Client/Service MRSA Architects and Planners, Chicago, IL/ Architectural design
Paper Fasson Crack-N-Peel
Colors One, match
Type FreeBe
Printing Offset
Software QuarkXPress
Initial Print Run 200
Photography of Piece Greg Heck

Concept A brand new box of table tennis paddles left lying in an alley by the client's house inspired this amusing New Year's gift promotion. The "Smashing New Year" wish is printed on a stock resembling blueprint paper—appropriately so for an architectural firm. White chocolate balls (only dark chocolate was around when this photo was taken) were then packaged in a plastic bag to look like table tennis balls and tied to the paddle with a blue ribbon.

Distribution of Piece The paddles were sent by mail to clients.

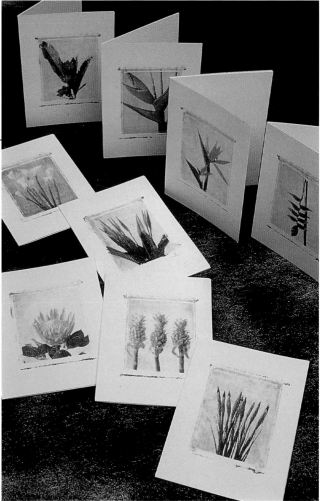

Metal Studio Inc.

Piece is Greeting cards
Art Director/Studio Peat Jariya/Metal Studio Inc.
Designers Peat Jariya, Scott Head/Metal Studio Inc.
Photographer Terry Asker Photography
Client/Service Metal Studio Inc., Houston, TX/Product and graphic design
Paper Strathmore
Colors Four, process
Printing Offset
Software Aldus PageMaker
Initial Print Run 1,500

Concept Unconventional floral designs set these greeting cards apart from the rows of others on retailers' shelves. The soft, muted shades and graceful movement of the flowers captured in each design conveys a peaceful tranquility and serenity. The cards are blank inside so they are suitable for sending on any occasion.

Special Production Technique Each flower was photographed with a Polaroid camera. The print was contacted directly on the Strathmore paper and then enhanced with a muted background shade and framing. From that, a high-resolution full-color separation was made for mass production of the cards.

Jones Intercable

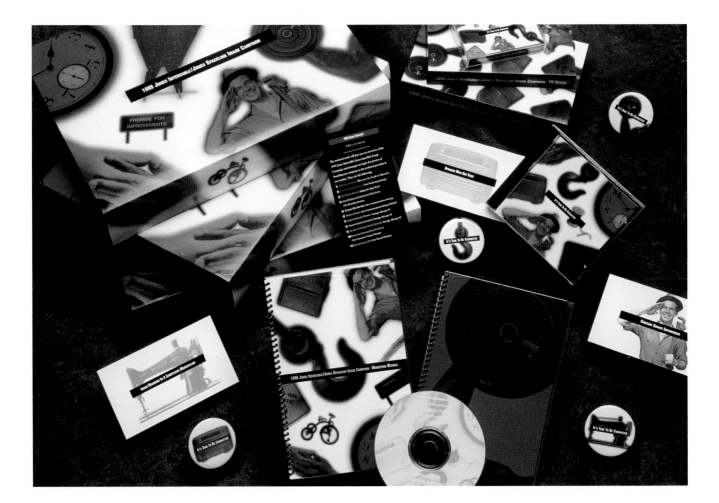

Piece is Manager's kit
Art Directors/Studio Steve Wedeen, Dan Flynn/Vaughn Wedeen Creative
Designer/Studio Dan Flynn/Vaughn Wedeen Creative
Photographers Dan Sidor, David Nufer
Client/Service Jones Intercable Inc., Englewood, CO/Cable television
Paper Champion
Colors Four, process
Type Helvetica, Inserat, Sabon
Printing Offset, Indigo
Software Adobe Photoshop, QuarkXPress
Initial Print Run 100
Photography of Piece David Nufer

Concept This kit was designed to inform the cable company's franchisees about the upcoming year's advertising campaign. Bright, bold colors and images that emphasize quality service and a customer focus anchor the design and bolster the theme of "It's Time to be Connected." Illustrations of things like a clock, a service man and a cable hook further support the theme. The kit contains video cassettes with commercial spots, a marketing strategy manual, a T-shirt and other collateral materials like buttons and management "tip" cards.

Cost-Saving Technique Much of the four-color process printing was done on an Indigo printing press, which costs about a third of the price of regular presses. Also, the kits were hand-assembled in-house.

Distribution of Piece The kits were mailed to Jones Intercable franchises.

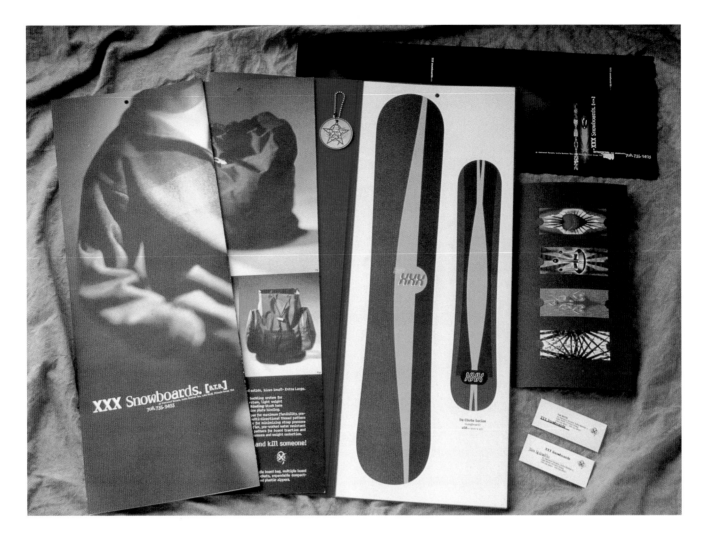

Piece is Brochure announcing a new line of snowboarding products

Art Director/Studio Carlos Segura/Segura Inc.

Designer/Studio Carlos Segura/Segura Inc.

Illustrators Tony Klassen, Carlos Segura

Photographer Jeff Sciortino

Client/Product XXX Snowboards [B.T.B.], Lake Bluff, IL/Snowboards

Paper Mohawk Ultrafelt, Confetti

Colors Four, process

Type Amplifier

Printing Offset

Software QuarkXPress, Adobe Photoshop, Adobe Illustrator

Initial Print Run 1,500

Concept Recipients of this piece probably thought they were getting a real snowboard in the mail. This oversized folder (with poster inserts) was developed to announce the launch of a line of new snowboarding products. The folders, done in various deep, rich shades like this red one, measure 35" x 23" and are folded three times to a finished size of 8¾" x 23". A hole is punched at the top for a metal key chain bearing the company logo. Also attached to the folder is a panel that folds out to display four business cards with various snowboard designs reproduced on one side and company contacts on the other. Four poster inserts, measuring roughly the same size as the folder, feature various snowboard designs as well as ancillary products like ski wax, ski wear and backpacks.

Distribution of Piece The brochures were mailed and handed out at trade shows to customers and buyers.

Rough

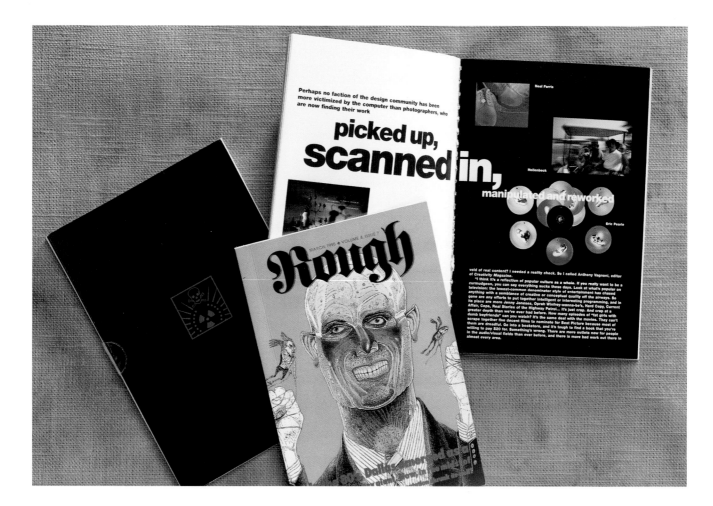

Piece is Issue of *Rough* magazine

Art Directors/Studio Todd Hart, Shawn Freeman, Jo Ortiz, Elizabeth Malakoff/Focus 2

Designers/Studio Todd Hart, Shawn Freeman, Jo Ortiz, Elizabeth Malakoff/Focus 2

Illustrators Todd Hart, Shawn Freeman, Jo Ortiz, Elizabeth Malakoff/Focus 2

Photographers Phil Hollenbeck, Shawn Freeman, Todd Hart

Client/Service Dallas Society of Visual Communications, Dallas, TX/Creative association

Paper Elloquence Silk

Colors Two, match; four, process

Printing Offset

Software Quark XPress, Adobe Illustrator, Adobe Photoshop, MacroMedia FreeHand

Initial Print Run 1,500

Cost All services and materials donated

Concept *Rough* is a monthly publication of the Dallas Society of Visual Communications. Each issue is designed (on a volunteer basis) by a different design studio member. For this issue, the designer created a pocket-size book (4" x 6") whose cover story is on the evolu-

tion of design, illustration and photography in the Dallas area. Examples from local studios of the styles that have emerged over the last fifteen years are featured inside. The cover design—a skeletal designer with his hands being tied—casts an eerie shadow over the topic, insinuating that the technology of the last decade is victimizing the profession and art of graphic design. The magazine was packaged in a small black envelope with an illustration of a skull and crossbones sitting atop an icon that represents technology.

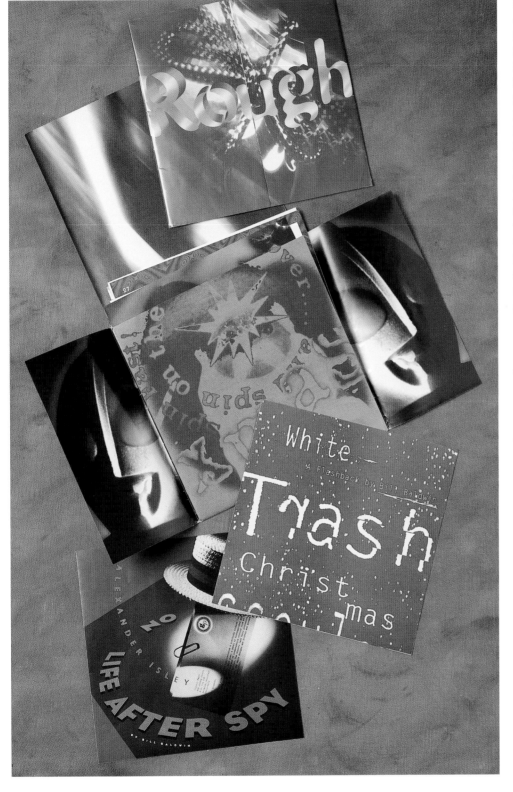

Piece is Issue of *Rough* magazine
Art Directors/Studio Todd Hart, Shawn Freeman, Jo Ortiz, Elizabeth Malakoff/Focus 2
Designers/Studio Todd Hart, Shawn Freeman, Jo Ortiz, Elizabeth Malakoff/Focus 2
Illustrators Todd Hart, Shawn Freeman, Jo Ortiz, Elizabeth Malakoff, Paul Corrigan
Photographers Shawn Freeman, Todd Hart, Phil Hollenbeck, Lisa Means, Eric Pearle
Client/Service Dallas Society of Visual Communications, Dallas, TX/Creative association
Paper Repap
Colors Four, match
Printing Offset
Software Quark XPress, Adobe Illustrator, Adobe Photoshop, MacroMedia FreeHand
Initial Print Run 1,500
Cost All services and materials donated

Concept For this holiday issue of *Rough,* the designers went all out to appeal to a tough audience of creative types. They used a completely unconventional format, in which four cover panels unfold like a box to reveal seven inserts that are actually the articles contained in the issue. The finished size (and shape) of each is about the same as a record album. Each of the inserts features a different offbeat but engaging design. Somber colors are used to unify the various pieces, and are brought to life through unusual patterns, contemporary design and special photo treatments.
Distribution of Piece The magazines were mailed to DSVC members.

Rough

Piece is Issue of *Rough* magazine
Art Director/Studio Scott Ray/Peterson & Company
Designers/Studio Scott Ray, Jan Wilson, Dave Eliason, Nhan Pham, Bryan Peterson/Peterson & Company
Illustrators Keith Graves, Aletha Reppel
Photographers John Wong, Phil Hollenbeck, Dick Patrick
Client/Service Dallas Society of Visual Communications, Dallas, TX/Creative association
Paper LOE Dull Cream
Colors Four, process (cover); two, match, plus black (inside)
Type Univers, Bank Gothic, Futura
Printing Offset
Software Quark XPress, Adobe Photoshop, Paint Box Illustrator
Initial Print Run 3,500
Cost All services and materials donated

Concept An oversized 11" x 14" format and a bevy of unusual spread designs mark the creative muscle being flexed for this issue of *Rough*. The cover design is a whimsical illustration of Dutch Kepler, a well-known design instructor at the University of Southwestern Louisiana in Lafayette; his interview with the magazine is the feature story. Kepler is referred to as a big fish in the little pond of Lafayette, which explains the exaggerated proportions of the cover illustration. Duotones and other enhanced photos highlight each inside spread as does unconventional typographic treatment of the table of contents and inside back cover.
Cost-Saving Technique Alternating (and combining) the two colors used inside of the magazine made it appear as if several more colors were used.
Distribution of Piece The magazines were mailed to DSVC members.

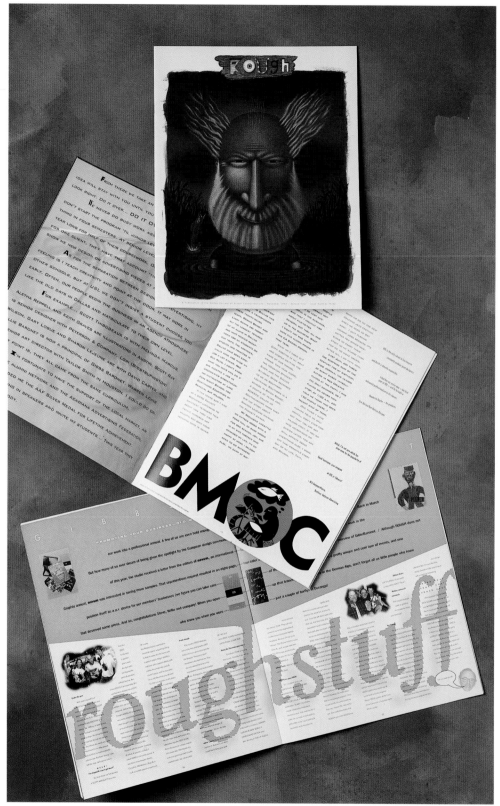

Piece is Issue of *Rough* magazine
Art Director/Studio Jan Wilson/
Peterson & Company
Designers/Studio Jan Wilson,
Dave Eliason, Nhan Pham, Bryan L.
Peterson/Peterson & Company
Photographers Holly Kuper, Phil
Hollenbeck, Dick Patrick
Client/Service Dallas Society of
Visual Communications, Dallas,
TX/Creative association
Paper Hopper Proterra Fleck
Colors Two, match; four, process
Type Cheltenham
Printing Offset
Software QuarkXPress, Adobe
Illustrator
Initial Print Run 3,000
Cost $26,000

Concept Peterson approached
this project as a chance to design
something without the usual client
restrictions. Using an extra-over-
sized 12½" x 18" format gave the
designers a lot of space to work
with in communicating club news
and upcoming events. The maga-
zine looks more like an artist's
poster or print book. The cover
story is on local designers who've
recently become parents. Photos of
the young families are featured on
the inside. The use of white space
and boxed copy throughout unifies
the issue.
Cost-Saving Technique Printing
was donated by Color Dynamics
and the film was donated by
Espinosa Color.
Distribution of Piece The
magazines were mailed to DSVC
members.

Copyright notices

P. 9 © Canary Studios
P. 10 © Grafik Communications, Ltd.
P. 11 © Tim Girvin Design, Inc.
P. 12 © Vaughn Wedeen Creative Inc.
P. 13 © Alexander Isley Design
P. 14 © Curry Design
P. 15 © The Riordon Design Group Inc.
P. 16 © The Pushpin Group, Inc.
P. 17 © Mike Salisbury Communications Inc.
P. 18 © Sam Smidt Studio
P. 19 © Tollner Design Group
P. 20 © White Design, Inc.
P. 20 © Platinum Design, Inc.
P. 21 © Evenson Design Group
P. 22 © Vrontikis Design Office
P. 23 © Modern Dog
P. 24 © Mires Design, Inc.
P. 25 © Mires Design, Inc.
P. 27 © Primo Angeli Inc.
P. 28 © Sayles Graphic Design
P. 29 © Sayles Graphic Design
P. 30 © Pressley Jacobs Design Inc.
P. 31 © Evenson Design Group
P. 32 © After Hours Creative
P. 33 © Grafik Communications, Ltd.
P. 34 © Primo Angeli Inc.
P. 35 © Primo Angeli Inc.
P. 36 © Segura Inc.
P. 37 © Pangborn Design, Ltd.
P. 38 © The Greteman Group
P. 39 © Phoenix Creative
P. 40 © Mike Quon Design Office
P. 41 © Platinum Design, Inc.
P. 42 © Segura Inc.
P. 43 © Lambert Design Studio
P. 45 © The Kuester Group
P. 46 © Curry Design
P. 47 © The Kuester Group
P. 48 © Monadnock Paper Mills, Inc.
P. 49 © The Kuester Group
P. 50 © The Kuester Group
P. 51 © Hal Apple Design
P. 52 © The Kuester Group
P. 53 © Pressley Jacobs Design Inc.
P. 54 © Wood-Brod Design
P. 55 © Wood-Brod Design
P. 56 © The Greteman Group
P. 57 © The Kuester Group
P. 58 © Viva Dolan

Communications & Design
P. 59 © Viva Dolan Communications & Design
P. 60 © Sayles Graphic Design
P. 61 © Sayles Graphic Design
P. 62 © After Hours Creative
P. 64 © TeamDesign
P. 65 © KINETIK Communication Graphics
P. 66 © KINETIK Communication Graphics
P. 67 © Segura Inc.
P. 68 © Morrison Design & Advertising
P. 69 © Pressley Jacobs Design Inc.
P. 70 © I & Company
P. 71 © Maverick Art Tribe
P. 72 © THARP DID IT
P. 73 © KINETIK Communication Graphics
P. 74 © DogStar Design
P. 75 © Phoenix Creative
P. 76 © Focus 2
P. 77 © After Hours Creative
P. 78 © Ultimo Inc.
P. 79 © Segura Inc.
P. 81 © Masi Graphica
P. 82 © Mires Design, Inc.
P. 83 © Mires Design, Inc.
P. 84 © Jock McDonald Photography
P. 85 © Jock McDonald Photography
P. 86 © Grafik Communications, Ltd.
P. 87 © White Design, Inc.
P. 88 © Scott Hull Associates
P. 89 © Scott Hull Associates
P. 90 © Scott Hull Associates
P. 92 © Earl Gee Design
P. 93 © Studio Wilks
P. 94 © TeamDesign
P. 95 © Sackett Design
P. 96 © Hornall Anderson Design Works
P. 97 © Hornall Anderson Design Works
P. 98 © Viva Dolan Communications & Design
P. 99 © Mike Salisbury Communications Inc.
P. 100 © Mike Salisbury Communications Inc.
P. 101 © Supon Design Group
P. 102 © Hornall Anderson Design

Works
P. 103 © Vaughn Wedeen Creative Inc.
P. 104 © The Greteman Group
P. 105 © Grafik Communications, Ltd.
P. 106 © Earl Gee Design
P. 107 © Earl Gee Design
P. 108 © Grafik Communications, Ltd. (both)
P. 109 © Platinum Design, Inc.
P. 110 © Vaughn Wedeen Creative Inc.
P. 111 © Vaughn Wedeen Creative Inc.
P. 112 © Primo Angeli Inc.
P. 113 © Hornall Anderson Design Works
P. 114 © Platinum Design, Inc.
P. 115 © Hornall Anderson Design Works
P. 116 © After Hours Creative
P. 117 © After Hours Creative
P. 118 © Earl Gee Design
P. 119 © Earl Gee Design
P. 120 © Sackett Design
P. 121 © Earl Gee Design
P. 122 © Supon Design Group
P. 123 © Supon Design Group
P. 124 © Hornall Anderson Design Works
P. 125 © Hornall Anderson Design Works
P. 126 © Primo Angeli Inc.
P. 127 © The Greteman Group
P. 128 © Mike Salisbury Communications Inc.
P. 129 © Mike Salisbury Communications Inc.
P. 130 © Hornall Anderson Design Works
P. 131 © Grafik Communications, Ltd.
P. 132 © Vaughn Wedeen Creative Inc.
P. 133 © Segura Inc.
P. 133 © Metal Studio Inc.
P. 134 © Vaughn Wedeen Creative Inc.
P. 135 © Segura Inc.
P. 136 © Focus 2
P. 137 © Focus 2
P. 138 © Peterson & Company
P. 139 © Peterson & Company

Only the names and addresses of individuals or studios who entered their work in this competition are included in this directory; to reach illustrators, photographers, or design studios who are listed in the project credits but who are not listed here, please contact the studio with whom they collaborated.

After Hours Creative
1201 E. Jefferson 100-B
Phoenix, AZ 85034

Alexander Isley Design
361 Broadway #111
New York, NY 10013

Canary Studios
600 Grand Ave.
Oakland, CA 94610

Curry Design
1501 Main St.
Venice, CA 90291

DogStar Design
626 54th St. S.
Birmingham, AL 35212

Earl Gee Design
38 Bryant St., Ste. 100
San Francisco, CA 94105

Evenson Design Group
4445 Overland Ave.
Culver City, CA 90230

Focus 2
2105 Commerce
Dallas, TX 75201

Grafik Communications, Ltd.
1199 N. Fairfax St.
Alexandria, VA 22003

Greteman Group (The)
142 N. Mosley
Wichita, KS 67202

Hal Apple Design
1112 Ocean Dr. #203
Manhattan Beach, CA 90266

Hornall Anderson Design Works
1008 Western Ave., Ste. 600
Seattle, WA 98104

I & Company
RR 3, Box 159
Feller Newmark Rd.
Red Hook, NY 12571

Jock McDonald Photography
46 Gilbert St.
San Francisco, CA 94103

KINETIK Communication Graphics
1604 17th St. N.W., 2nd Fl
Washington, DC 20009

Kuester Group (The)
81 S. 9th St., Ste. 300
Minneapolis, MN 55402

Lambert Design Studio
7007 Twin Hills Ave., Ste. 213
Dallas, TX 75231

Masi Graphica
4244 N. Bell
Chicago, IL 60618

Maverick Art Tribe
112 C 17th Ave. N.W.
Calgary, Alberta T2M OM6
Canada

Metal Studio
1210 W. Clay, Ste. 13
Houston, TX 77019

Mike Quon Design Office
568 Broadway #703
New York, NY 10012

Mike Salisbury Communications,
Inc.
2200 Amapola Ct. #202
Torrance, CA 90501

Mires Design, Inc.
2345 Kettner Blvd.
San Diego, CA 92101

Modern Dog
7903 Greenwood Ave. N.
Seattle, WA 98103

Monadnock Paper Mills, Inc.
Antrim Rd.
Bennington, NH 03442

Morrison Design & Advertising
2001 SVL Ross
Houston, TX 77098

Pangborn Design, Ltd.
275 Iron St.
Detroit, MI 48207

Peterson & Company
2200 N. Lamar, Ste. 310
Dallas, TX 75202

Phoenix Creative
611 N. Tenth St.
St. Louis, MO 63101

Platinum Design, Inc.
14 W. 23rd St.
New York, NY 10010

Pressley Jacobs Design Inc.
101 N. Wacker Dr.
Chicago, IL 60606

Primo Angeli Inc.
590 Folsom St.
San Francisco, CA 94105

Pushpin Group, Inc. (The)
215 Park Ave. S.
New York, NY 10003

Riordon Design Group, Inc. (The)
131 George St.
Oakville, Ontario L6J 3X9
Canada

Sackett Design
2103 Scott St.
San Francisco, CA 94115-2120

Sam Smidt Studio
666 High St.
Palo Alto, CA 94301

Sayles Graphic Design
308 Eighth St.
Des Moines, IA 50309

Scott Hull Associates
68 E. Franklin St.
Dayton, OH 45459

Segura, Inc.
361 W. Chestnut St., 1st Fl
Chicago, IL 66610

Studio Wilks
8800 Venice Blvd. #306
Culver City, CA 90034

Supon Design Group
1700 K St. N.W. #400
Washington, DC 20006

TeamDesign
1809 7th Ave., Ste. 500
Seattle, WA 98101

Tharp Did It
50 University Ave. #21
Los Gatos, CA 95030

Tim Girvin Design, Inc.
1601 2nd Ave., 5th Fl
Seattle, WA 98101

Tollner Design Group
111 N. Market St. #1020
San Jose, CA 95113

Ultimo, Inc.
41 Union Square W., Ste. 209
New York, NY 10003

Vaughn Wedeen Creative, Inc.
407 Rio Grande N.W.
Albuquerque, NM 87104

Viva Dolan Communications &
Design
1216 Yonge St., Ste. 203
Toronto, Ontario M4T 1W1
Canada

Vrontikis Design Office
2021 Pontius Ave.
Los Angeles, CA 90025

White Design, Inc.
4510 E. PCH #620
Long Beach, CA 90804

Wood-Brod Design
2401 Ingleside Ave.
Cincinnati, OH 45206

index of design firms

index of clients

FREE CATALOG OFFER:
North Light Books publishes
instructional books for artists,
crafters, illustrators and designers.
For a FREE catalog, write to
North Light Books, 1507 Dana
Avenue, Cincinnati, OH 45207,
or call toll-free 1-800-289-0963.

Got some fresh ideas of your own that you'd like to share with us?

If you'd like to be put on our mailing list to receive a call for entries for future Fresh Ideas books, please copy the form below (or include the same information in a note to us) and send it to:

LYNN HALLER

FRESH IDEAS MAILING LIST

NORTH LIGHT BOOKS

1507 DANA AVENUE

CINCINNATI, OH 45207

or call Lynn Haller at (513) 531-2690 x277, or fax her at (513) 531-4744. Who knows—maybe you'll see your own work in the next Fresh Ideas book!

PLEASE PUT ME ON YOUR MAILING LIST TO RECEIVE CALLS FOR ENTRIES FOR FUTURE FRESH IDEAS BOOKS.

My name _____

Studio name _____

Address _____

City _____

State _____ Zip Code _____

Phone _____

Fax _____

call for entry mailing list